ADRIAN HENRI

Total Art

Environments, Happenings, and Performance

PRAEGER PUBLISHERS

New York · Washington

BOOKS THAT MATTER
Published in the United States of America in 1974
by Praeger Publishers, Inc.,
111 Fourth Avenue, New York, N.Y. 10003

Library of Congress Cataloging in Publication Data

Henri, Adrian.
 Total art; environments, happenings, and performance
 (World of art)
 Bibliography: p.
 1. Happening (Art) I. Title.
PN3203.H4 709'.04 72-79509
ISBN 0-275-43540-4
ISBN 0-275-71580-0 (pbk.)

Printed in Great Britain

Contents

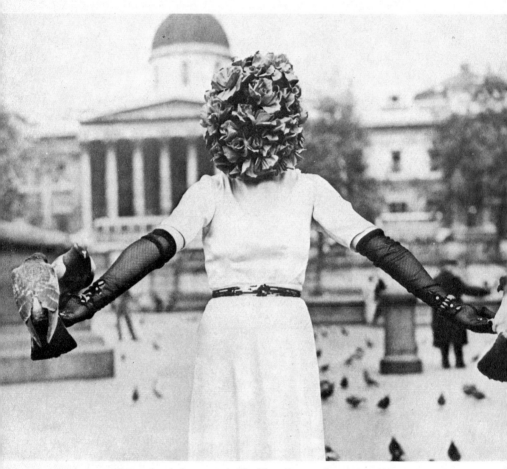

1 Flower-headed woman in Trafalgar Square, London, 1936

6

Towards a Total Art

A flower-headed woman feeding the pigeons in Trafalgar Square in 1936
A concert of factory hooters in Russia in 1922
Yves Klein throwing gold-dust given him for a piece of 'the Void' into the Seine
Allan Kaprow's melting palaces of ice-blocks in city streets
Christo packaging a section of the Australian coastline
Claes Oldenburg proposing to cover Manhattan with a giant ironing-board
An enormous jetty spiralling into a lake, the water inside stained red with algae
Black Mask renaming Wall Street 'War Street'

These are some of the most important images in twentieth-century art. They are also among the least well known. The common quality all these activities share is their awkwardness, their inability to fit into a preconceived artistic framework. Not only are they as important, in my view, as any 'conventional' painting or sculpture; they also spring from a well-defined tradition. Before trying to give some idea of the vast range of activities taking place today in the field of environmental art, it will be necessary first to look at some of the more important elements of this tradition.

The divorce between 'fine' and 'folk' art, and also between hand-made object and physical ritual, is of course a recent one in historical terms. The isolated, individual artist, the unique, irreplaceable object, have been a part of the human consciousness for about two thousand years: for how much longer has art as magic, as ritual, as disposable object, as body-adornment, been part of our heritage? In a fascinating book about the tribes of the Mount Hagen area of New Guinea,[1] Andrew and Marilyn Strathern describe an art that exists *only* in terms of bodily adornment; these tribes practise no pottery, no carving, no decoration of homes or burial-grounds; and yet there are very precise, defined rules, traditions, prohibitions governing their art. Each colour, each form, each object used, has a definite significance. Red can mean success in war, black aggression. A chevron has a

2

7

precise meaning, as does a particular kind of feather. Is it possible that this is the only tribe ever to have stressed ephemeral decoration in this way? It seems more likely that other traditions have perished with the tribes that created them, and that the surviving potsherds and masks in the ethnographic museums have been isolated from their context and assimilated into a nineteenth-century conception of 'material culture'. With the re-evaluation of primitive art at the beginning of the twentieth century came a rediscovery of the possibilities of visual art as a social function: however obscurely, Picasso and Apollinaire must have been aware of the magical, ritual significance of the beautiful objects in the museum-cases.

Even when considering the relatively short span of Western European art, there are whole areas of activity that remain tantalizingly undocumented. Paintings and sculptures, by their nature, are often preserved; what we have lost is any real idea of the look of medieval pageants, or the elaborate 'triumphs' which Leonardo da Vinci and other Renaissance artists designed. These street-works, incorporating

2 Dances at a Kuli festival, Mount Hagen, New Guinea

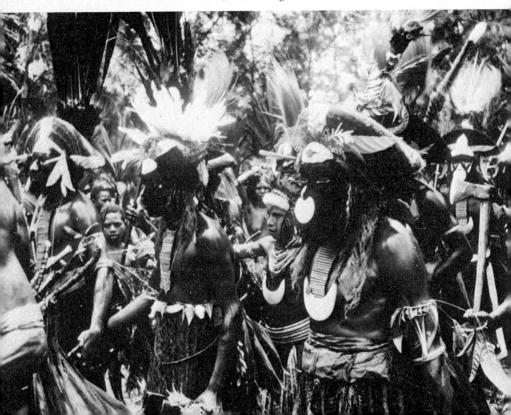

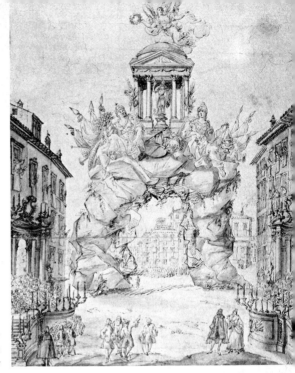

3 MEMBER OF THE GALLI FAMILY
*An Imperial Festival in a
North Italian Town* 17th century

music, verse, costume and mobile constructions on floats, may well
have been the only contact between the common people and the
major artists of the time, apart from the occasional distant glimpses of
an altarpiece. Vasari designed triumphs for Cosimo I in Florence, and
oil-sketches of designs for processions by Rubens still exist; indeed,
such events were still being mounted well into the eighteenth century. 3
In England, Inigo Jones and later Sir James Thornhill designed
spectacular masques for performance at Court, and there was a strong
and continuing medieval tradition of mysteries and other works
played in streets and inn-yards. Watching the Yorkshire Gnomes
playing to a crowd in a cobbled courtyard outside the Traverse
Theatre in Edinburgh in 1971, I was struck with the closeness of the
work of these young English artists to this medieval tradition. Indeed,
like the oral poets of the new generation in England, it seems that they
are deliberately returning to a popular tradition lost since the deliberate
self-isolation of the Romantics.

The nineteenth-century critic Walter Pater said that 'all art aspires
to the condition of music'. This reveals a great deal, not only about
the so-called Aesthetic and Symbolist movements of the 1890s, to

9

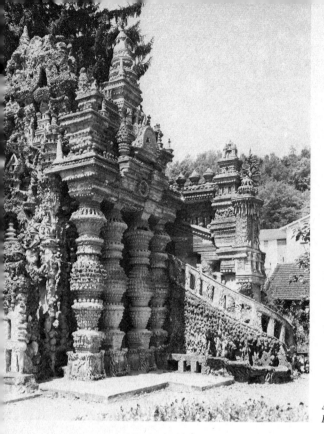

4 FERDINAND CHEVAL
Palais Idéal, Hauterives 1879–1905

which Pater was very close, but about a historical tendency which was to come to fruition in the twentieth century. The Symbolists came to see argument, reason, even representation, as incidentals; they wanted to appeal to reactions and impulses that were profound, irrational, unaccountable, impossible to express directly. Similarly, much of the art discussed in this book appears inconsequential because it is an appeal to pure imagination, by-passing reason. This has always been a characteristic of the kind of environmental art to which this book is devoted – for which Pater's contemporary Richard Wagner adopted the significant term *Gesamtkunstwerk*, 'total art-work'. Such a work, like one of Wagner's own music-dramas, sets out to dominate, even overwhelm, flooding the spectator/hearer with sensory impressions of different kinds. It is not meant as information but as experience.

It therefore follows that architecture, although an environmental art, lies for the most part outside the scope of this book: most buildings,

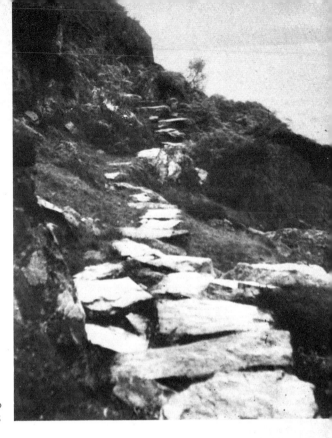

5 ALEXANDER MACDONALD
The Burma Road 1939–45

old and new, have a function and a rationally conceived structure.
The architecture which springs most directly from the imagination,
and which appeals most directly to it, belongs in one way or another to
naïve or primitive consciousness.[2] It is not conceived as a finished
work, but grows; it works by extension, addition, subtraction. Hence
the fascination many modern artists have found in the so-called naïve
builders. Simon Rodia's Watts Towers in California, and, above all,
the 'dream palace' of the French rural postman Ferdinand Cheval,[3] 4
have been revered by several generations of artists now. Less well
known are the sculptures (similarly a life's work) of the Spaniard
José Jordá, known as his *Paraíso*,[4] and an amazing piece of earth art by
the Scottish ex-soldier Alexander MacDonald, a hand-built stone
road at Mallaig round an otherwise impassable headland, nicknamed
by his neighbours *The Burma Road*. I am indebted to Richard Demarco 5
who told me about this, and also about the *Happy Graveyard* at

11

Sapinta in Romania, the work of one old man who makes carved and painted wooden gravestones to celebrate the lives of the villagers who are buried there. The Italianate village of Portmeirion in North Wales, by Clough Williams-Ellis, although vastly more sophisticated than any of the above, is still largely constructed on the additive principle and has a particular poetry of its own.[5]

6, 17 Clarence Schmidt's life-work has been the creation of an endless succession of grottoes, corridors, caves and vistas on O'Hayo Mountain, in the woods near Woodstock, NY.[6] Although a large amount of this was recently destroyed by fire, enough remains and has been reworked for it to remain possibly this century's finest piece of 'total art'. Schmidt lives in some of the construction; but most of it is purely decorative. Anything is grist to his mill: the older parts often use remains of other buildings – doors, window-frames, old furniture – and the most recent ones are sometimes trees sprayed with silver or foil-wrapped, or plastic dolls and flowers mixed with rusting auto components and other urban detritus. The environment is often hung with Christmas-tree lights or other forms of lighting. There exists a photograph, taken in the 1930s, of different-shaped mirrors set by Schmidt at angles in the forest, which antedates the recent 'mirror displacements' of Robert Smithson by some twenty or more years.

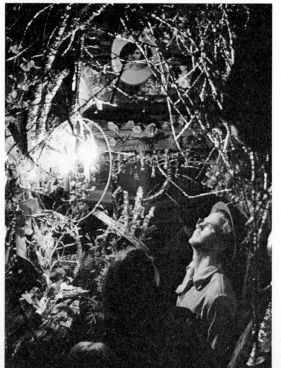

6 CLARENCE SCHMIDT
Environment 1930

Modernism and Total Art

Environments and happenings as purpose-made artistic forms have a pedigree in most of the earlier art movements of this century. The Italian Futurists were perhaps the first to grasp these possibilities;[7] their *Aerial theatre*, for instance, uncannily anticipates the aerobatics and coloured smoke-trails of flying teams like the R A F's Red Devils:

We futurist aviators will give day- and night-time aerial theatre performances. . . . During the day, above an immeasurable expanse of spectators, painted aeroplanes will dance in a coloured aerial environment formed by the smoke they diffuse, and at night they will compose mobile constellations and fantastic dances, invested with light projections.

<div align="right">Fedele Azare</div>

And they conceived truly mixed-media theatre:

<div align="center">NEGATIVE ACT</div>

A man enters, busy, preoccupied. He takes off his overcoat, his hat, and walks furiously forward, saying:
What a fantastic thing! Incredible!
He turns towards the public, is irritated to see them, then coming to the apron says, categorically:
I . . . I have absolutely nothing to tell you. . . . Bring down the curtain!

<div align="center">CURTAIN</div>
<div align="right">Bruno Corra and Emilio Settimelli</div>

Colours, an 'abstract theatrical synthesis' by Fortunato Depero, has the following cast-list:

Empty, cubic blue room. No windows. No doors.

FOUR ABSTRACT INDIVIDUALITIES *(mechanical movements by invisible strings)*	1. GREY – plastic, dynamic ovoid 2. RED – plastic, triangular dynamic polyhedron 3. WHITE – plastic, long-lined, sharp point 4. BLACK – multiglobe

The poet F. T. Marinetti experimented with theatre-pieces,[8] as did Anton Giulio Bragaglia, who made the only surviving Futurist film, *Il Perfido Incanto*. Perhaps the nearest thing in the Futurist context to a present-day happening was performed by a friend of Bragaglia's, who set up a tent, made a 'labyrinth' of rags and other hanging objects, invited people there at night, and pursued them through it on a motor-cycle.[9]

<div align="center">13</div>

In Russia between 1917 and 1923, the most revolutionary situation in the history of Western society held an equally revolutionary potential for the arts. The seeds of this revolution were there before 1917, of course, in the peculiarly Russian version of Futurism, in the poetry of Vladimir Mayakovsky, the early theatre of Vsevolod Meyerhold, the music of the young Igor Stravinsky, and in various 'peasant art' movements. The deliberate outrageousness that marked Italian Futurism, and which was to form a permanent element in avant-garde thinking, was equally strong in Russia. In 1913 and 1914 Natalia Goncharova, Vladimir Larionov, Mayakovsky and the Burliuk brothers would walk the streets carrying flowers or vegetables, with algebraic symbols painted on their faces and radishes in their buttonholes. David Burliuk painted 'I, Burliuk' on his forehead. They made a film of their activities, *Drama in Cabaret No. 13*, in 1913.

The problem for these artists was to find an artistic vocabulary to match their social concepts. In the confusion of the early years of the Revolution, various movements appeared, held sway and disappeared; finally, as the dead hand of Stalinism closed over the country, the concept of Socialist Realism was slowly to strangle initiative and experiment in all but the hardiest. Initially, however, the struggle was between two opposing artistic factions: one felt that the working classes had not yet had a chance to evolve their own revolutionary culture, and that the most avant-garde, the most 'modern' by the highest current standards, would have to do until a truly revolutionary culture evolved. The other faction held that the revolution could only come from beneath, and that only the workers could provide a new culture. Trotsky's *Literature and Revolution*[10] is the classic exposition of the former attitude; the Proletcult group led by Burliuk (and the German Agitprop groups) exemplified the latter. The groups Feks and Blue Blouse (the 'Living Newspaper' group) and the Agit-Trains

7 Agit-train, Russia, 1917

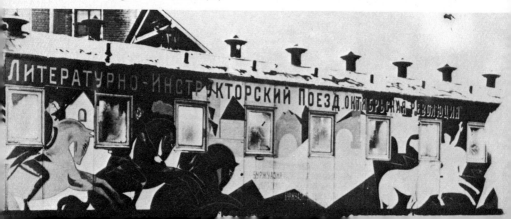

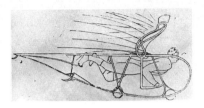

8 VLADIMIR TATLIN
Drawing for Letatlin c. 1930

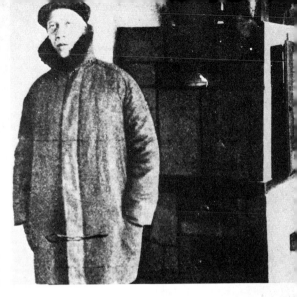

9 Vladimir Tatlin in an overcoat
designed by him, in front of a home-
made stove

and Agit-Boats,[11] evolved directly from this approach. Perhaps the best examples of worker-artist collaboration were the series of concerts for factory hooters and other noises, suggested originally by the poets Gastev and Mayakovsky. These took place from 1918 onwards. The most impressive must have been one in Baku in November 1922. The sirens of all the factories, the foghorns of all the ships, squadrons of machine-guns and two battalions of artillery were involved, together with a 'choir' consisting of thousands of spectators.

It is particularly hard to choose examples to cover the variety of works produced during this period, which saw the Rosta poster-poems of Mayakovsky, the revolutionary theatre productions of Meyerhold, like *Mystery-Bouffe, The Dawn, Tarelkin's Death*[12] (with equally innovatory settings by Liubov Popova and Varvara Stepanova), and the radical cinema of Dziga Vertov, both in his *Kino-Pravda* series and in his masterpiece, *Man with a Movie Camera*:

> I am an eye, I am a mechanical eye,
> I free myself today and for ever from human immobility.[13]

The group of avant-garde artists loosely called Constructivists were deeply involved with environmental concerns. They believed in a Platonic idea of perfect form that they sought to apply to all areas of life. Perhaps their most versatile and productive member was Vladimir Tatlin, who designed stage-sets, a flying-machine (a one-man ornithopter for the masses), new clothing for workers, a stove

8
9

15

to give more heat for less fuel, a gigantic *Monument to the Third International*, a prototype tubular chair for mass production, décors for cafés and layouts for magazines, besides more conventional works like paintings and sculptural constructions. Some of these schemes were idealistic to the point of being unrealizable: the Constructivists were above mere functionalism, and their aim was a visionary Socialist utopia.

Like many other terms in art history, Constructivism covers all kinds of activity: on the one hand Tatlin (and related artists like El Lissitzky and Rodchenko); on the other Kasimir Malevich. The most radical innovator (along with Marcel Duchamp) in twentieth-century art, Malevich was a dedicated Communist and as practical in his concerns as Tatlin; but he was nevertheless also deeply concerned with 'spiritual' values. The square, for him, was a perfect form; perfection needed no variety. There is a ruthless kind of mysticism in Malevich's 'Suprematism' that is peculiarly Russian.[14] After great canvases like *Black on White* of 1913 and *White on White* of 1918, Malevich concentrated mainly on his work as a teacher and on architectonic projects. Sergei Eisenstein said of him:

In the main streets the red brick has been covered by white paint. And the white paint bears green circles. Orange squares. Blue rectangles. This is Vitebsk in 1920. The brush of Kasimir Malevich has passed across these brick walls.

The final triumph of Suprematism was to come shortly after his death in 1935. Suetin, his friend and pupil, carried out Malevich's funeral arrangements as previously instructed. The coffin, white and Suprematist in design, bore a black square above a green circle; a Malevich painting hung above it, while a reconstruction of one of his 'columns' stood before it; the coffin was taken to the cemetery in a lorry with a black square painted on the radiator; the gravestone was a cube of cement on which was painted a red square.

While the First World War raged outside, and the Revolution catalysed the energies of the young Russian artists, in neutral Switzerland and the U S A the group of disillusioned, anarchic painters, poets, dancers, photographers we have come to know as Dada was slowly forming.[15] It was a negative, deliberately absurd gesture against the whole culture which had produced the war. Dada had in common with both Italian and Russian Futurism a sense of outrageousness. What was

16

new was its total rejection of established forms, and its amazingly widespread growth. Dada was the first truly international artistic movement; its rapid spread prefigured the international develop-ment of happenings and similar activities at the end of the 1950s (see Appendix 1).

Dada, as it spread, emerged as embodying two major concepts: a deliberate courting of the anti-rational, negative gesture; and a com-mitment to social or political action. Zürich Dada was essentially negative – a combination of mischief and disgust. So when the Cabaret Voltaire opened in Zürich in 1916, the young artists taking part had to evolve a new style of performance. Poems composed by randomly cutting up printed material – or made up entirely of non-sense syllables – would be performed, sometimes simultaneously by a number of oddly garbed figures. Apparently meaningless songs were sung. Walter Serner performed a 'poem' which consisted of placing a bouquet at the feet of a dressmaker's dummy. There were other, less alarming manifestations; dance and costume design were very much communal activities. Mary Wigman, an associate of Rudolf von Laban, one of the founding fathers of modern dance, was involved in the Cabaret Voltaire. But Dada was never a style, and the more con-ventional art-works of Zürich Dada – paintings, sculptures, and to some extent poems – are negligible compared with what we know of its performances.

The political side of Dada was particularly strong in post-1917 Germany. The Berlin Dadas, one of whom, Richard Huelsenbeck, had also been in Zürich, were involved in the 1918 uprising; and at their 'Dadafair' of 1920 a dead pig in Prussian officer's uniform hung from the ceiling. The wildest member of the group, Johannes Baader, who had a police certificate declaring him incapable of criminal responsibility, created a major scandal by disrupting services in Berlin Cathedral and showering leaflets at the founding session of the Reichstag.

The irrational side of Dada was inherited by the young Parisian writers grouped round the magazine *Littérature*. They gave concerts like the one at which Philippe Soupault's *The Famous Magician* was performed: masked, strangely garbed figures released multi-coloured balloons bearing the names of literary and artistic celebrities; there were the Dada visits and excursions, where parties of people were taken round drab quarters of Paris; and they staged provocative

events like *The Trial of Maurice Barrès* of 1923, in which the celebrated conservative writer was tried *in absentia* for 'crimes against French culture'.

Meanwhile, while cultural terrorism and political subversion were emerging as legitimate tactics for the young Dada artists, one of them was increasingly involved with the same sort of environmental urge that was causing Clarence Schmidt to begin his life's work on O'Hayo Mountain.

In the early 1920s Kurt Schwitters began work on what he at first called a *Schwitters-Säule*, a 'column' made of an accretion of wood, plaster and all kinds of collaged objects which quickly grew to the ceiling of his apartment in theWaldhausenstrasse, Hanover.[16] It went on to grow down and across the walls; niches were made to contain mementoes of friends, and later covered over; the work finally grew up through the ceiling, down through the floor, and even out on to a small projecting roof. The whole thing was finally called a *Merzbau*,

10

10 KURT SCHWITTERS *Hanover Merzbau c.* 1927

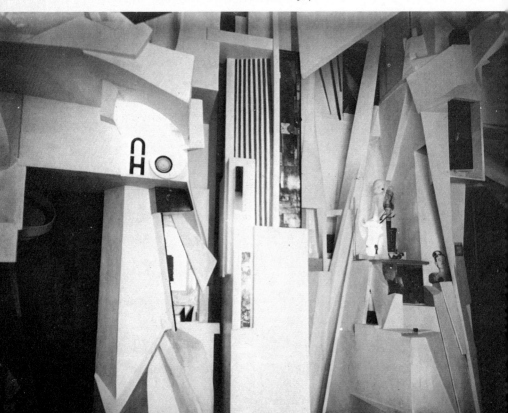

or merz-house. *Merz*, a word arrived at by chance when Schwitters cut up a newspaper containing the word *kommerz* for one of his collages, came to stand for anything he did: merz-poem, merz-picture, merz-house. The problem of finding a label for your activities, should they fall outside the conventional 'painter', 'poet', or whatever, still exists today, and largely accounts for the multitude of 'isms' that confuse the layman. Schwitters had finally to leave the *Merzbau* in the 1930s, when he was hounded from Germany by the Nazis. The building somehow survived until 1943, when it was destroyed by bombing. Schwitters had moved to Norway, where he began another *Merzbau*, the Hus am Bakken at Lysaker. The Hanover house had slowly changed, from its complex, fragmentary beginnings to the plainer manner we can see in the surviving photographs. The new house was made entirely of wood, and from the descriptions given by his son, seems to have been even more geometrical and 'worked-out' in composition. Schwitters was forced to flee to England when the German invasion came. He was interned for a time, and ended up at Ambleside in the Lake District, earning a precarious living painting portraits. The Norwegian *Merzbau* was finally burnt down by children in 1951. In the uncertain days following the end of the war in Europe the fate of the Hanover *Merzbau* was still uncertain: it was thought to have partly survived, and the Museum of Modern Art in New York offered the artist a grant to try and restore it. When this proved impossible it was agreed that the money would be used for the construction of a new environment.

Mr Pearce of Cylinders Farm, Little Langdale, had offered Schwitters the use of a barn in a beautiful landscape garden to work in, and it was there in 1947 that Schwitters, old and ill, began work on his final piece of 'total art', his *Merzbarn*. This work was to be made almost entirely of plaster, with the usual 'found objects' embedded in it. The rhythms this time, like those of his last sculptures, were curvilinear, organic, non-geometrical. When I visited the farm in 1964, it was a desolate and sorry memorial; the one wall the artist had completed before his death was slowly disintegrating, lumps of fallen plaster joining rusting objects waiting to be added to the work. For a long time it seemed that, in a world where envelope-sized Schwitters collages sell for thousands, his last major work must be allowed to disintegrate. Finally, the University of Newcastle-upon-Tyne stepped in, and the completed wall is now safe and on permanent view in Newcastle.

Schwitters's most ambitious project was that of the *Merzbühne*, the total merz-theatre:

All solid liquid gaseous bodies such as white wall, man barbed wire entanglement, blue distance . . . surfaces that fold like curtains, or shrink . . . everything from the hairnet of the high-class lady to the SS Leviathan. Even people can be used – People can even to tied to backdrops.[17]

Though this project was never to be realized, it resembled a number of other projects for a new, 'total theatre' that were developing in Europe during the 1930s. Schwitters's old Dada companion Theo van Doesburg had changed his ideas radically and become co-founder of the De Stijl group.[18] They, like the Russian Constructivists, saw perfect structure as the artist's highest aim. They also considered chairs and paintings, shop-signs and abstract sculpture, to be within the range of the complete artist. Then in 1926, Gropius founded the Bauhaus theatre,[19] in which many of the partly realized ideas of the Futurists, Schwitters and others came to fruition in the work of Oskar Schlemmer, László Moholy-Nagy and a number of the Bauhaus students. Their ideas of 'total theatre', of a new use of space, resembled the theatre that El Lissitzky had designed (but which was never built) for Meyerhold in Russia.

At the same time, there developed a strain in Germany of 'Revolutionary Professional Theatre', which, to some extent, resolved the worker-versus-intellectual conflict which had existed in Revolutionary Russia.[20] This was derived partly from the earlier, proletarian Agit-prop theatre, but also from the non-naturalistic techniques of the Expressionist playwrights, and even more from Expressionist film. The profoundly political spirit of Berlin Dada joined with the politics-oriented *Der Sturm* wing of Expressionism. Erwin Piscator[21] and Bernhardt Reich drew on the talents of George Grosz, Moholy-Nagy and particularly John Heartfield, the brilliant inventor of photo-montage; on the music of Hans Eisler and others; and on the writing of Ernst Toller and above all Bertolt Brecht.[22] The later careers of these men are now well known: Piscator in both Russia and the USA, Brecht eventually founding his own Berliner Ensemble; what is important is that they conceived theatre as multi-media, didactic yet entertaining, using modern technological devices like film and back-projected montages, as well as techniques from cabaret and music-hall. Piscator's elaborate plans for stage-machinery often foundered

through sheer lack of finance, and through dependence on techniques that simply did not exist at that time. Brecht, on the other hand, with his concept of simple, bare staging, fared better in the uncertain financial world of political theatre.

Vastly different in intention, but equally revolutionary in concept, were the ideas being expressed in France by Antonin Artaud.[23] His concept of a physical, non-verbal theatre, aiming for a total emotional effect, was seldom realized, partly because of his own intractability and mental ill-health and partly because of the inability of conventional theatre people to see the importance of his ideas. It was only after the Second World War, notably in the work of Peter Brook in England and Jerzy Grotowsky in Poland, that some of Artaud's most important concepts were realized. Artaud, although too much of a lone wolf to join anything for long, was an influential early member of the Surrealist group.

As Ronald Hunt has pointed out, Surrealism shares with Constructivism the consistent misinterpretation of critics and historians who see only formal or aesthetic end-products in a movement which was aiming at political and social revolution.[24] The artefacts left behind tell us only as much about the lives of their creators as do, say, the potsherds we dig out of prehistoric villages.

'Surrealist', a word coined by Guillaume Apollinaire to describe his play *Les Mamelles de Tirésias*, was used by Breton and his poet friends associated with the magazine *Littérature* after their break with the Dadaists Tristan Tzara and Francis Picabia in 1922. A vital and difficult distinction between the two movements should be made here. Dada stood for chance, for negation, 'to destroy in order to build on the ruins'; its name was a loose catch-all word to cover almost any avant-garde or provocative activity. Surrealism, on the other hand, stood for a definite system, an aesthetic, an order of disorder, perhaps best described in Rimbaud's phrase 'a systematic unhinging of all the senses'. It was a methodical exploitation of the resources of the unconscious; it involved a commitment to the imagination and to the 'waking dream'. It was firmly defined (it even had its own 'dictionary'), rigidly codified by Breton, and had all the trials, expulsions and *Apparat* of a political party. Certainly the Surrealists were explicitly political in their intentions. The sad history of the Surrealists' relations with the French Communist Party, which even at the time of the 'United Front' could not tolerate as members people dedicated to the

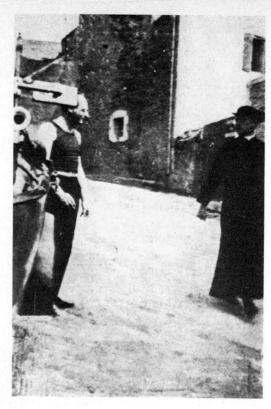

11 'Our contributor
Benjamin Péret insulting a
priest', from *La Révolution
surréaliste*, 1926

liberation of the mind as well as the body, bears witness to this.[25] That
Breton was ultimately justified became apparent when his slogan ALL
POWER TO THE IMAGINATION appeared on the barricades of Nanterre
and Saint-Germain in May 1968.

The Surrealists are perhaps the most obvious forerunners of many
of the most recent kinds of art-activities. The street was the focus of
many of their activities: Eluard and Breton attempted to induce
inspirational events by cultivating certain 'magic' places, perhaps a
development from their earlier Dada visits and excursions, and there
11 exists an amazing photograph of the poet Benjamin Péret in the act of
insulting a priest in the street. Provocative slogans were flyposted all
over Paris. There were projects for a new Surrealist architecture. They
instituted a cult of popular entertainment, idolizing Feuillade's
penny-dreadful film serial *Fantômas*.

Salvador Dali is important in the present context not for his minutely
detailed Surrealist paintings – fine though the pre-war ones are – but

22

for his adoption of a totally surreal life-style, described in his book *The Secret Life of Salvador Dali*.[26] His 1936 London lecture,[27] which he gave in a diving-suit, with a loaf of French bread strapped to the helmet, leading two white Russian wolfhounds; his 'found and reinterpreted' objects; the scandalous psychological reinterpretation of Millet's *Angelus*; the *Rainy Taxi-Cab* he made for the 1938 Surrealist exhibition, in which a fur-coated dummy sat inside a cab fitted with a permanent shower of water, her body the home for dozens of water-snails, the driver made of wire-netting grown through with ivy: all these epitomized the total absorption in a Surrealist life, but none more than his plan to achieve world domination:

I then confided to them that the principal act of the bread, the first thing to be done, was to bake a loaf fifteen metres in length. Nothing was more feasible on condition that one go about it seriously. First one would build an oven large enough to bake it in. This loaf of bread was not to be unusual in any way, and was to be exactly like any other loaf of French bread, except in its dimensions. When the bread was baked, one would have to find a place to put it in. I was in favour of choosing a spot not too conspicuous or too frequented, so that its apparition would be all the more inexplicable, for only the insoluble character and cretinizing purpose of the act counted under the circumstances. I suggested the inner gardens of the Palais-Royal. The bread would be brought in two trucks and placed at the designated spot by a gang of members of a secret society disguised as workers, who would seem to be bringing a pipe to be laid down as a water main. The bread would be wrapped in newspapers tied with string. Once the bread was in place some members of the society, who would previously have rented an apartment overlooking the spot, would come and take their posts in order to be able to make a first detailed report of the various reactions which the discovery of the bread would occasion. It was easy enough to foresee the highly demoralizing effect which such an act, perpetrated in the heart of a city like Paris, would have. . . .

A new act, doubly, triply more sensational than the first – the apparition in the court of Versailles of a loaf twenty metres in length. . . .

But instead of the third loaf of bread which was expected, an event exceeding all the limits of plausibility would occur. On the same day, at the same time, thirty-metre loaves would appear in public places of the various capitals of Europe. The following day a cable from America would announce the apparition of a new loaf of French bread forty-five metres long lying on a sidewalk and reaching from the Savoy-Plaza to the end of the block where the Hotel St Moritz stands. If such an act could be success-fully carried through with the rigorous attention to all the relevant details

23

that I had planned, no one would be able to question the poetic efficacy of such an act, which in itself would be capable of creating a state of confusion, of panic and of collective hysteria, extremely instructive from an experimental point of view and capable of becoming the point of departure from which, in accordance with my principles of the imaginative hierarchical monarchy, one could subsequently try to ruin . . . systematically the logical meaning of all the mechanisms of the rational practical world.[28]

These public acts were designed to break the barriers between dream and reality, to bring the domain of the marvellous within the confines of everyday life. The cinema was a perfect medium for this, and the early films of Luis Buñuel, like *Un chien andalou* and *L'Age d'or*, both with scenarios by Dali, are among Surrealism's finest achievements.[29] Other notable films were Cocteau's *Le Sang d'un poète*[30] and *La Coquille et le curé*, made by Germaine Dulac from a scenario by Antonin Artaud (which he later, characteristically, disowned).[31]

The art exhibition as a total experience and a form of provocation dates from Dada, and perhaps most particularly from Max Ernst's first Cologne exhibition in 1920, in which he was joined by other artists who, like him, were later to be Surrealists. It was entered through a men's urinal, and was opened by a young girl in a First Communion dress reciting obscene verses. An axe hung from one of the exhibits, inviting the visitor to destroy the work if he didn't like it. A head of hair floated in a tank of red dye. Similar scandals marked Ernst's first Paris exhibition in 1920.

The great Surrealist exhibition of 1936 in London (which was
1 graced by the flower-headed lady I mentioned at the head of this
12, 13 chapter), and that of 1938 in Paris, were perhaps the most direct precursors of today's environmental art.[32] The Paris one in particular owed its impact mainly to the genius of Marcel Duchamp, always a nonjoiner of movements but adopted by the Surrealists as by the earlier Dadas. The ceiling of the main room was hung with 1,200 coalsacks filled with paper, a gramophone played German military marches (this in 1938!), there was an ornamental pool, the smell of roasting coffee-beans wafted round the room, and the only light was from a glowing brazier. The actual works were supposed to be viewed by the light of electric torches, but most of these had been stolen at the
14 opening of the show. For later exhibitions Duchamp designed a maze of string and a shower of indoor rain falling on to artificial grass and a billiard-table.

24

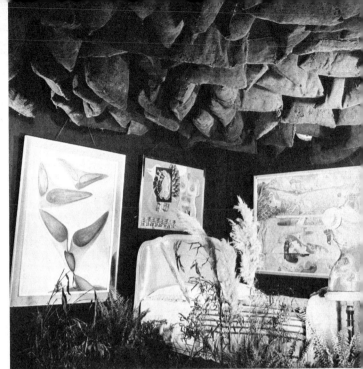

'International Exhibition of
-realism', Galerie des Beaux-
:s, Paris, 1938, showing *The*
ol; right, Marcel Jean's *Horo-*
>e; on the wall paintings by
.len, Roland Penrose and André
.sson

'International Exhibition of
-realism', Paris, 1938, showing
ver by Oscar Dominguez in
foreground

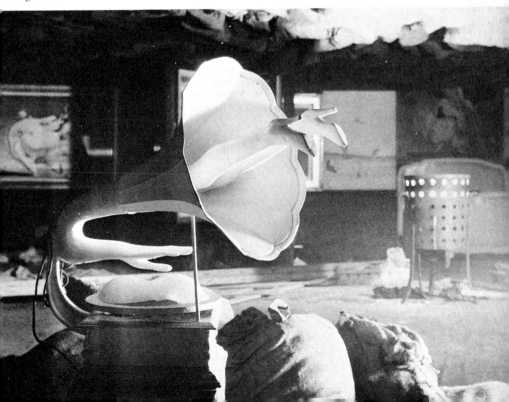

Duchamp, like Malevich, triumphed posthumously, his final ironic act. Assumed to have renounced art since the 1920s, Duchamp spent the last years of his life, from 1946 to 1966, making his only large environmental work, in total secrecy. It is now permanently installed in the Philadelphia Museum of Art, where the majority of his works are housed.[33] Peepholes are set in a large, weathered wooden door in a brick wall. Through a hole apparently smashed in a further brick wall is a painted illusionistic woodland with an artificial waterfall. In the foreground there is a life-size nude woman, legs spread, with tufts of hair under arms but none on her pubis, her blonde hair concealing her face. She lies on a heap of branches, one arm aloft holding an electric lamp. A final irony: the work cannot be photographed, only *seen*. Its title comes from the notes for his other masterpiece, *The Large Glass: Given: (1) The Waterfall, (2) The Lighting Gas.*

I have gone into this very selective history of the modern movement because I feel that the works that make up the rest of this book stem from a tradition of 'total art'. That this tradition is seldom made clear in histories of modern art makes this recapitulation all the more necessary. One final example: recently a young English artist, Keith Arnatt, documented a 'piece' called *I have decided to go to the Tate Gallery next Friday.*[34] Duchamp, talking of himself in 1914, said:

At that time I was preoccupied with the idea of doing a certain thing in advance, of declaring 'At such-and-such an hour I'll do this' . . . I never did it.[35]

14 'Surrealist Exhibition', New York, 1942, showing twine by Marcel Duchamp

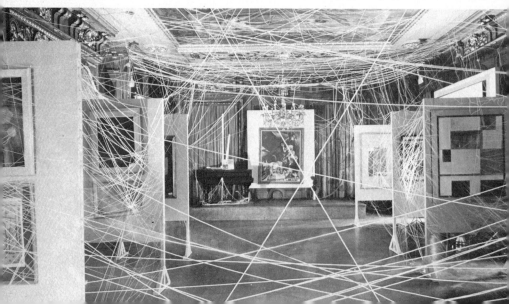

Art as Environment

Pop as Environment

I am for art that comes out of a chimney like black hair and scatters in the sky.
I am for art that spills out of an old man's purse when he is bounced off a passing fender.
I am for the art of a doggy's mouth, falling five stories from the roof.
I am for the art that a kid licks, after peeling away the wrapper.
I am for an art that joggles like everyone's knees, when the bus traverses an excavation.
I am for the art that is smoked, like a cigarette, smells, like a pair of shoes.
I am for art that flaps like a flag, or helps blow noses, like a handkerchief.
I am for art that is put on and taken off, like pants, which develops holes, like socks, which is eaten, like a piece of pie, or abandoned with great contempt, like a piece of shit.
I am for the blinking arts, lighting up the night. I am for art falling, splashing, wiggling, jumping, going on and off.
I am for the art of fat truck-tires, and black eyes.
I am for the Kool-art, Pepsi-art, Sunshine-art, 39 cents art, 15 cents art, Vatronal art, Dro-bomb art, Vam art, Menthol art, L & M art, Exlax art, Venida art, Heaven hill art, Pamryl art, San-o-med art, Rx art, 9.99 art, Now art, New art, How art, Fire Sale art, Last chance art, Only art, Diamond art, Tomorrow art, Franks art, Meat-o-rama art.

Claes Oldenburg[1]

After the Second World War the directions that had become apparent in pre-war avant-garde movements profoundly affected a new generation of artists. Art could go into the streets, be a political act, take away the barrier between fantasy and reality, affect the quality of daily life, seek inspiration from humble and despised objects, create an environment of its own. It is with these two latter categories that this chapter is concerned.

Pop art began in England as an expression of fascination with the glamour of modern American life as seen by the wartime and post-war generation of young British artists. It began, in fact, with the recognition of a whole new field of subject-matter in the general

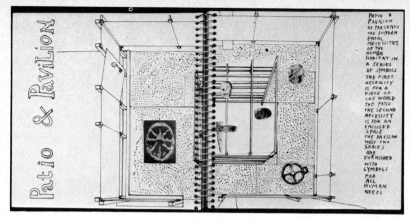

15 EDUARDO PAOLOZZI, NIGEL HENDERSON, ALISON AND PETER SMITHSON *Drawing for Patio and Pavilion* 1957

environment outside art. The phrase 'Pop art' was first coined by the Independents' Group[2] to apply to a new era outside the traditional Fine Art/Folk Art dichotomy: specialist-designed artefacts for mass production and consumption – sports cars, pop music, advertisements. The phrase was initially used to describe the source material of a number of artists working between 1951 and 1958, rather than their work. Other than lectures and discussions, the main results were a series of exhibitions – 'A Parallel of Art and Life', 'man, machine and motion' – held mostly at the Institute of Contemporary Arts (I C A) in London and using photographic or documentary material in a sort of environmental 'maze'.[3] The culmination of this phase was 'This is Tomorrow', held at the Whitechapel Art Gallery in 1957. Inside the gallery were a series of 'pavilions' by groups of artists and architects, notably one by Eduardo Paolozzi, Nigel Henderson and Alison and Peter Smithson which was a kind of minimal shelter housing displays of varied artefacts. The Richard Hamilton/John McHale/John Voelker collaboration was a kind of mass-consumers' funhouse, with a floor that changed texture, ultra-violet light, false perspective. Outside were a life-size cut-out of Marilyn Monroe, a huge beer-bottle and a massive cut-out tableau from a cinema marquee for *The Forbidden Planet*. M G M were persuaded by Richard Hamilton to lend Robby the Robot, the hero of the film, to open the exhibition.

'Pop as Polemic and Affiliation' was Lawrence Alloway's name for the work of the second-phase artists, Richard Smith, Robyn Denny, William Green and others, who gave their hard- or soft-edged abstracts titles like *Flip-Top*, *Gully Foyle*[4] and *Errol Flynn*. The

28

culmination of this phase was an exhibition called 'Situation'.[5] Though influenced by the large canvases of the Abstract Expressionists, these artists were also affected by CinemaScope, Todd-AO and soft-focus billboard ads. This exhibition, though meant primarily as a protest against the reluctance of the Bond Street galleries to show big paintings, is interesting in this context in that the work was done to a minimum size, and was arranged as a walk-through environment. In the early 1960s another painter of the same generation, Bridget Riley, projected a circular Op-art environment.

At this point the initiative passed to America, and English Pop became weaker as it grew more financially successful. One of the few exceptions has been a recent exhibition by Allen Jones of 'Erotic Furniture': life-size, life-coloured voluptuous blonde models wearing minimal articles of leather-fetishist clothing to be used as tables, chairs, a hat-stand. Nicholas Munro works more subtly on the environment. He operates, like Christo (p. 76), by alienation; his multiple red reindeer, for instance, bring an air of strangeness to any setting. In 1972 he temporarily gingered up the bleak modern Bull Ring precinct in Birmingham by erecting a giant fibreglass gorilla there.

Pop in the USA grew up at the end of the 1950s in the small, mostly co-operative New York galleries around 10th Street, such as the Green, the Hansa and the Reuben. It was in the same milieu and at the same time that the progression from assemblage to environments and happenings took place.

George Segal's work was environmentally conceived from the outset: from the plaster figure on the real bicycle to the life-cast of a shop-

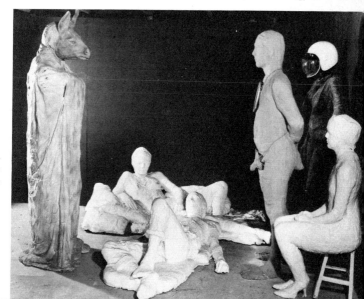

16 GEORGE SEGAL
Costume Party
1965–67

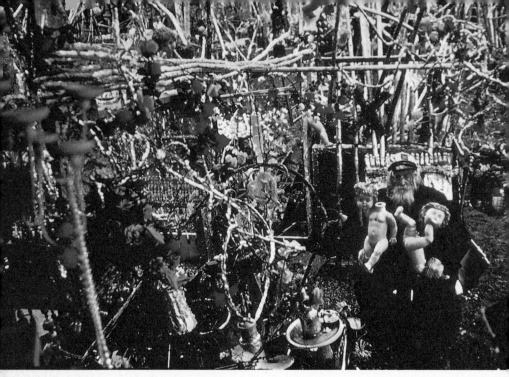

17 CLARENCE SCHMIDT *Environment c.* 1970

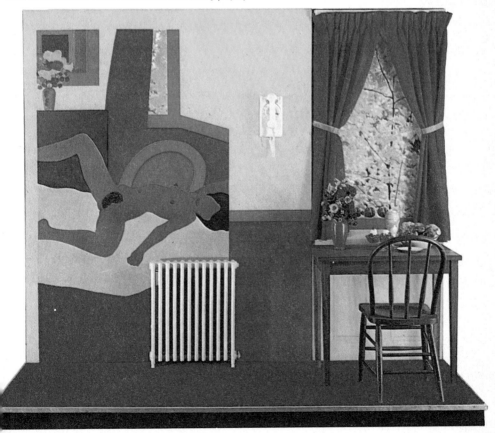

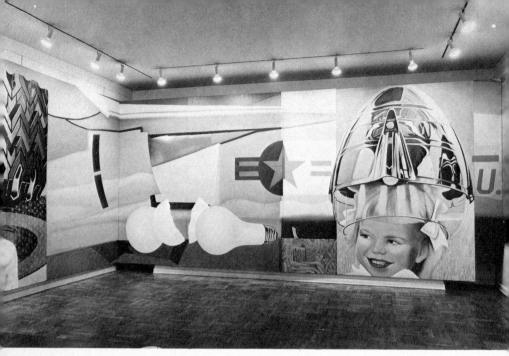

19 JAMES ROSENQUIST *F–111* 1965

girl leaning on her counter, seen through the neon window-sign, or
the woman in her own kitchen. Segal has been concerned more and
16 more to place his figures in a 'real' environment; and, though some-
times the figures are coloured, his pieces always exploit the contrast of
an artist-made object with a real environment. In this he differs from
some of the more explicitly realist sculptors of the younger generation,
who are unconcerned with this 'distancing' effect. Tom Wesselmann
18 has also been concerned to make his *Great American Nudes* environ-
mental by confusing the spectator's space with that of the painting: the
painted carpet extends as a *real* carpet under your feet, the telephone
next to the painted girl may ring from time to time.

James Rosenquist, although working mainly with paint on canvas,
has from the outset been affected by both the style and the scale of bill-
boards. His style, like that of pre-war works by René Magritte, is
derived more from sign-painters' conventions than *belle peinture*. His
19, 21 major work so far, *F-111*, was made to fit exactly round four walls in
the Castelli Gallery: the spectator is thus involved in a 'wrap-around'
painting.

32

Larry Rivers, again concerned mainly with easel-painting, made a giant cut-out *History of the Russian Revolution*, and Alex Katz has made free-standing life-size cut-out portraits, and figures for *The Dream of George Washington*, a play by Kenneth Koch. Red Grooms, dancer, movie-maker and one of the originators of happenings, made a mechanical panorama, *Chicago*, a combined history and geography of that city. 20

It is Andy Warhol and Claes Oldenburg that have made the most of the environmental possibilities of Pop art. Even more than with Dali, Warhol's life-style is itself a work of art – the 'superstars', 'The Factory' and so on – and yet, although endlessly documented, he preserves a kind of anonymity, a Duchamp-like reserve. It was rumoured that a West Coast lecture tour of Warhol's was in fact made by a substitute in a blond wig and dark glasses. Warhol has written and made movies. For a time he ran a night-club, The Exploding Plastic Inevitable, featuring the singer Nico and the rock group Velvet Underground. However, what we are most concerned with here is not Warhol's subject-matter in itself so much as the formal procedures it leads him to. Thus a 1964 installation shot of his *Brillo Boxes* has them laid out in symmetrical rows on the gallery floor. In a more recent show of his work in London, the boxes were piled in one

20 RED GROOMS *City of Chicago* 1968

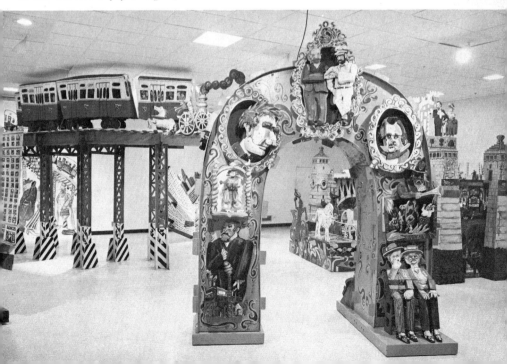

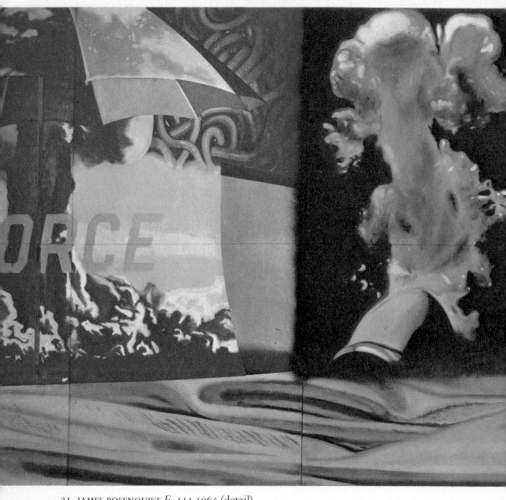

21 JAMES ROSENQUIST *F–111* 1965 (detail)

34

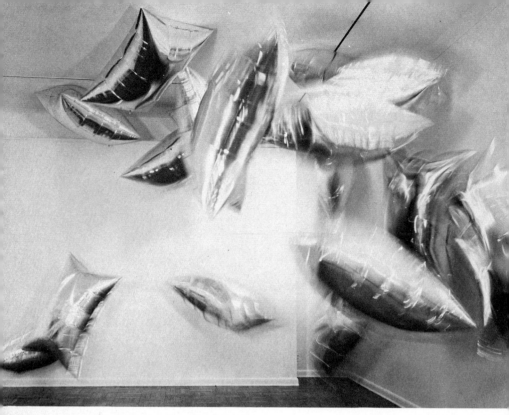

22 ANDY WARHOL *Clouds* 1966

giant block, creating, in effect, a totally new work from the same
basic elements, and one which makes entirely different demands on the
22 spectator: to be moved *around* rather than *through*. His *Clouds* of 1966
were free-floating silver pillows that moved with the air-currents of
26 the room. The *Cow* wallpaper means something only when pasted on
a real wall. The purely formal implications of these and many other
pieces were realized by a later generation of minimal artists.

 When I spoke to Ed Kienholz about doing this book he said 'You're
doing a chapter on Oldenburg, of course?' That I am *not* is a tribute
both to Oldenburg's importance and to his versatility. His work is as
relevant in the field of 'artist's theatre' as in that of environments, and
these are topics that demand to be treated separately (see p. 100). Claes
23, 24 Oldenburg opened *The Store* in December 1961.[6] It was a real store at
29 107 East 2nd Street, and the objects he made (food, stockings, shirts,

36

girlie-figures) were displayed on counters and shelves. It was open for two months, and, as with any other business, inventories and a balance-sheet were drawn up. In 1960 he and Jim Dine had exhibited *The Street*,[7] an environment, mainly of paint and cardboard and burlap, using detritus from the streets around. It is interesting that the French artist Jean Dubuffet, one of the main influences on Oldenburg at the time of this exhibition, has recently shown objects – three-dimensional environmental versions of his *Hourloupe* series of paintings – which bear a strong resemblance to many of the works in *The Street*.

Oldenburg's development after 1960 was marked by a series of 'thematic' shows: *The Store, The Home*. His materials changed from torn card to plaster on chicken-wire to stuffed or inflated cloth or vinyl. His most recent objects, based on domestic machinery or one favourite make of car, almost always exist both in 'hard' and 'soft' versions. Each Oldenburg exhibition has formed an environment of related objects, although each object is conceived independently. His best-known pieces, the giant hamburgers or ice-cream cones, are important for their formal originality: soft, floppy, shiny, rough, stuffed, hanging sculptures.

It is in his grandiose projects for landscape-objects that Oldenburg is at his most exciting. With a graphic style that can range from a

3 CLAES OLDENBURG
Preliminary Report on the Store 1965

24 CLAES OLDENBURG *The Store* 1965

25 CLAES OLDENBURG *Icebag* 1970

26 ANDY WARHOL *Cow wallpaper* 1971 ▶

38

27 CLAES OLDENBURG *Postcard study for Colossal Monument: Thames Ball* 1967

Watteau-like delicacy to the toughness and accuracy of a blueprint, he has created an endlessly inventive range of objects:[8] an ironing-board above Manhattan to serve as weather-shield and heliport, a pair of miniskirt-high knees above the Chelsea Embankment, a giant wind-screen-wiper in a Chicago park that dips into a lake at either end of its arc. Some of his monuments exist only as verbal concepts.

The Memorial to Pinetop Smith Chicago
This is a wire strung westward over North Avenue . . . from Clark Street to the city limits and beyond. At intervals of 15 minutes, a blue impulse travels along the wire. In a split second it moves from Clark to Austin Boulevard. Along its path, the impulse touches off a blue light at the intersection of Larrabee Street. Near there, according to legend, Pinetop Smith, the inventor of Boogie-Woogie, was killed. The light burns about a minute and fades away. The monument ignites each evening at the same time as the city lights.[9]

It seems sad that, with one small exception, none of these projects has been realized. There has been nothing worthy of gracing our rebuilt cities since the demise of nineteenth-century monumental sculpture.

40

Even the movable lipstick-sculpture erected at Yale University met with opposition in academic circles, and spends most of its time touring other universities.

One major Pop figure remains to be mentioned. Ray Johnson was, in the 1950s, very much an American equivalent of Richard Hamilton. Relatively unpublicized and unshown, his work has the same blend of high and popular art and the same fastidious ingenuity. In the mid-1950s he made *Moticos*, cut-out display-collages, shown here on the street. Since then his main work has been the New York Correspondence School, a world-wide network of letters containing information, drawings, collages, messages and occasional invitations to actual meetings or manifestations.[10] *28*

The formal concepts of the Pop artists – soft sculptures, landscape monuments, art as correspondence, regular permutated units – have recently re-emerged in new, non-figurative ways. To take one instance, Claes Oldenburg's *Store* has borne a number of progeny: Daniel Spoerri's *Restaurant. Spoerri* in Düsseldorf and Les Levine's *Levine's Restaurant* both move from the same context into a study of *30* the process of making and selling food. In 1964 the Bianchini Gallery

28 RAY JOHNSON *Moticos* 1955

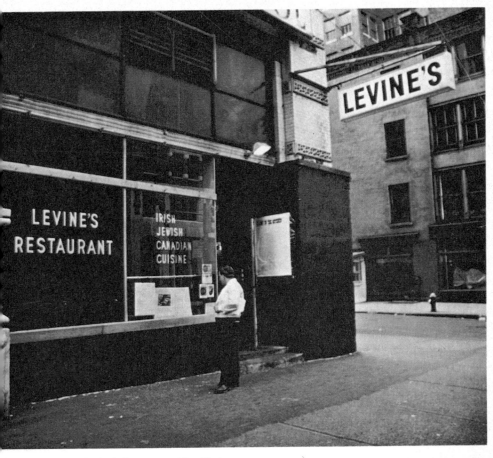

30 LES LEVINE *Levine's Restaurant, New York* 1969

◀ 29 CLAES OLDENBURG *Store Days* 1965

43

turned itself into a 'Supermarket' with Pop objects on display in a real environment, even to Warhol-designed carrier-bags. More recently the young English artist Peter Dockley has used empty shop-premises to show his realistic wax sculptures in a gradual process of disintegration or decomposition. A head or a completed figure may contain food for rats or chickens, who are allowed to eat it over a period of time. Or Dockley himself will melt the wax gradually with a blow-torch. The resultant images are often horrifying, recalling the finale of the old Hollywood movie *House of Wax*, which Dockley says he has never seen. The cinematic possibilities of this process are exploited in his short film *Cast*. It is, however, his use of art-made objects in a real-life context – butcher's stall, clothier's, bakery – that concerns us here.

Total Environment: Ed Kienholz

Pop painting dominated the New York art scene in the 1960s and was dominated by it. Its participants were largely art-college trained, part of a bar and coffee-house élite, and reacting radically to the previous generation, either by extending the range of Abstract Expressionism, like Dine or Kaprow, or denying it, like Lichtenstein or Warhol.

Ed Kienholz comes from an alternative tradition. Californian art, remote from the politics and polemics of New York, seems to be either rough, deliberately nasty, politically committed, or ultra-cool. On the one hand the 'funk' art of Clayton Bailey or the ceramics of Robert Arneson or David Gilhooly, on the other the calm elegance of John McCracken's lacquered planks; the Grateful Dead, or early Beach Boys; Watts, or Redondo Beach. In the cool world of the new American art, a Kienholz tableau goes off like an anti-personnel bomb. It's committed. It feels. It smells. It lives. An old lady has died forgotten, waiting for her forgotten – who? husband, lover, son? (*The Wait*). A crudely aborted foetus slops into a stained enamel dish (*The Illegal Operation*). A five-dollar whore is a treadle sewing-machine, as used, as mechanical (*Roxy's*). There is compassion as well as anger: the crowd in *The Beanery* will never die or fade from the scene. They are preserved for ever, like flies in amber. And nostalgia: the hit-tunes on the 1940s juke-boxes we all used to hang round, the cheap trinkets that meant so much.

Of all the Kienholz images, the one that sticks in my head comes from *The State Hospital*.[11] A big box, grey, anonymous. A door in it,

44

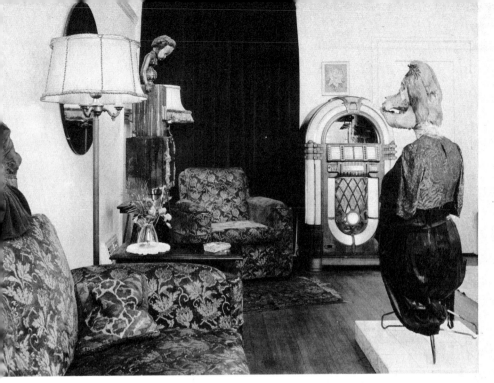

31 ED KIENHOLZ *Roxy's* 1961

with a barred window, the only way to see in. A strong smell of lysol
in your nostrils. Two metal bunk beds. On them both, identical
reclining figures: a naked, bony old man, on a waterproof sheet,
wrist chained firmly to the bed. A neon 'thinks' balloon encloses the
upper one, leading from the lower. Where the heads should be, there
are illuminated goldfish-bowls with two black fish swimming in each.
Black shapes, endlessly flickering: an old man's thoughts, aimlessly
circulating, never getting anywhere. This is Kienholz's mature style:
the concept tableau. In 1960 he exhibited a row of framed 'concepts',
a brass plaque to go with each. You could buy (1) the 'concept', which
gave you the option to purchase; (2) a drawing for it; or (3) the com-
pleted tableau, where feasible. A contract was drawn up: the work to
be completed at a standard rate, plus cost of materials. *The State
Hospital* is the only fully realized concept tableau so far.

All Kienholz's tableaux are a combination of meticulous realism and
free, painterly treatment of surfaces; the resin that hardens the surface

45

32 PETER DOCKLEY *Wax Event* 1971

and mummifies objects is splashed on unevenly, left to run. To see why, we have to consider Kienholz's early history.

Born in Fairfield, Washington, in 1927, Kienholz moved to Los Angeles in 1953. By then he had worked in a mental hospital, run a dance-band, sold cars and vacuum-cleaners, kept a drinking-club. In 1954 he started making constructions, rough nailed-together pieces, often painted, literally, with a broom. In 1956 he opened the New Gallery and in 1957 the Ferus Gallery, with Walter Hopps. His constructions grew to become floor-pieces. Junk objects were added, wryly ironic titles given: *I aint a fig-plucker or a fig-plucker's son, but I'll pluck your figs till the fig-plucker comes.* Starting with *Little Rock Incident* in 1958, through *John Doe* and *Jane Doe* of 1960, the works became more politicized, socially concerned. In *Psycho Vendetta Case* of the same year, a powerful protest about the execution of Caryl Chessman, the 'case' is literal. A black door, on the front the California State seal. Open, the door bears the flags of the USA and the State of California. Inside the box is a shrouded miniature gas-chamber. Since then he has made two specifically political tableaux: *The Eleventh Hour Final* and *Portable War Memorial.* Where Kienholz differs from, say, the meticulous realism of Duane Hanson, or the powerful political canvases of Wally Hedrick or Peter Saul, is that he *distances* you, as he involves you. Some of the elements are real, some junk-constructions. The free, runny treatment of the surfaces is a 'disturbing' element, like the rough plaster surfaces of Segal's figures.

31 Not all the tableaux make a specific comment. *Roxy's* of 1961 was his first total environment; a memory of a well-known Las Vegas brothel, it grew from making two female whore-figures. Having made them, he decided to try and create their environment. So there are all the whores, 'Fifi, a lost angel', Miss Cherry Delight, Cockeyed Jenny, together with the Madame, the red lamp outside the door, the juke-box against the wall, 1940s copies of *Life* magazine, the semi-circular bakelite radio set, the smell of cheap perfume and disinfectant. The period detail is meticulous.

Most of Kienholz's tableaux are set in this period, beat-up junk, not smart enough to be Art Deco and not new enough to be modern. A sort of time-warp, back to the 1940s, swing bands and sweater-girls.

34, 35 *Back Seat Dodge 38*: your first sexual experience in the back of a car, Glenn Miller on the radio. The boy exists only as chicken-wire, apart from the hand finding its way into the girl's pants. The couple have

48

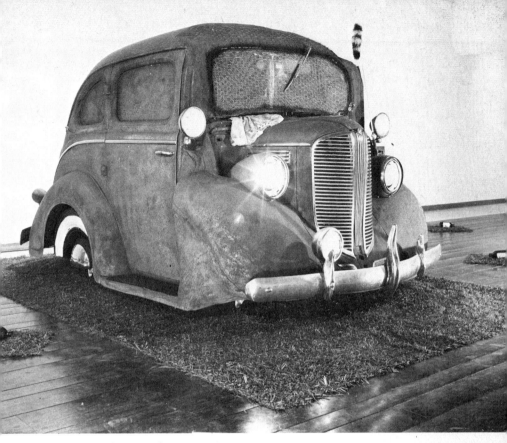

34 ED KIENHOLZ *Back Seat Dodge* 1964

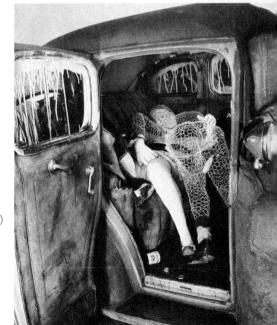

35 ED KIENHOLZ *Back Seat Dodge* 1964 (detail)

36 PIERO GILARDI *Featherweight Cobbles*

37–38
NIKI DE SAINT-PHALLE,
JEAN TINGUELY AND
PER OLOF ULTVEDT
Hon 1966

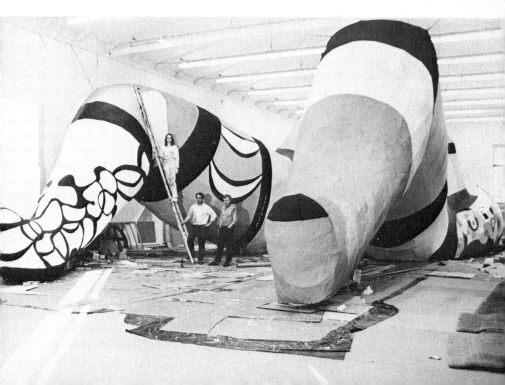

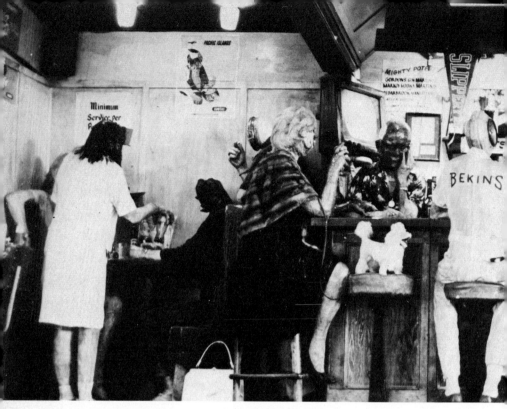

39 ED KIENHOLZ *The Beanery* 1965

one head. An empty beer-bottle lies on the floor, and another, flung away, is lying on its own separate island of grass. But the car windows are mirrored (so we see them better), the car has been shortened and covered with blue flocking, the radio is tuned into whatever's on today.

39 The original Beanery is a café-hangout for artists in Los Angeles. Kienholz's *The Beanery* is scaled down by one half, but the figures are life-size. You have to push past them, casts of real people, their clothes carefully hardened. Their heads are all clocks, all stopped at ten past ten. Only Barney, the owner, has his own head. Similarly, all the fittings of the bar are the real ones, or as real as they can be reproduced. A smell of cooking hangs in the air. A 'mirror' is a photo of a real reflection in the Beanery. As you walk through the double doors a tape comes on which is a soundtrack made in the place on one particular

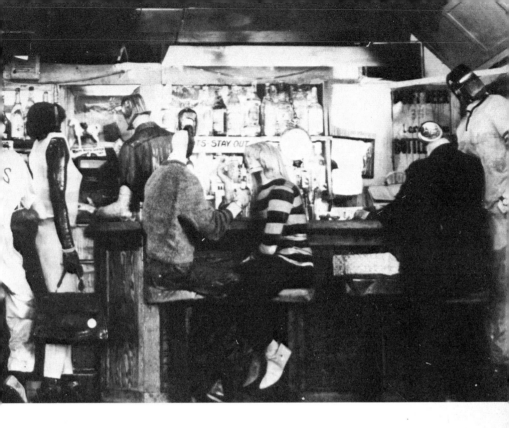

night. Outside is a newspaper-stand, the papers all for the same date.

His other works show the same attention to detail: in the few belongings, all grey-coloured, of the woman giving birth, in *The Birthday*, there is a letter which, if read, changes the whole meaning of the piece. His most ambitious recent project, for a tableau involving five full-size American cars and nine figures, was cancelled by the British Arts Council as being too expensive, but was finally put on at Kassel, Germany, as part of 'Documenta 5' in 1972. It is night, and a group of men wearing joke-store rubber masks are emasculating a Negro. He lies, spreadeagled, helpless, in the glare of the headlights from the cars, which are drawn up round the scene in a circle. This is Kienholz's most literal, least metaphorical piece.

In the area of environment-making the one other outstanding recent contribution has been made by Paul Thek. The imagery of

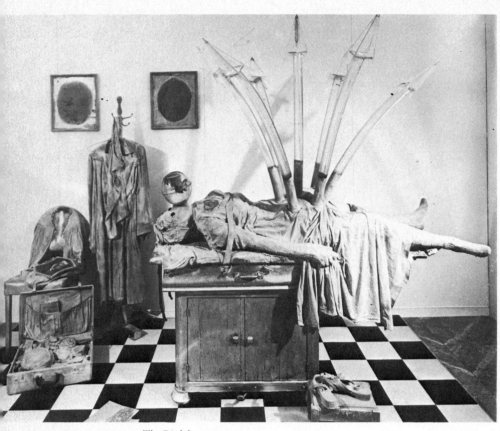

40 ED KIENHOLZ *The Birthday* 1964

Text of letter:
Dear Jane
I couldn't come down now because Harry need me here
Ma says she might make it later.
Keep a stiff upper lip kid. (ha–ha) Dick

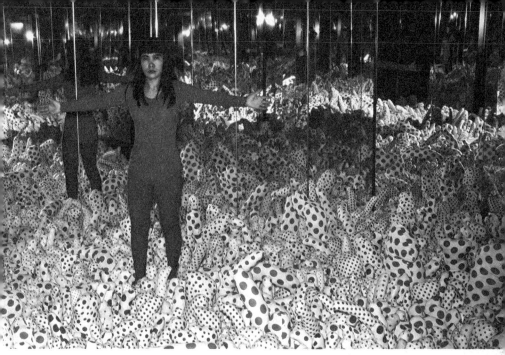

41 YAYOI KUSAMA *Endless Love Room* 1965–66

42 DAVID PEARSON *Bedroom at Arles*

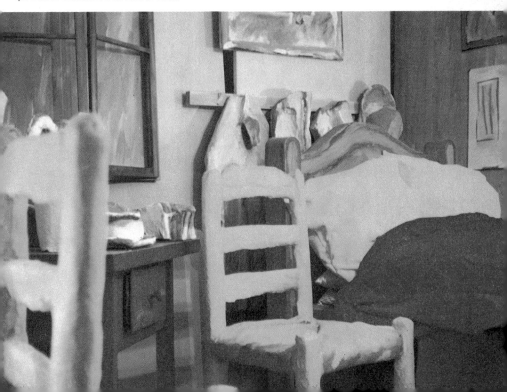

Thek's sculptures is perhaps similar to that of Francis Bacon's paintings. There is an almost morbid emphasis on the quality of raw flesh and decomposition, combined with an aesthete's delight in fastidious manipulation of surfaces.[12] His major work is *Death of a Hippie* of 1967. In this, the rather decadent aestheticism of his smaller pieces is transcended by the scale of the work and the austerity of its colour. The life-size figure, its pyramid tomb, and all its enigmatic trappings, are coloured a uniform shade of pastel pink. A dream, an elegy, a celebration? Nowhere is the artist's intention specific: both figure and tomb are ambiguous, mysterious, ultimately anonymous. Recently, Thek has exhibited an even more ambitious environmental work (at 'Documenta 5') on the theme of voodoo: a figure curiously like the hippie lies in a coffin surrounded by fruit, flowers, mysterious objects. The coffin lies in a field of sand, raked into wavy lines. Set out at intervals on the sand are candles, their light the only light in the room. Elsewhere are a white hare, a white swan, a deer, a rowing-boat filled with cult objects, hidden among bushes surrounding the sand, components of an unexplained ritual.

43

The young artist June Leaf from Chicago has made a number of environments involving cut-out or stuffed figures, notably *Street Dreams: the Ascent of the Pig Lady* at the Frumkin Gallery in 1969.[13] Her work, though more expressionistic and almost caricature-like in

43 PAUL THEK *Death of a Hippie* 1967

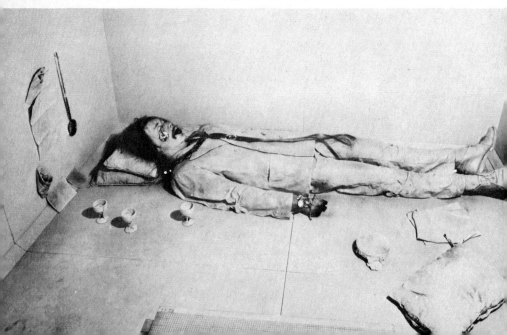

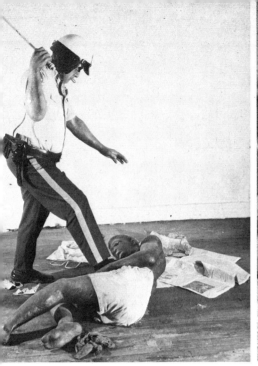

44 DUANE HANSON *Race Riot* 1969–71 45 *Rent Collection Courtyard* 1965 (detail)

manner, nevertheless relates to Thek and Kienholz through its very personal vein of imagery, and through the slightly ambivalent attitude of the artist to her subject-matter though stylistically her work relates more closely to the tableaux of Alex Katz (who is also from Chicago).

The ultra-realist works of the American sculptor Duane Hanson make an interesting comparison, on the one hand with the extreme works of the Catholic Counter-Reformation (the mourning woman in his *Pietà* cries real tears, like so many Spanish and South American versions of the same theme), and on the other with some of the work produced in Communist China. Thus, the Chinese *Rent Collection Courtyard* compares with Hanson's powerful protest piece *Race Riot,* as well as with the politically neutral figures of George Segal: sculptured figures using real objects in a real environment. 45 44

These works of Hanson's are emotionally and politically committed; in a more recently exhibited *Self-Portrait* he seems to have reached a cool, unemotional stance like that of some of the younger artists who

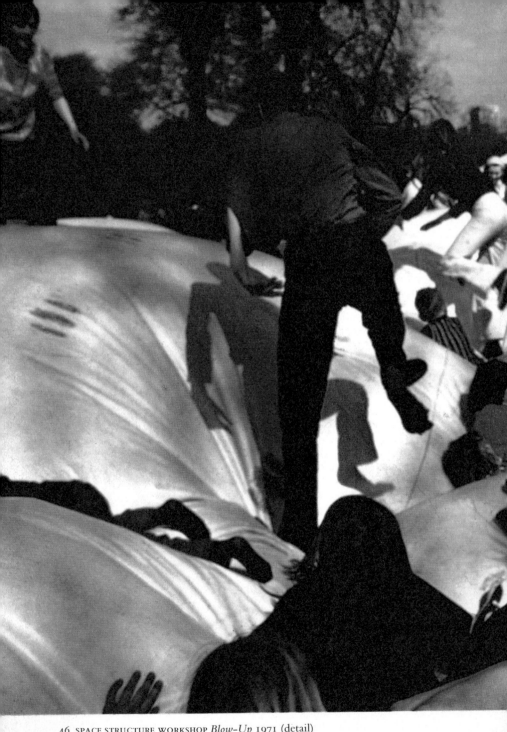

46 SPACE STRUCTURE WORKSHOP *Blow-Up* 1971 (detail)

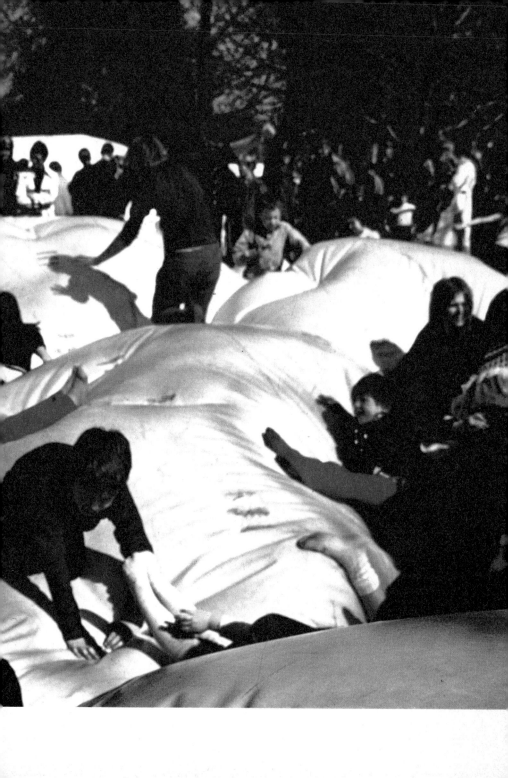

have followed him, such as John de Andrea in America and John Davies in England. De Andrea's most spectacular recent work is an amazingly lifelike post-coital pair of lovers. Davies's world is inhabited mainly by small, shabbily dressed men with strange excrescences growing from their heads or faces, like party-hats that have grown into a permanent fixture.

Spectator-involvement: Europe and Elsewhere

Surrealism is by no means a back-number: although before Breton's death it had perhaps become too obsessed with hermetic and cabbalistic ideas, its spirit re-emerged during the 1950s in the work of the New Realist group and similar artists, and towards the end of the 1960s a new concern with politics echoed the preoccupations of French artists of the pre-war period.

In France after the war, one of the minor Surrealist artists came into her own. Meret Oppenheim, maker of the famous fur-covered cup, saucer and spoon (*Breakfast in Fur*) of 1935, emerged as one of the leading artists at the post-war international Surrealist exhibitions, *48* notably the tenth exhibition of 1959, for which she made a *Spring Feast* consisting of the figure of a girl with a gilded face whose body was covered with fruit, laid out on a long dinner-table surrounded by waxen male figures. (At the private view, the girl and the diners were *47* real.) Her one-man exhibition at the Galerie Claude Givaudan in 1969 was yet another example of the Surrealist gift for making an art gallery into a new kind of environment: a catwalk was built round the room, which was then filled with water. The work exhibited was seen through a wire-netting fence.

Italy has produced a number of interesting artists who work in the *36* field of environment. Piero Gilardi, who lives in France, makes roll-out lengths of foam-rubber landscape. Gino Marotta makes cut-out wooden environmental figures. Giancarlo Baruchello presented a 'billboard exhibition', in Rome, 1968, which consisted of a poster flyposted about the city. Michelangelo Pistoletto makes mirror-steel pieces on which cut-out life-size figures are pasted, their images mingled with the reflected image of the observer. Pistoletto also works with ZOO, a mixed-media theatre group.

In 1967, a group of young poets gathered at Fiumbialo to present a festival of public poetry.[14] C. Parmiggiani and A. Spatola presented

47 Meret Oppenheim Exhibition, Paris 1969

48 MERET OPPENHEIM *Spring Feast* 1959

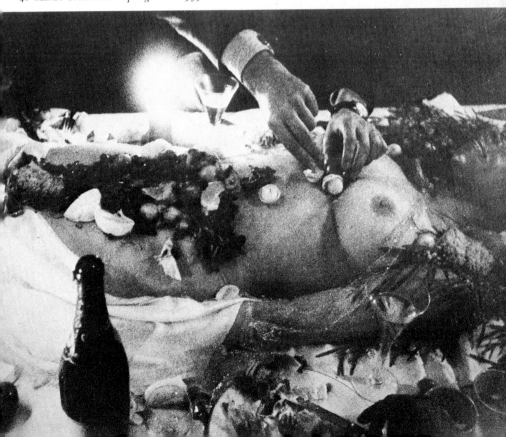

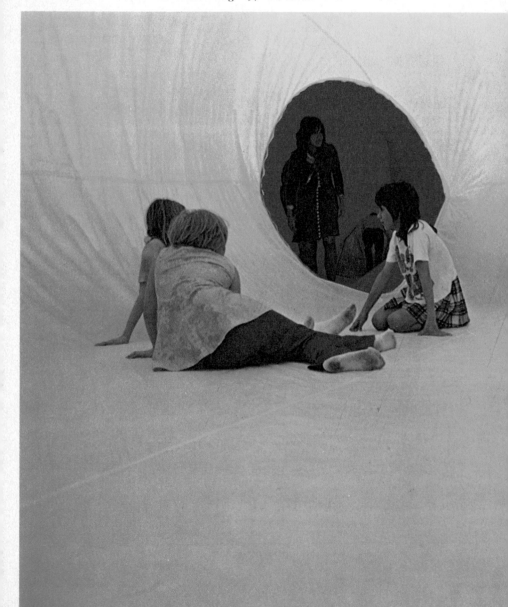

wall-poems; F. Tiziano made a poem to be destroyed publicly, and wore a placard proclaiming IO SONO UNA POESIA ('I am a poem'). These events, and subsequent activities in Italy, relate closely to the activities of young French poets like Jochen Gertz, who uses handbills and labels as part of public poetic activities, and to the young Polish artist Maria Michalowska, who similarly uses wall-posters as her chosen medium. All this could perhaps be seen as the militant or political wing of the 'concrete poetry' movement. 'Public' environmental art has its practitioners elsewhere as well: in New York a number of mostly abstract artists have set out to use any available blank wall-space as their canvas. Some of them are grouped together under the banner of City Walls Inc. Their social concern, and their conscious revolt against the art-gallery ethos, relate their work to the big stripe paintings placed on urban poster sites by the French artist Daniel Buren.[15]

Sweden's comparative lack of an artistic tradition makes life easier in some ways for young artists than it is in, say, Italy. In the post-war years, a strong *entente* has grown up between Sweden and the USA, perhaps first noticeable in the emergence of important Swedish jazzmen like Lars Gullin, who were helped enormously by the presence of American musicians attracted by freer social conditions and the absence of racial prejudice. More recently, an important contribution has been made to new art by Swedish-born artists. This is to a large extent due to the work of Pontus Hultén at the Moderna Museet in Stockholm, who has consistently encouraged progressive international artists to work there. Claes Oldenburg was, of course, born in Sweden, as was Oyvind Fahlström, another artist who now lives in America.

Fahlström's own private version of Pop art is often political, satirical and highly inventive formally. He has made numerous 'variable paintings', strip-cartoon-like images with movable, magnetized elements, a number of theatre-pieces including a *Fahlström's* 51 *Corner* (1962), and a large tableau, *Dr Schweitzer's Last Mission*, shown at the Venice Biennale in 1966. He also contributed one of the most impressive items, *Kisses Sweeter than Wine*, to the 'Evenings in Art and Technology' mentioned below (p. 71).

Per Olof Ultvedt is a maker of moving or movable wooden sculptures. He is perhaps best known as a collaborator with the French 37, 38 artist, Niki de Saint-Phalle and her husband Jean Tinguely on *Hon*,

64

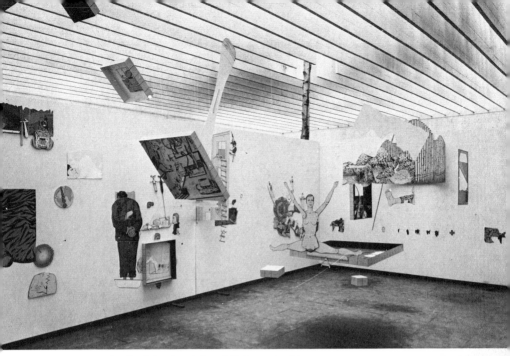

51 OYVIND FAHLSTRÖM *Dr Schweitzer's Last Mission* 1964–66

a huge reclining figure of a woman which visitors entered through a
passageway between the legs, finding themselves in a sort of funhouse
including a silk-lined boudoir for lovers and a milk-bar inside one of
the breasts. In 1970 Pi Lind presented a gallery full of *Living Sculptures*,
people presented on plinths or pedestals, at the Moderna Museet.

South America has produced a number of major figures. Marta
Minujin from Argentina has made one of the most important contri-
butions to environmental art, particularly with *El Batacazo* (*The
Débâcle*) of 1965, a work including a number of life-size stuffed rugby
players, live rabbits, and a giant soft vinyl figure of the actress Virna
Lisi, which groaned softly when touched. In 1966 Minujin took part
in a *Three-Country Happening* with Allan Kaprow and Wolf Vostell
(see pp. 90, 170). Recently in New York she exhibited a telephone-
box from which one could dial and speak to the artist. As the phone
was used, the colour of the walls changed and the user's own image
appeared on a TV screen in front of him. A very beautiful and simple
environment, *Minucode* (1968), consists of four films of a cocktail-

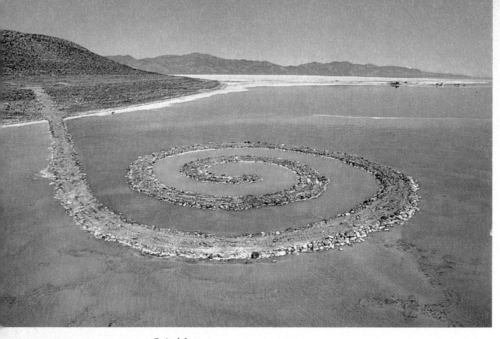

52 ROBERT SMITHSON *Spiral Jetty* 1970

53 DENNIS OPPENHEIM *Branded Mountain* 1969

54 CHRISTO *Valley Curtain* 1970–72

party projected on to the walls of an empty room, related perhaps to Robert Whitman's cinema-works: a perfect answer to the problems of the lonely and unsociable.

Lygia Clark, a Brazilian artist, has been particularly influential in the field of kinetic art. Her *Animals,* hinged metal floor-pieces to be manipulated by the spectator, were made between 1959 and 1964. Since then she has extended the concept of spectator-involvement by making *Objects for Manipulation* such as *Water and Shells* and *Air and Stones* (both 1966); suits of clothes to be worn to stimulate tactile experiences (*Body Cloths,* 1968); and small objects of rubber to be manipulated (recalling the rubber room-piece made from cut-up bathing-caps by Marcel Duchamp while visiting South America), including *Dialogue of Hands* of 1966, made in conjunction with Helio Oiticica. Oiticica, also from Brazil, makes extremely personal and inventive environmental and performance-pieces. These include pieces to be worn in the form of capes – *Parangoles* of 1964–65 – and *Bolides,* boxes to be manipulated by the spectator, which were filled with pigment, stones, water and other tactile elements, as well as short poetic texts. He is involved in the life and music of the poor people of Rio, and samba and bossa nova music have been integral to the large environments he has made, like *Tropicalia* of 1967, a room filled with plants and live tropical birds and music, and *Eden,* of 1969, shown at the Whitechapel Art Gallery in London.[16]

A number of Japanese artists who are best known for work done in the USA extend the environment idea by imposing arbitrary and often disturbing over-all patterns on an environment (with or without spectator participation). Ay-O's major works have been environmental, notably *Orange Box,* a six-foot-square box lined with soft foam rubber to be crawled into, and a *Tactile Room* at Venice in 1965, which further explored the idea of his *Finger Box Suitcase* of 1964, in which the visitor pushes his finger into holes programmed to give tactile sensations pleasurable or otherwise. He has also made a very beautiful series of *Rainbow Rooms.* He showed a *Rainbow Staircase* environment in 1964 at the Smolin Gallery, New York, and followed this with *Venus de Milo Rainbow Tactile Room,* Venice, 1966.

Yayoi Kusama, in common with certain other women artists such as Carolee Schneeman, promotes the cause of sexual liberation and frequently uses her own body as an intrinsic part of her environments.[17] She has made garments, like *Flower-Coat* of 1963. Her major obses-

68

sional theme, however, has been the accumulation of objects covered with strange white phallic growths: familiar domestic objects, boats, and sometimes whole rooms, have been transformed in this way. These have been included in her *One Thousand Boat Show* of 1965, *Narcissus Garden* of 1966, a mirror-room filled with her objects, and *Endless Love Room* of 1965–66. In 1970 she staged a number of public demonstrations of nudity, notably on Wall Street and in the sculpture garden of the Museum of Modern Art in New York.

Yoko Ono's pieces, be they paintings, sculptures, performances, musical events, or even thought-pieces, exist (like Kienholz's concept tableaux) as ideas which may or may not be realized. Thus, when she held an exhibition of her work at the Indica Gallery in London in 1966, she had it remade from her written concepts rather than ship the existing works from New York. She was involved with the post-Cage music scene in New York, and her notations have a peculiarly Japanese kind of poetry about them, reminiscent of the *haiku*. Since her much-publicized marriage to John Lennon, she has produced little of artistic worth: a very beautiful recent book of concept-art by her, *Grapefruit*,[18] contains only work done before her meeting with Lennon in 1966.

Canada has recently produced a number of artists who work within the fields of environmental art, notably the film-maker Joyce Wieland,[19] Les Levine, a sculptor and conceptual artist whose main activities have taken place in New York, and Iain Baxter. Baxter has held a number of important environment exhibitions, including 'Bagged Place', in 1966, at the Fine Arts Gallery of the University of British Columbia, and 'Piles', at the same gallery in 1968. Baxter presents his various works under the collective title of 'N.E. Thing Co.'. His work is notable for formal invention and for a personal vein of surreal humour: a large, hanging, inflatable PVC cloud comes in a specially cloud-shaped tartan carrying-case.

Levine has also made films, multiple vacuum-formed unit sculptures and wall-panels, as well as more conventional works. It is, however, his technologically oriented studies of process that are most interesting. In *The Process of Elimination* he left three hundred pieces of curved plastic lying about on a vacant lot, removing ten daily for thirty days. He has worked with both TV circuits and computers. The most important of these studies of process were his purchase in March 1969 of five hundred shares of common stock in the Cassette Cartridge

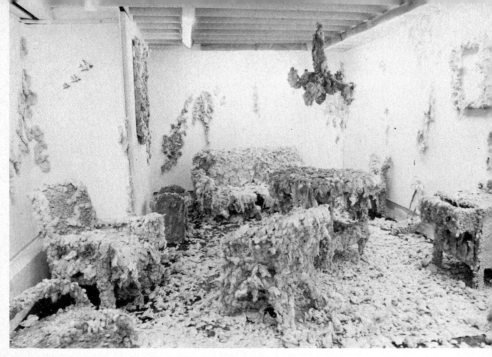

55 CAROL JOSEPH *Living Room* 1970

Corporation, and subsequent documentation of their fluctuating
30 values on the market, and his opening of *Levine's Restaurant* at 19th
and Park Avenue South in that year. *Levine's Restaurant* involved a
study of the whole process of sale and the flow of customers.

55 In England, the young environmentalist Carol Joseph makes rooms
42 filled with menacing, fur-covered furniture; and David Pearson, an
obsessional artist from Lancashire, has emerged as one of the most
exciting new artists around in a series of recent shows. His work is
almost entirely motivated by the life and work of Van Gogh, the most
striking pieces being larger-than-life tableaux based on *The Potato
Eaters, The Cornfield* and *Van Gogh's Bedroom*.

Technology and Environment

In recent years there have been notable attempts to harness industry to
the artist's purpose, or to create meaningful collaborations between
the two. In 1968 the Kansas City Museum presented 'Magic Theatre',

in which technologically oriented artists made environments, among whom Boyd Mefferd presented *Strobe-Lighted-Floor* and Stephen Antonakos *Walk-On-Neon*, both involving audience reaction and participation. Earlier, in 1966, under the inspiration of a Swedish engineer, Billy Klüver, a series of 'Evenings in Art and Technology' were presented using an enormous New York armoury hall, and promoting collaborations between the artist and the engineer. Fahlström, Rauschenberg and others took part, including the painter-dancer Alex Hay, whose work made telling use of simultaneously *56* projected large-screen television as an integral part of what was basically a dance.

There have been a number of ambitious recent projects, including 'Software – Information Technology: its New Meaning for Art', presented by courtesy of the American Motor Company at the Jewish Museum in New York in 1970.[20] 'Software', using a time-shared central computer, consisted of exhibits ranging through the poet John Giorno's pilot guerilla radio system, and Theodosius Victoria's project to use solar batteries on the roof to power broadcasts from the Museum windows, to a highly complex piece by a group of young *57*

56. ALEX HAY *Grass Field* 1966

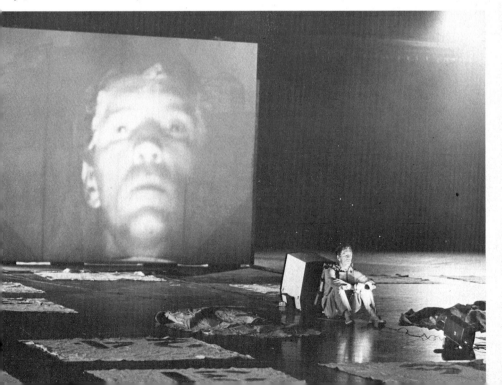

architects from MIT: *Seek*. This was a computer-controlled environ-
ment of cubes which were constantly assembled and reassembled by
an overhead electromagnet. The arm had been programmed to make
certain decisions, but was constantly frustrated by the random move-
ments of a family of gerbils: a metaphor for the planners' constant
problem of human demands versus planned programme.

In 1971 the Los Angeles County Museum presented 'Art and
Technology', a programme of works by artists commissioned to work
inside industrial combines.[21] Rockne Krebs made a laser environment,
25 Oldenburg a giant, sixteen by eighteen foot breathing icebag,
Rauschenberg *Mud-Muse*, a tank of smooth mud through which air
bubbled in response to taped sounds. In the same year, 'Lucht/Kunst',
an exhibition at the Stedelijk Museum, Amsterdam, presented works
by a number of artists which used natural elements – light, sound,
wind – in technologically controlled ways.[22] Bruce Nauman, a pro-
tean and unclassifiable American artist (see p. 166), presented *Wind*

72

Room, a huge box structure that almost filled a room, leaving only a narrow corridor round the periphery for the visitor. The box, with no apparent entrance, was filled with the noise of rushing winds. Alan Sonfist, also from the USA, showed plexiglass boxes containing constantly changing crystalline structures. Perhaps the most impressive and certainly the most complex work in the show was *With Energy* **58** *Beyond These Walls*, made by Juan Downey, a Chilean artist living in America, in collaboration with Lloyd S. Cross, who had previously worked with both electronically generated music and holograms. This work used lasers and various other electronic equipment, and was a complex set of responses to natural energy sources. Various stimuli from outside – aircraft radio, background radiation, temperature –

58 JUAN DOWNEY
Drawing for *With Energy
Beyond These Walls*
1971

were used to generate a laser-projected pattern and electronic music within the room. Charles Frazier showed some large pieces relating to the principles of parachutes and balloons: huge nylon structures which inflated and deflated with random gusts of air from wind-machines. Frazier had previously made flying sculptures, some of which worked on the hovercraft principle. The German artist Pannamareco has similarly worked with flying-machines, and a large recent piece of his (in 'Documenta 5'), which resembles a captive dirigible, also relates to Frazier's recent wind-pieces.

In England, John Latham's Artists' Placement Group (APG) has made similar attempts to marry art and industry; but the most exciting work done by technologically oriented English artists is being made by the Space Structure Workshop of Maurice Agis and Peter Jones. Their recent project for a *Colour Space Village* is already partly realized, the project having at the time of writing eleven 'units' of the following colours: two reds, two blues, one green, one transparent, two yellows, with some colours repeated in different sizes. Each unit is at least four hundred square feet, the zipped-together rooms being envisaged as chambers for living, contemplation, listening to music.

The quietness of this project contrasts with the rough and tumble of *46* the inflatable pieces for children in the summer 1971 *Blow-Up* series. Agis and Jones have developed from their earlier *Space Place* projects of 1964–66, twenty-two angular colour-constructions articulating interior spaces,[23] through their more public inflatables, to the recent *49* major projects for coloured living-spaces. The work of the American Truthco group (Land Truth Circus) and the English Action Space group is similar in methods, aiming at a social use of advanced technology.

Apart from the major museum projects, there are, of course, a large number of artists who have used industrial, technological processes as part of their work. For example, Lucas Samaras: his boxes and furniture-pieces are notable, as with Paul Thek, for their sado-masochistic overtones, but similarly concerned with a delicate manipulation of surface qualities. However, his major environmental piece, a *59* mirror-room complete with table and chairs, is a pure and beautiful object. Similarly the artist and film-maker Robert Breer used tiny motors to power his *Self-Propelled Styrofoam Floats* of 1965 and his more recent *Carpets*: pieces that creep about slowly and unnervingly with an apparent will of their own.

74

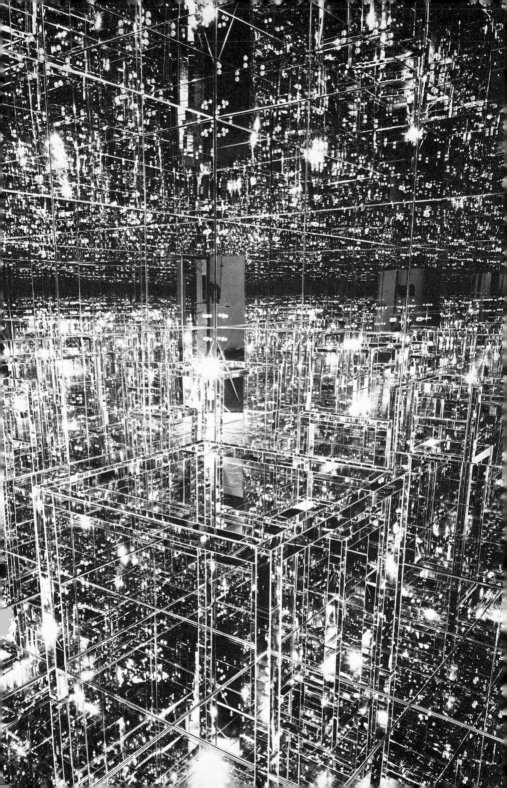

Landscape and Environment

Hills are all that is necessary, and a few trees for shade . . . in these days of Universal cycling it would not be absurd to make use of summer Sundays in the countryside to stage a very few short performances . . . in places not too far distant . . . the places in the sun should be free . . . and as for the props, the bare necessities could be transported in one or two automobiles.

Alfred Jarry[24]

Christo, a Bulgarian artist now domiciled in the U S A, became known for his wrapped and tied objects (*empaquetages*): chairs, books, girls or even monuments wrapped in polythene and tied with rope, and related to Man Ray's wrapped sewing-machine, *The Enigma of Isidore Ducasse*.[25] His next works were a series of *Store Fronts*, each window lit but hung with a cloth, as if empty or being decorated. A row of these in a gallery has the same kind of desolate poetry as a painting by Giorgio de Chirico. Early in his career, Christo made an environment

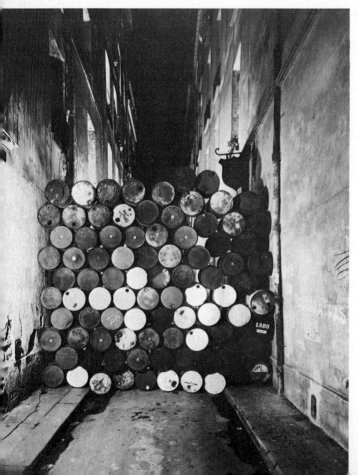

60 CHRISTO
Iron Curtain 1962

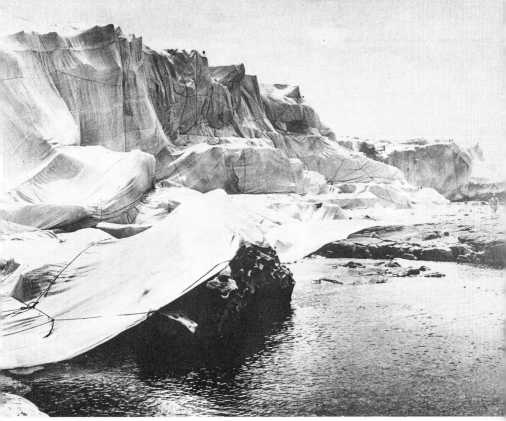

61 CHRISTO *Wrapped Coastline* 1970

by blocking off a small Paris street with stacked oil-drums (*Iron* *60*
Curtain). His most recent work has been a spectacular return to his
earlier wrapped pieces, in the form of landscape projects of which the
most striking is his *Wrapped Coastline*, done in Australia in 1970, *61*
which used a million square feet of polythene sheeting and thirty-five
miles of rope to cover a mile of coastline. In 1971 he set out to construct
a *Valley Curtain* in Rifle Gap, Colorado, a giant hawser slung between *54, 62*
two mountains 1,250 feet apart and carrying an orange curtain
weighing four tons. The massive problems of logistics, weather,
returning the landscape to its former condition after the piece, and so
on, caused its postponement until 1972.

These vast assaults on the urban and rural environment have the
same purpose as Christo's earlier wrapped objects, or as Man Ray's
sewing-machine or Meret Oppenheim's fur cup and saucer: to

77

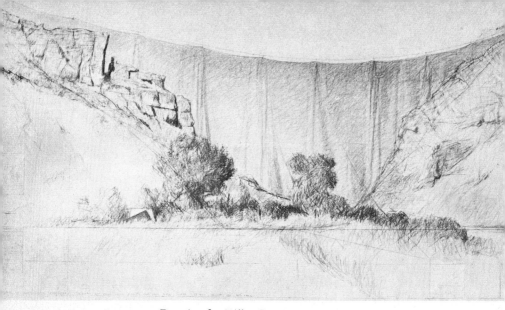

62 CHRISTO Drawing for *Valley Curtain* 1971

stimulate the imagination by evoking disquiet through an otherwise
16, 31 neutral object. Segal's plaster, and Kienholz's resin, have a similar
'alienating' purpose. One interesting aspect of Christo's work is that
he pays for these commercially valueless projects by making very
beautiful drawings and prints to be sold via galleries as handmade art-
objects, thus using the dealer system against itself.

A German artist of note also working in the USA, Hans Haacke, has
moved from making objects which involve natural or unnatural
processes, like mixtures of oil and water, towards a study and presenta-
tion of processes themselves. From pieces involving the growth of
grass (*Grass Cube*, 1967), or of ice round a freezing element (*Ice-Stick*,
1966), he progressed to works like *Spray of Ithaca Falls Freezing and
63 Melting on a Rope* and *Chickens Hatching*, 1969,[26] and *Moss Transplant:
Maintained in Artificial Microclimate* (Saint-Paul, France) of 1970,
literal presentations of natural processes. In a letter to the critic Jack
Burnham of 1960 he had said: 'I would like to lure 1000 seagulls to a
certain spot (in the air) by some delicious food so as to construct an air
sculpture from this combined mass', a project he later realized. (A
recent Dutch ecological/artistic study by Van der Kam and Hellenius
has produced documentation of a similar nature.)[27] Now he has moved,
like Les Levine, to presentations of social and political processes as well.

78

In 1970 the Guggenheim Museum refused to allow him to show some photographs of New York slum property, together with documentation about their real owners, the financial deals involved and the density of housing. He also proposed to present visitors with a profile of themselves, by feeding forms they had filled in into a computer, which displayed a changing statistical political profile of the average visitor on TV screens. The Museum trustees also objected to the political nature of some of the questions, and several members of the staff resigned, the artist finally refusing to show any work at all.

In England much of the work in the 'landscape' area has been merely decorative or imitative,[28] although the sculptor Barry Flanagan has produced, among other pieces, a very beautiful concept, poetic yet simply achieved: *Hole in the Sea*, a plastic cylinder sunk in a beach *65* in Holland and filmed from above while the tide came in. Keith Arnatt's earth-holes, self-burials and mirror-plugs also extend the boundaries of this kind of activity.[29] Arnatt, furthermore, has the saving grace of wit in a field often dominated by half-digested philosophical propositions presented as 'art-works'. A recent piece consisted of a reprint of a discussion of the word 'real' reprinted from a textbook ('real duck' implies not a decoy or painted duck, for instance); on the reverse of the card was a photograph of Arnatt holding a placard saying I AM A REAL ARTIST. Adrian Phipps-Hunt, who began *64* making simple cairn structures outdoors in the early 1960s, is now making pieces involving research into the properties of concrete: slabs of it dropped into wet concrete from varying heights, or different

63 HANS HAACKE
Chickens Hatching
1969 (detail)

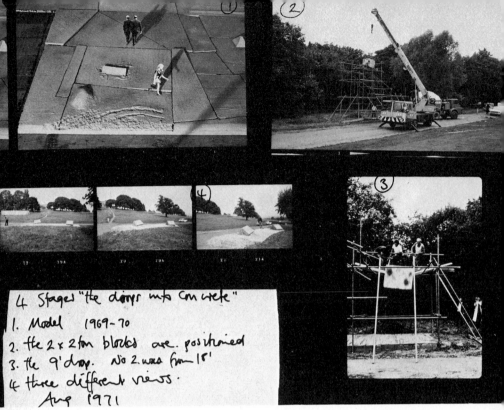

4 Stages "the drops into concrete"
1. Model 1969-70
2. the 2 × 2 fon blocks are positioned
3. the 9' drop. No 2 was from 15'
4 three different views.
 Aug 1971

64 ADRIAN PHIPPS-HUNT *The Drops into Concrete* 1971

elements mixed into the concrete to produce controlled disintegration and weathering.

The major works in the new earth art are American. The vast scale of the country, the huge uninhabited spaces, and the availability of money for work on which no direct return can be expected, together with the spirit of experiment that has characterized American art since the war, have all contributed to the rise of this activity.[30] The major figures here are Dennis Oppenheim and Robert Smithson. It must be said that it was the superhuman size of the 'Minimal' sculpture of Tony Smith, Carl Andre and Robert Morris that led directly to the growth of interest in work on a vast scale.

53 Oppenheim's first landscape-work was a piece of snow-fencing laid across a Pennsylvania wheatfield. Since then he has made numerous pieces involving the use of ploughing, including *Directed Seeding* –

80

65 BARRY FLANAGAN
Hole in the Sea
1969

Wheat, in which a field in Holland was ploughed and planted according to the contours of the land rather than the usual straight lines. He has followed through the planting process into the actual sale of grain, made long lines through snow, cut a line along the USA-Canada border. In 1969 he presented an undersea piece, *Removal-Transplant (Cornfield)*, in which corn was grown on a sea-bed in Tobago. Peter Hutchinson also planted an undersea rose-garden, *Flower Triangle*, as part of the same 'Ocean Project'.

Robert Smithson has made landscape-pieces using mirrors, notably a series of *Mirror Displacements* in Mexico.[31] His major work, however, is *Spiral Jetty* of 1970. Over 1,500 feet long and 160 feet in diameter, this projects into a salt lake, the water between its coils stained red with algae.

66
52

Peter Hutchinson created a ring of fungus where none would normally grow by planting moist bread round the rim of Paricutín volcano in Mexico. Michael Heizer has hewn out vast earth-and-rock pieces in the middle of the Arizona desert. George Brecht (as Brecht and McDiarmid Research Associates) has produced a pilot *Land Translocation Project*, a proposal to move the Isle of Wight to the Azores. Douglas Huebler made a 'time-line' across the USA by having letters mailed and re-mailed across a selected route.

All these pieces have in common a kind of new Sublime, a revitalized version of the discovery of the Lake District by the English artists and poets of the eighteenth and nineteenth centuries.[32] The majesty of natural phenomena, even the powerful upthrust of a slope in the ground or the emptiness of the mountain air, struck the Romantics with a force and freshness that can still be felt in their work. These are simple formal perceptions which demand power and economy of expression. The Romantics, however, were essentially opposing nature as a force to the rational, civilized world of cities: even as the factory-views of Philippe de Loutherbourg or Wright of Derby transformed man-made works into natural phenomena. The new generation of 'sublime' landscape-artists differ in using technology as a natural ally in the manipulation of landscape. Robert Barry makes works consisting of lines of invisible radiation. Michael O'Day envisaged a thousand-mile-long sea-piece, consisting of five 150-mile strips laid on the sea at fifty-mile intervals. After seven hours these would dissolve into fishfood. Walter de Maria has a project for making huge regular shapes on three continents, the three to merge if photo-

graphed from above by an astronaut. Daniel Warren had a ten-foot glass sphere made that will change colour slowly over a long period of years and finally disintegrate. Perhaps nearest to the spirit of Wordsworth, James Ward and John Martin is Justine Dane, who has worked with Westinghouse Electric to produce man-made lightning, and has 'seeded' clouds to produce storms.

Holland seems to be a natural home for environmental art. Dutch artists are revolutionary in all senses of the word. We will consider the

66 ROBERT SMITHSON *Fifth Mirror Displacement* 1969

67 WIM GIJZEN
Project for Schouwburgplein,
Rotterdam 1966

68 HERMAN DAMEN
Cow Poem 1969

84

work of directly political groups (like the Provos) in Chapter Four. Working in the 'earth art' manner are Jan Dibbets, Ger Van Elk and Marinus Boezen; but the most interesting Dutch work has a distinctly less 'ivory tower' approach, as seen for instance in Wim Gijzen's idea of transforming a new city plaza in Rotterdam into traditional *67* Dutch green fields. Cows being of particular importance to Holland, it is not surprising that they crop up again in the work of the experimental poet Herman Damen. *68*

Rotterdam's enterprising Arts Foundation sponsors a fascinating experiment: *Atlas voor een nieuwe Metropole* – 'Atlas for a new Metropolis' – a cross between sociology, earth art, architecture, history and town-planning. The Atlas is edited by Jan Donia and is mailed in a large envelope which may contain plans, photographs, and occasional objects like packets of seeds. Artists participating have been Hans de Vries, Lex Weschelaar, Wim Gijzen (whose project was to photograph 240 streets in Rotterdam and Amsterdam that bear the same name) and Cor Blok.

Correcting this section of the book on a train going through industrial South Wales, I was struck by the extent to which artists tend to condition our vision of the world. In precisely the way that Cézanne, Monet or Turner have altered our view of particular kinds of landscapes, it is now impossible to see the randomly formed slag-heaps, piled-up sacks in bright polythene, heaped slabs of rusting metal, the sudden ivy-shrouded chimney of a disused factory, the bulldozed path of a new motorway through a landscape, without being reminded of the work of Oppenheim, Heizer or Morris.

Happenings

Stage = place where I paint.
It should have been made clear that Happenings came about when painters
and sculptors crossed into Theatre taking with them their way of looking
and doing things.

Claes Oldenburg[1]

In 1964, in Edinburgh, on the last day of the Festival Drama Con-
ference, a nude lady was wheeled across a balcony on a trolley. Ever
since then, the Great British Public has associated happenings with
naked ladies.[2] To the public at large, happenings are things that 'just
happen': formless, accidental. Even relatively well-informed people
think this: 'All improvisations are, to some extent, happenings in the
sense that none of the participants is exactly sure what is going to
happen.'[3] Thus the author of a recent book on improvisation, talking
about happenings.

It is therefore necessary to make clear the true difference between
happenings and theatre proper. Something of the basic difference
emerges from Claes Oldenburg's quote at the head of this chapter, and
from Allan Kaprow's remarks quoted below. Michael Kirby attempts
a definition: 'a purposefully composed form of theatre in which diverse
alogical elements, including nonmatrixed performing, are organized
in a compartmented structure'.[4]

This, though rather obscurely phrased, hits the spot. A play in-
volves a 'matrix' of information, some from the programme, some
from costumes and setting, some from elapsed action; the actor is
always in character. In happenings the people are just people, like the
Coke-bottles stuck on an assemblage, and there is no narrative inten-
tion. The 'compartmented' aspect of happenings tended to disappear
with time: Allan Kaprow's latest work involves gradual progressions
rather than distinct episodes. Happenings have thus been drawing
closer to theatre; and theatre in its turn has been so much influenced
by the 'alogical' collage aspect of happenings that it is often hard to
see where one ends and the other begins. Jérôme Savary's Magic
Circus group or Ariane Mnouchkine's Théâtre du Soleil in France,

86

the wordless plays of Peter Handke in Germany, the train-pieces by Theaterspiel in London, the street theatre of Ed Berman's troupe, and the early Spike Milligan/John Antrobus works in England, come very close to happenings; but, however much certain theatre directors (Charles Marowitz is another notable instance) have taken from the technique of the happening, their works spring from the structure of dramatic action, and not from the activity of the visual artist, and thus lie outside the scope of this book. A project like Paul Sill's *Monster Model Fun House*,[5] 'a model for popular theatre', remains no more than a distant relative of a Kaprow happening like *Eat*.

One consequence of this distinction between happenings and the theatre lies in the performing talents required. Actors are, by and large, useless without a character to play; and so, during the early days of the New York happenings, there sprang up a repertory company of people who simply had the right kind of responses for taking part in their friends' work: names like Simone Whitman, Lucas Samaras, Letty Eisenhauer and Pat Oldenburg recur constantly.

69

69 PAUL SILLS
Monster Model Fun House
1965

The sources of the happening lie in the whole range of twentieth-century artistic preoccupations that find a place in the first two chapters of this book: the Surrealist films and exhibition-environments, the theatre and film of Artaud and of the Expressionists (the photos of Red Grooms's *The Burning Building* show a great affinity with the settings for UFA films like *The Cabinet of Doctor Caligari*), the developing Pop artists' desire to take the trivia of modern society as their starting-point, and the consequent evolution of the environment. The central concept, from the artistic point of view, is that of collage, the juxta-position of unrelated real-life elements in a relationship contrived by the artist; this was the innovation through which the Cubist painters had finally destroyed the Renaissance 'window-in-the-wall' con-ception of pictorial space.[6]

The movement which led to the invention of the happening proper can be traced to an evening in 1952 organized by the musician John Cage at Black Mountain College. An audience was seated in four triangular, inward-facing blocks, rather in the shape of a Maltese cross. The action took place partly outside the seating area, partly in the aisles through it. Cage delivered a lecture, punctuated by silences, from the top of a ladder. Charles Olsen and M. C. Richards read poems from another ladder. David Tudor played a piano, Robert Rauschen-berg a wind-up gramophone. Merce Cunningham and other dancers moved about through the spaces. Each seat had an empty cup on it, and at the end of the piece the cup was filled with coffee, regardless of what had previously happened to it (some had used it as an ashtray). Some of Rauschenberg's early white-on-white paintings were sus-pended as a sort of false ceiling overhead.[7]

Cage's purely musical development does not concern us here, except for his idea (derived from the work of Edgard Varèse) of treating all forms of noise as 'sound to be used by the composer, to-gether with the corollary that silence is as important'.[8] This led him ultimately to the *nec plus ultra* of modern music: *4′ 3″*, perhaps the musical equivalent of the white-on-white canvases of Malevich. This work consists of silence 'performed' by the performer, in any way he thinks fit, for this duration. David Tudor, Cage's devoted interpreter, marked the time-limits by opening and closing a piano-lid. This work also defines the other major point about Cage's work: his increasing concern with *chance*. The fortuitous noises in the room, usually un-noticed, and the hearers' own thoughts, were the 'content' of the piece.

88

Cage and his followers allowed more and more freedom to the performer, and the works themselves were increasingly chance-generated. He has made extensive use of the *I-ching* or *Book of Changes*, an elaborate Chinese system of chance operations. The possibly un-intentional result of all this is that musical works have become increasingly visual performances.

Cage's most profound effect on the world of visual arts, other than his long and fruitful friendship with Rauschenberg and Johns, came from the class in 'Experimental Composition' he ran at the New School for Social Research in New York in 1958. As the news spread, the class became filled with artists from other areas who wanted to learn from Cage: the poet Jackson MacLow, the artists Al Hansen, Allan Kaprow, George Brecht and Dick Higgins.

Cage has, recently, moved towards a sort of a-political political stance, not unlike that of Joseph Beuys (see Chapter Four). He cites as the major influences on his current thinking Buckminster Fuller, Henry David Thoreau and Mao Tse-tung.

Art influenced by Cage tends to be not only non-sequential (and thus, in intention, liberating) but unpredictable even to the artist. However, the artists who created the happening, from the late 1950s onwards, always fixed the over-all form in advance. Allan Kaprow used a sort of matchstick-men notation to script his performers' movements; Oldenburg's *Fotodeath* had a strict system of lighting-cues.[9] My own 'events' were cued from tape or live sound. This is not to deny that chance-operations played a part in the planning of a number of early happenings, especially in details: a drive-in movie screen in the background, a couple of suspicious policemen inter-rupting the show, a corner empty at rehearsal filled with people. In *The Burning Building*, done by Red Grooms in 1959, the show opened on the first night with someone coming from backstage and asking for a match. This was greeted with some merriment; a helpful person finally obliged. This was unplanned: no one backstage had a match, and a lit candle was essential to the piece. This beginning was liked so much it was deliberately used for other performances. The analogy with collage is particularly close here: chance is used, but the resulting combinations are then fixed, just as Arp made his collage *According to the Laws of Chance*, of 1920, by taking scraps of paper which had fallen to the floor and sticking them down exactly as they fell.[10]

Allan Kaprow

The central figure in the rise of the happening, and the main authority on the way in which it evolved out of the environment, is Allan Kaprow. Born in Atlantic City in 1923, he studied in New York, eventually becoming a professor of art history, and this academic side of his activities has made him a fluent and perceptive theorist. He studied painting with Hans Hofmann and composition with John Cage. His paintings moved from Abstract Expressionism into increasingly complex assemblages, like *Penny Arcade* of 1956, *Wall* of 1957–59 ('series of rearrangeable panels') and *Kiosk* of 1957–59. This development paralleled that of other artists like Jean Follet, Jim Dine, Robert Whitman and Robert Watts. Here is his account of what happened next:

I developed a kind of action-collage technique, following my interest in Pollock. These action-collages, unlike my constructions, were done as rapidly as possible by grasping up great hunks of varied matter: tinfoil, straw, canvas, photos, newspaper, etc. I also cut up pictures which I had made previously, and these counted as autobiographical fragments, as much as they were an intended formal arrangement. The straw, the tinfoil, occasional food, whatever it was, each of these had, increasingly, a meaning that was better embodied in the various non-painterly materials than in paint. Their placement in the ritual of my own rapid action was an acting-out of the drama of tin soldiers, stories and musical structures, that I once had tried to embody in paint alone. The action-collage then became bigger, and I introduced flashing lights and thicker hunks of matter. These parts projected further and further from the walls and into the room, and included more and more audible elements: sounds of ringing buzzers, bells, toys, etc., until I had accumulated nearly all the sensory elements I was to work for during the following years. The next exhibition was an extension of these single works. Now I just simply filled the whole gallery up, starting from one wall and ending with the other. When you opened the door, you found yourself in the midst of an entire Environment. I made its parts in my studio in New Jersey according to a floor plan of the gallery, and what I thought would be able to fill it properly. I then hung the parts in an overlapping planar arrangement along the dominant axis of the room. The materials were varied: sheets of plastic, crumpled-up cellophane, tangles of Scotch tape. Sections of slashed and daubed enamel and pieces of coloured cloth hung in bands that looked like Jewish prayer shawls or other ceremonial adornments. From any position you could see the lights hung in the space but dimly through various layers of the materials, and every

person entering the place was immediately lost in a suspended atmosphere because no one could clearly see another. The lanes, the passageways, the breaks in the planes were all small, so that you tended to move in a waving, billowing, cloud world slowly and with some difficulty. Once every hour for about fifteen minutes, five tape machines spread around the place played electronic sounds which I had composed. But I complained immediately about the fact that there was a sense of mystery until your eye reached a wall. Then there was a dead end. At that point my disagreement with the gallery space began. I thought how much better it would be if you could just go out of doors and float and Environment into the rest of life so that such a caesura would not be there. I tried destroying the sense of bounded space with more sound than ever played continuously. Hidden up in the lights were all kinds of toys that I had gimmicked up so that it was impossible to tell their identity: bells, tinkles, rattles, grinders, marbles in tin cans that turned over, and so on. But this was no solution, it only increased the growing discord between my work and the art gallery's space and connotations. I immediately saw that every visitor to the Environment was part of it. I had not really thought of it before. And so I gave him opportunities like moving something, turning switches on – just a few things. Increasingly during 1957 and 1958, this suggested a more 'scored' responsibility for the visitor. I offered him more and more to do until there developed the Happening.[11]

In 1959 Allan Kaprow presented *18 Happenings in 6 Parts* at the Reuben Gallery in New York.[12] The Gallery was in a loft, which was divided by Kaprow into three 'rooms', formed by laths covered with polythene sheeting. Some of the wall-areas were covered with painted or collaged material, panels of roughly painted words, or rows of plastic fruit. At intervals during the action, slides or films were projected on to the walls. There were various music-and-sound sources. At one point two members of the audience (normally Alfred Leslie and Lester Johnson, but on one occasion Robert Rauschenberg and Jasper Johns) painted each side of a canvas, one with circles, one with stripes, in a single colour each. The audience was given information about the piece before and on arrival, and also two cards which instructed them when and where to change their seats, which they did a number of times during the performances, moving through the different 'rooms'. The players, six in all, had very strict sequences of movement to perform. All movements were made parallel to, or at right angles to, the outside walls: there were no diagonal movements; a definite 'about turn' was made. The players had to pause when entering each

'room', and the movements had to be carried out to definite beats counted in the head, as dancers do. Some movements were purely physical actions, some everyday events, like a girl squeezing oranges. One sequence was for an 'orchestra' of toy instruments.

All the early Kaprow happenings were tightly scripted and strictly drilled. Two types of work emerged: one involving a more or less static audience, the other a walk-around environment like *Garage* 70 or *An Apple Shrine*. *Words*, at the Smolin Gallery in 1962, was an arrangement of audience-participation devices: rolls of words to move, words on cards hung on strings, words to pin up and rubber-stamps to make phrases with. Right from the outset, documentation of his activities has been central to Kaprow's work. He set up a system of mailing scripts for happenings all over the world, and exchanges information with those involved in similar activities.

After *18 Happenings* he did a number of similar pieces, including *Coca-Cola, Shirley Cannonball?* and *A Spring Happening*. The latter took place in the new downstairs premises of the Reuben Gallery in March 1961. This piece involved perhaps the most radical re-orienta-tion of spectator-space in the early happenings (alongside Robert Whitman's *The American Moon*, done at the same Gallery a few months earlier). After waiting in a curtained-off lobby, the audience (seventy-five for each performance) were shown into a dark tunnel, made of wood and hardboard painted black, and with a slit running along both sides at eye-level. Here they would, in fact, stay for the duration of the piece. Lights might go on slowly or flash on and off, outside or inside the 'tunnel'. On the walls opposite the tunnel there hung constructions; both they and the wall were painted either red or green. At one point the constructions started to shake about, making rustling noises. Tapes of various kinds of noises were heard. Two figures fought a silent battle with branches of wood, and a male and female figure made a sort of shadow-play behind a lowered cloth; the slit in the 'tunnel' through which this was watched was covered in polythene, which was rinsed with soapy water. An almost naked girl, mouth full of green vegetables, dodged away from the spotlight repeatedly until finally caught. She was covered in a blanket and sub-sided in a twitching heap. At one point a floor-polisher was moved along the roof of the 'tunnel' and back. Finally, a large electric fan was turned on at one end of the 'tunnel' and a motor-mower with a head-light began to move towards the audience from the other. The sides

71 ALLAN KAPROW *Calling (City Section)* 1965

of the tunnel fell down, leaving them only one avenue of escape, into the full gallery-space for the first time, as the happening finished and the lights came up.

The basic form of Kaprow's happenings has been progressively simplified: a happening is commissioned from him by an organization; a poster is made which is both advertisement and working script for the event; the piece is prepared and performed; and information about it is distributed. The audience consists of the performers; he has moved from ritualized theatre-pieces for a static audience to group rituals, performed mainly in an outdoor environment. Recently, he published *Calendar*, a tear-off book of a year's happenings.

With words like *Birds*, *Household* and *Soap*, of 1964, Kaprow moved towards his mature style. In *Calling*, a 'happening for performers only' of 1965, there was a city section on a Saturday, followed by a country section done on the Sunday. Wrapped figures left in public places call on the telephone: in the woods people are found hanging, undressed and left to call each other (see Appendix 3). Like Kienholz and Oldenburg, Kaprow has a poet's gift for using words, as well as creating purely visual metaphors:

75, 77

71
72

94

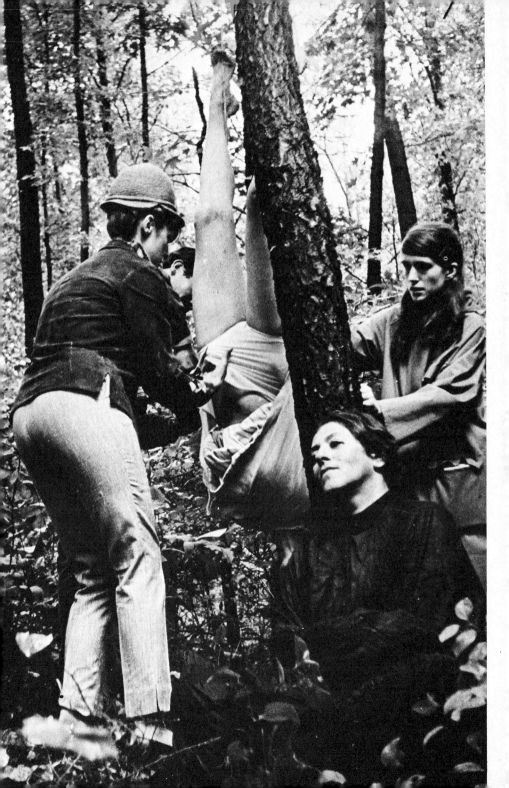

Scheduled for performance in the Spring, for any number of persons and the weather. Times and places need not be coordinated, and are left up to the participants. The action of the rain may be watched if desired. (For Olga and Billy Klüver, January 1965.)

> Black highway painted black
> Rain washes away
>
> Paper men made in bare orchard branches
> Rain washes away
>
> Sheets of writing spread over a field
> Rain washes away
>
> Little gray boats painted along a gutter
> Rain washes away
>
> Naked bodies painted gray
> Rain washes away
>
> Bare trees painted red
> Rain washes away

In *Print*, figures were sprayed or sprayed themselves in outline in public places. In *Pose*, Polaroid photos of various actions were attached to the spot where the action took place, and left there. *Fluids* is one of his most beautiful recent images: huge structures of ice-blocks built, and then left to melt, in city streets. The absolute simplicity of concept in

73, 74
75, 76

73, 74 ALLAN KAPROW *Pose*

75 ALLAN KAPROW
Poster for *Fluids* 1967

FLUIDS
**A HAPPENING BY
ALLAN KAPROW**

DURING THREE DAYS, ABOUT TWENTY
RECTANGULAR ENCLOSURES OF ICE
BLOCKS (MEASURING ABOUT 30
FEET LONG, 10 WIDE AND 8
' HIGH) ARE BUILT THROUGHOUT
THE CITY. THEIR WALLS ARE
UNBROKEN. THEY ARE LEFT TO MELT.

THOSE INTERESTED IN PARTICIPATING SHOULD ATTEND A PRELIMINARY MEETING AT THE PASADENA ART MUSEUM, 46 NORTH LOS ROBLES AVENUE,
PASADENA, AT 8:30 P.M., OCTOBER 9, 1967. THE HAPPENING WILL BE THOROUGHLY DISCUSSED BY ALLAN KAPROW AND ALL DETAILS WORKED OUT.
10

76 ALLAN KAPROW
Fluids 1967

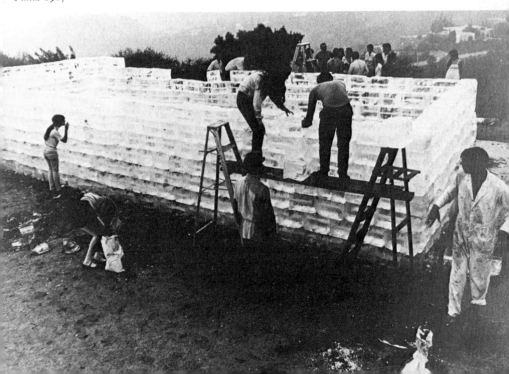

the recent pieces leaves room for all kinds of overtones: the small groups of participants sometimes impinge on the consciousness of the casual spectator in all kinds of unexpected ways. The amateur cast recruited each time makes the ritual a sort of therapy, which distinguishes his work from that of some of the younger British artists involved in actions (see p. 116), works done by a group of professionals to be viewed by an audience.

A very recent Kaprow piece, *Graft*, reveals not only a poet's gift for words, but also a sly sense of humour (as in the implications of the title, for instance):

> hothouse greenery
> fixed to bare January branches
> dollar bills too (exact value of greenery)
>
> maybe ten fifteen trees around town
>
> mass media reports process
> gives public instant info on all locations
>
> reporters return next day
> see what happened to leaves
> (spies? charity? robins?)

60 Kaprow has evolved the happening into a personal art form capable of infinite flexibility: *Transfer* of 1969, a piece involving oil-drums, is dedicated to Christo, a reference to his early *Iron Curtain*. As with Warhol and Oldenburg, Kaprow's radical rethinking of the whole artist/audience/environment/information relationship has been a source of inspiration to many younger artists working in apparently different fields.

New York Happenings: Oldenburg, Dine, Whitman, Monk

At a certain point, fantasy is an object in the physical world. It is like a street or rain.

Robert Whitman

It would be impossible to describe the whole range of happenings that were presented in New York in the early 1960s. Here I have tried to give the feeling of three of them, hoping to make clear that there were as many ways of making 'artist's theatre' as there were of painting

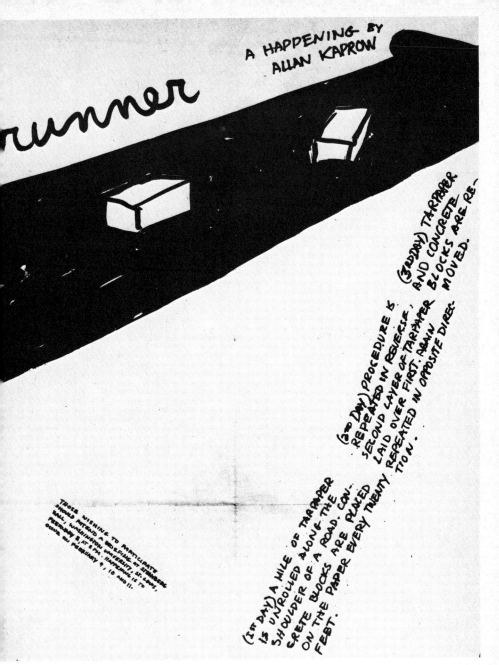

77 ALLAN KAPROW Poster for *Runner*

or sculpture. Indeed, the word 'happening' only came into general use after some of these pieces had been performed. In Appendix 3 there are some extracts from working scripts for the Oldenburg and Dine happenings which I hope will convey a feeling of the kind of controls and freedom involved in both the setting and the actions. The third artist, Robert Whitman, did not make scripts, but used mainly small drawings of physical situations or odd key-phrases. The action was worked out in rehearsal.

Claes Oldenburg's happenings were personal, physical, concerned with objects and basic human and domestic predicaments. They can be seen as extensions of the sub-matter of his sculpture. *Store Days I* was the first event held in the Store, one of a cycle about seasonal changes and memories called collectively 'Ray Gun Theater'. Oldenburg said of it later that 'it showed desperation and boredom of gayety – man's indoor life in winter'. *Store Days I* took place in three adjacent 'rooms': Room 1, *The Bedroom – Jail*; Room 2, *The Kitchen – Butcher Shop*; Room 3, *The Livingroom – Funeral Parlor – Whorehouse*. Above Room 2 was an 'attic', with a door on to each room, containing three 'spirits' who performed actions which were sometimes independent of, sometimes related to, the main action. There were three 'periods': *A Customer Enters*, *A Bargain*, and *How the Founders Struggled*. Each room had several 'stations' for the different phases of the action. The costumes, properties and furniture were made by Oldenburg, and relate to his various sculptural projects at the time: for example, the 'table' in Room 2 had three 'tops' made of stuffed canvas, on to which were sewn plates, cups, etc. The distant effect was slightly like that of pancakes on a plate.

The audience was limited to thirty-five per performance, and they stood in each room, separated from the action by a clothes-line, although able to move from one room to the other if they wished. Room 2 had large windows in the walls, so that action in the other rooms could be seen. The actions were simple, physical, sometimes unusual. A man sits eating a sandwich; another man inside a huge parcel plays a drum. The sandwich man slowly becomes aware of the parcel man, unwraps him slowly, goes through his pockets, wraps him up again. Some variations on domestic situations: a woman sits eating ice-cream, messily, slopping it on herself. Lights a cigarette, has a drink, goes to the sink and starts noisily chopping up green vegetables. The man in the room works on a carved ship model, throws

29

it at her in a rage, bangs the stuffed table, causing it to fall to the floor, picks up the pieces, starts shaving.

After the 'Ray Gun Theater' series, Oldenburg did a number of happenings in galleries, and some outdoor ones: *Injun*, 1962 (Dallas Museum of Art, in some outbuildings behind the museum), *Washes*, 1965 (in a New York swimming-bath), and *Autobodys*, 1963 (in a Los Angeles car-park).

Jim Dine's happenings were a brief but important contribution to the genre, sometimes funny (like Oldenburg's), and always highly personal. *The Smiling Workman*, 1960, and *The Shining Bed*, 1962, were virtuoso display-pieces for himself. *The Car Crash* is his most *78–80* ambitious piece, and is interesting in being the most 'linear-narrative' of all the early happenings: there is a definite thread of at least psychological continuity. The personal element is strong: it could be described as a sort of psycho-drama for the exorcism of Dine's experience of a real car crash. It is interesting to note Dine's own statement about giving up the form: 'I do not feel there was enough of a perspective between art and life in them. I felt they were too closely allied with me. . . . Everybody I ever talked to was misinterpreting them.'[13]

The Car Crash was presented at the Reuben Gallery in November 1960. The action took place in a rear room, where shelves and some materials left behind from previous tenants had been used as part of a complex wall-environment. Tyres, lengths of hose and tubing, gloves and other objects, rolls of paper and cardboard, were fastened to, or hung from, the shelves, and painted white. The room had overtones of hospitals, bandages, machine-parts and visceral organs. Even the floor was painted white, and Dine at one point had thought of dressing the audience in white caps and overalls in order to preserve this feeling. A dark-haired, white-faced girl, who seemed to be eight feet tall, stood silent in one corner. She was, in fact, sitting on a ladder, which was hidden by her long white robe. Cut-out crosses, some white, some red or silver, hung from the ceiling. The seats were set in a rough U-shape.

The action began in darkness, with recorded traffic noises; a man dressed in silver, with two lights on his head, appeared. This was the car, played by Dine himself. Two other figures appeared holding two flashlights held like headlamps. Both wore white masks and white clothes, a boy and girl wearing clothes of the opposite sex. They proceeded to play a sort of hide-and-seek game with their lights.

Whenever the lights struck the silver man he moaned loudly. Lights on. The silver man reappears without lights, making honking noises. The girl on the ladder starts a stream-of-consciousness monologue: THE CAR IS MY HERTZ SPOT OF LOVE TO ZOOM THROUGH THE WHOLE TRANSMISSION OF MY LOVELY TIME. . . . Clanking and clattering off stage. The silver man blows up a white balloon which bursts. Lights go out. Car noises again, this time climaxing in the sound of a car crash. Lights on. The silver man is at a wringer which is fastened above a blackboard. As he turns the handle the word HELP appears painted on every piece of a roll of paper towel. As the roll unwinds, one of the actors gives the pieces to the audience. The girl on the ladder says HELP slowly, getting louder. Lights off. Girl on the ladder spotlit. Another monologue, degenerating into stammers. The silver man stands at the blackboard with a chalk, frantically drawing cars, with human faces. He stammers incoherently. The other performers join in the sounds, which swell to a climax as the work finishes.

Robert Whitman is, apart from Kaprow, the artist who has contributed most to happenings, and who has kept working within this area of activity longest. His happenings work at a higher level of abstraction than those of Dine or Oldenburg. At best his work has a kind of pure, distilled visual poetry. Non-logical poetic rituals, happenings are his way of manipulating time:

Time for me is something material . . . it can be used in the same way as paint or plaster or any other material. It can describe other natural events. I intend my works to be stories of physical experience. . . . Time is the material I use to describe these things.[14]

Like Dine's and Kaprow's, Whitman's early pieces grew out of the making of assemblages. An untitled six-foot-square construction of 1958 involves a number of regular-sized pieces of paper fastened to polythene or laid on the floor in a grid-pattern. One of the most *81–83* original aspects of *The American Moon* was derived from this. Even more than Kaprow's *A Spring Happening*, this piece involved a radical rethinking of the audience's role in the happening. They were seated, facing inwards, in six tunnels that radiated out from the centre of the room, leaving a roughly oval area where most of the action of the piece took place. At the two ends of the oval the performers could wait out of sight of the audience, who saw part of the central area, and

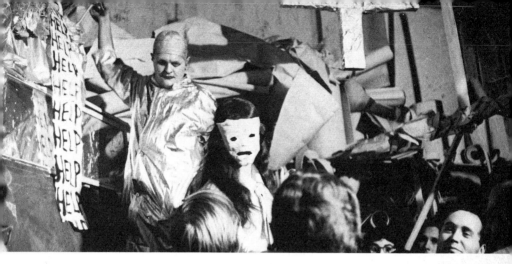

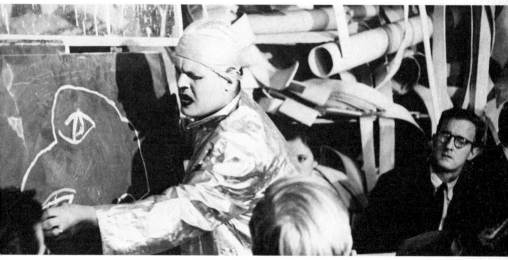

78–80 JIM DINE *Car Crash* 1960

81–83 ROBERT WHITMAN *The American Moon* 1960

the mouth of the opposite tunnel. They were deliberately left unsure about the shape of the room until the end of the happening. A burlap curtain hung over the end of each tunnel. When raised it served to cover the catwalk which was built round the central space and over the mouth of each tunnel. At one point a film was projected from the back of each tunnel on to a polythene sheet on which were pasted a number of sheets of typing-paper in a regular grid, so that the image was broken into a number of regular facets, with perhaps a view of the rear of the 'screen' opposite. The film showed cloth-shrouded figures and heaps of coloured cloth moving in an autumn landscape. Tapes of electronic music were used.

The main part of the action, like that of the film, consisted of strange movements by animated bundles of cloth, in the central area. A large ball of red cloth swung across the central space: layers of cloth fell off it to reveal a man swinging on a rope. Huge paper balls were rolled about, often blocking the mouths of the tunnels completely. In dim light, a polythene sheet rose and inflated slowly while torn newspaper rained down on it. A man hung rigid on a rope

trapeze above the heads of the audience. The happening finished with a blackout in which impassive faces on the catwalk could be seen in flashes of torchlight. When the lights came up the audience found their way out through the now-familiar structure of the tunnels.

Whitman has made other happenings since, notably *Mouth*, 1962, *Flower* and *Water*, 1963, and *The Night Time Sky*, 1967. One of his *84* most fascinating other works is *Cinema Piece* of 1968, a real shower with a film of a girl taking a shower projected on to the curtain.

Some happenings were done only once, but most of those described here were repeated over a period. Some involved only the performer, others quite a large audience. They were done with limited means, often using whatever materials came to hand. It is interesting to compare these low-budget works with the 'Evenings in Art and Technology' mentioned in Chapter Two, which were much more spectacular and expensive, and, perhaps for that very reason, less innovatory in any basic sense. Claes Oldenburg describes what *Store Days* meant to him:

I am very grateful to the audience for coming each weekend. I cannot deny

it is good to have an audience, though the nature of this theater is such that it would go on without an audience as a painter might go on painting with no one to watch him. . . . This space has great limitations, I am aware of this . . . partly I enjoy the pressure these limitations put on me. I mean the time, the expense, and the space. . . . I hope you are not too miserable . . . my aim is to develop under these concentrated circumstances a sort of kernel of infinite expansion . . . so that at the end of this season I shall have ten extremely powerful seeds. . . . It is becoming obvious I guess that these pieces are not unrelated. . . . The 'happening' which was in the beginning a very limited form is bearing fruit as a new physical theater, bringing to the dry puritan forms of the US stage the possibilities of a tremendous enveloping force.[15]

In the USA a number of artists took up the making of happenings in the early 1960s. Al Hansen was a member of the John Cage composition class of 1958. In 1960 he took part in 'Ray Gun Spex', along with Dine and Oldenburg, presenting a multi-projection film collage. Of his later series of happenings, the best known are *Parisol 4 Marisol* (Gramercy Arts Theater, 1963) and *The Gun Boat Panay* (Third Rail Gallery, 1965), and he has exhibited assemblages at the Judson Gallery in 1964 and the New York Gallery in 1965, including the well-known Hershey Bar wrapper collages. In addition to his own activities, he is a chronicler of the activities of other artists working in this area.[16]

Associated with Hansen and others, Robert Watts is perhaps best known for his performances like *Mail-Box Event*:

> open mail box
> close eyes
> remove letter of choice
> tear up letter
> open eyes

He sent a number of these instruction-pieces out as part of the 'Yam Festival' with George Brecht in 1963. Well known as a painter and assemblagist, he contributed to the 1964 Bianchini Gallery 'Supermarket' show boxes of metal casts of fruit chromed or painted in bright colours, displayed as in a fruiterer's shop.

Carolee Schneeman, a veteran of the New York happenings scene, now lives and works in England. Her best-known event was *Meat Joy*, presented at the Judson Memorial Church, New York, in 1964, a sort of spectacular multi-media orgy, with naked and near-naked

132
85

performers 'lovemaking with paint brushes'. She has made a number of films as well as continuing to present happenings: the theme of all her work is a joyous plea for sexual liberation.

A demolished rail depot at dusk. Spectators being carefully seated on long sheets of polythene. The air filled with a loud humming. Straining against the dark, we see two large groups of people at either end of the large, enclosed field, lying on their backs, their legs bent, motionless. Each is singing a single sustained wordless note. Two girls unroll a banner: VESSEL: AN OPERA EPIC, PART THREE. At one side stand an electric organ and a microphone. At it, a tiny figure, her hair in plaits beneath a trilby hat: Meredith Monk. She starts to sing, also wordlessly, accompanying herself with a repetitive, rhythmic figure on the organ. A bushy-haired man sets up a standard-lamp and two armchairs in the middle of the space. A girl carrying an oil-lamp goes round and 'tags' each of the reclining figures, who get up in turn and stop singing. Each 'army' is dressed in a dominant colour, red or blue. Dancers, a truckload of revellers, a motor-bike gang, appear during the hour-long piece.

85 CAROLEE SCHNEEMAN *Meat Joy* 1964

Vessel was performed in New York and Liverpool in 1972 by Meredith Monk and The House. I saw the version she performed at the Great Georges Project, Liverpool. Monk is perhaps the single most important figure to emerge in the field of 'artist's theatre' since the New York happenings of the early 1960s. The Wagner or the Piscator of the happening, she aims at the epic, considering her works 'operas'. Trained as a dancer, she took part in the second-generation happenings of Hansen, Higgins and others, and has always been a musician. Now she operates with The House, a commune of people whose special skills and particular interests she welds together: photography, fabric-dyeing, calligraphy are used as integrally as the basic skills of dancing, singing and movement.

Vessel is very much a musical piece, although realized in multi-media terms: actions, sounds, light-effects, movements recur in the three sections in changing contexts, a sort of theatrical polyphony. Meredith Monk herself talks about the spatial qualities of her work; she praises some photographs she sees because they have caught the 'architecture' of the piece.

Parts One and Two take place indoors. In the Liverpool version, Part One took place in a crypt-like basement of the old church that houses the Project. It was dark, oracular, sometimes obscure, sometimes sinister. Each part of the work, as with all Monk's pieces, has its own rhythm of sound and action, and although the work never succumbs to the common avant-garde vice of deliberately induced tedium, it nevertheless takes time for these rhythms to set themselves up in the spectators' head. A family group sit round a standard-lamp in the dark, one girl telling an endless fairy-tale. You are shown to your seat in the darkness, as this proceeds, through a tunnel of hanging drapes. This section is mainly lit by flickering oil-lamps, apart from one moment near the end when a beautiful dark-haired girl in a white robe appears in a doorway, dazzlingly spotlit. Just before, Monk had spoken a passage from Shaw's *Saint Joan*, the only overt clue to the meaning of the piece: *Vessel* is a version of the Joan of Arc story.

Part Two is brightly lit and often humorous, but with dark overtones, like a Grimm fairy-tale. An artificial mountain has been made on stage: white sheets draped over platforms, high up on the organ-loft in the main auditorium of the church. Perched above the organ-loft, perhaps thirty feet above our heads, a man in a dark suit, carrying a stick, watching. A traveller walks round the room, up and down the

mountain. Like figures from cuckoo clocks, the mountain-people appear, sing wordlessly, and perform repetitive sequences of actions. A 'court' of robed figures appears. A girl attempts, unsuccessfully, to juggle some metal discs. Monk sings wordlessly off stage, again to the organ. At the end, echoing Part One, the lights go down on the mountain: three white-robed figures, the dark girl, a young man and an old lady, stand spotlit in the niches of the organ-loft. The light slowly moves up to the watching figure above them (Monk calls him the Inquisitor). He stands up, raises his stick, raps three times on the ceiling. The second part ends, like the first, in darkness.

Part Three of *Vessel* is a symphony of lights, enacted in darkness: a standard-lamp lit in the middle of a field, creating a strange feeling of an invisible living-room; a hand-held spotlight, throwing a single dancer's shadow on to the red-brick outer wall of the yard; a photographer's flashlight; small fires lit by one of the opposing 'armies'; three white-draped figures (from the finale of Part Two) singing, tiny and spotlit in the distance. The final act: Monk leaves the organ for the first time, dances about a girl in overalls welding pieces of metal together, the electric-blue flashes of Joan's martyrdom.

Other works in The House's repertoire are *Juice*, a similarly large-scale work, and two solo pieces for Monk's extraordinary voice and organ-playing, *A Raw Recital* and *Education of a Girl-child*, in which members of The House act out part of her recital.

86

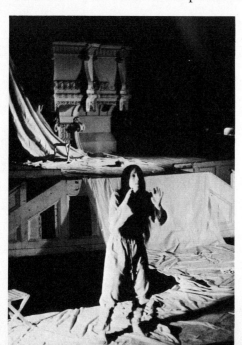

86 MEREDITH MONK
Education of a Girl-child 1972

Great Britain

In England, though there have been influences from both American and Continental movements, there is, in the best work in the field, an urge to use environmental forms to by-pass the modern tradition of the isolated artist. The performing arts, at their best, have moved into more popular fields, often in alliance with new forms like rock music.

Throughout the 1960s the growing popularity of poetry-readings meant that a new generation of poets arose, doing one-night stands from town to town to earn their living, and with a predominantly youthful audience. At the beginning of the 1970s a similar situation developed for young performance artists. Now, like pop groups, they travel the motorways in Ford Transit vans, moving from one festival to the next.

Although much of the support for these groups has come from the Arts Council of Great Britain, either directly or indirectly via local Arts Associations, this movement, like the new poetry movement, basically comes from a provincial rather than a London context.

To see just why, we have to move back in time to 1962, when a group of artists belonging to the Fluxus group held a show at Gallery One in London.[17] Ben Vautier (see p. 160) lived in the gallery window for a week. Inside, there were a mirror staircase to reflect up ladies' skirts, and a do-it-yourself rubber-stamp poem-wall. The show, followed by an evening performance at the ICA, went virtually unremarked by the critics at the time, but it had its effect on those young artists who did see it. It came at a time when London was emerging as a major centre of the art world. The success of the English Pop artists, and the favourable financial conditions that made London a centre for art-auctions, were contributory reasons for this. This newly acquired status was not, however, without its drawbacks: the larger Bond Street galleries have tended to remain conservative in their tastes, usually following New York tendencies a couple of years later, and always preferring the handmade, one-off art object. There have been honourable exceptions: Victor Musgrave's Gallery One, for instance, during its short life, was host to a number of very important shows, including the only London one of Yves Klein in 1962. However, the encouragement has come, when it has come at all, from non-commercial organizations like the ICA. More recently the Arts

Council's Serpentine Gallery in Kensington Gardens became host to all the main groups of young artists working in multi-media activities.

These exceptions apart, the London art world has tended to promote safe, easily saleable commodities, and much of the work emerging from the major London art colleges, like the Slade School and the Royal College of Art, has tended to reflect this attitude. This may well help to explain why the English pop-music scene has been enriched and strengthened by so many art-school drop-outs, from Stuart Sutcliffe and John Lennon onwards.

Elsewhere in the country, however, for financial and social reasons, it has been more possible for small, self-sustaining groups of artists to create multi-media works in a localized context. There is a strong provincial tradition of contact with avant-garde groups in other countries: in Edinburgh, Cardiff and Newcastle it is possible, via letters, little magazines and exchange visits, to relate to an international movement and be free from fashionable London attitudes. Thus, both 'Pop' poetry and 'concrete' poetry in England are almost exclusively non-metropolitan in origin, and performance artists similarly flourish in the provinces. The most important English mixed-media artists of the early 1960s who did work in London – Mark Boyle, John Latham, Jeff Nuttall – have seldom shown in commercial galleries and have been largely ignored by the modern art establishment.

During the brief life of Paul Keeler's Signals Gallery in London, it, with its house magazine, was a major focus for kinetic art, notably that of the Filipino artist David Medalla, best known for his sand-and-foam sculptures and 'hydroponic rooms'. Medalla led the Exploding Galaxy, a multi-media music/dance group, during 1967–68.

The movement from assemblage to happening with the New York artists in the early 1960s was paralleled in the work of a number of British artists. One assemblagist moving into the area of happenings about this time was Mark Boyle, working first in Edinburgh and later in London. His first 'random studies', areas selected on a map, then removed and fixed as a painting, were done in 1964. In 1966 he led the 'Institute of Contemporary Archaeology' in a dig on the site of a monumental sculptor's yard. The results were later exhibited. Boyle's *Presentations* of areas of beach, building site or street have continued; in his events, too, he has presented pieces of the real world to an audience. Thus, in *Suddenly Last Supper* of 1964, which took place in Boyle's flat, while the audience were watching a show of slides of

87

88

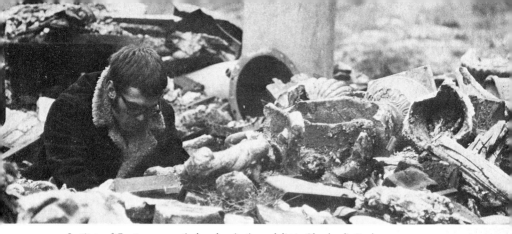

MARK BOYLE *Institute of Contemporary Archaeology's Annual dig in Shepherd's Bush,* ndon 1966

MARK BOYLE *Suddenly Last Supper* 1964

Botticelli's *Birth of Venus* projected on to a naked girl in the same pose, Boyle and his friends quietly moved their possessions out. The audience were finally left in the empty flat. Similarly, the audience for *Street* of 1964 were led into a small curtained auditorium. When the curtains were opened they found themselves looking through a shop-window into the street. The 'action' was the usual life of the street outside. Boyle started making liquid light projections about 1967, and was involved in the running of U F O, Britain's first 'underground' night-club. He eventually worked for a time with the Soft Machine, a progressive rock group, doing an outstandingly beautiful light-show that was an integral part of their stage presentation. Boyle's most ambitious theatre-pieces were *Son et Lumière for Earth, Air, Fire and Water* and *Son et Lumière for Bodily Fluids* of 1966. In the latter, Boyle used all possible liquids extracted from his own body as a source

89 of visual material projected in the course of events. In one sequence a couple made love while their encephalograms were projected on to a screen above them. Boyle is now working on a grandiose project for making *Presentations* of hundreds of chosen sites all over the world.[18]

Jeff Nuttall, poet, theorist, assemblagist, jazz musician and playwright, has written brilliantly about the avant-garde in England in the 1950s and 1960s in his book *Bomb Culture*.[19] His own work is violent, sado-erotic, scatological: what distinguishes his work from superficially similar work by the Vienna Group (see p. 168) is a saving sense of the ribald. In the basement of Better Books in London in 1966,

90 he and a group of other artists made an environment, *The Stigma*. In the following year Nuttall made another environment, *The*

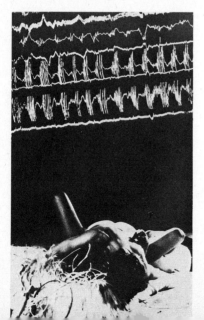

89 MARK BOYLE
Son et Lumière for Bodily Fluids 1966

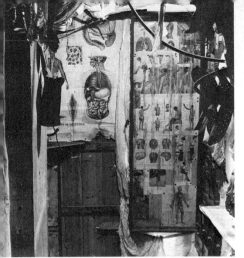
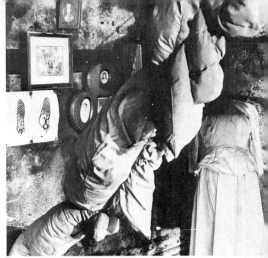

90 JEFF NUTTALL *The Stigma* 1965 91 JEFF NUTTALL *The Marriage* 1966

Marriage, as part of an exhibition in the same place. His most recent *91*
show of sculpture was transformed into an environment by having
the gallery papered in old-fashioned wallpaper and Nuttall's dialogues
broadcast from small loudspeakers near the figures. Perhaps his most
important work has been his scripts for the People Show, a radical *92, 94*
theatre group who have worked in streets, pubs and every con-
ceivable environment. The group has changed direction several times
with personnel changes, the sole remaining founder-member being
Mark Long.

Involved with Nuttall in Group H, which also showed at Better
Books in the mid-1960s, was Bruce Lacey. The Dr Coppelius of
sculpture, Lacey creates figures that are brilliantly animated: a
comedian with a row of wooden arms which applaud his own jokes;
other figures with an in-built recycling system. He has used his
electronic figures in a theatrical context, notably with the Alberts and
Spike Milligan in the successful *Evening of British Rubbish*. Recently he
made a giant digestive system as a sort of fairground funhouse, and a
splendid sliced-open suburban room for the ICA's 'Ten Living
Rooms' show of 1970. His lecture/film-show *Experience*, a long auto-
biographical discourse, is both profound and wildly funny.

Working with figures similar to Lacey's is Roger Ruskin Spear,
once part of the anarchic, satirical Bonzo Dog Band, now working
on his own as the Giant Kinetic Wardrobe, who takes similarly

115

92 THE PEOPLE SHOW *Christian Aid World Hunger Demonstration* 1969

animated figures and automata into the context of rock clubs and festivals. Neil Innes of the Bonzo Dog Band sometimes wore a stage-suit of canvas which he had painted with his own version of Constable's *Hay Wain*, a wooden American car replacing the cart of the original. The Bonzos, originally an art-college band, were highly successful until their break-up in 1969.

In 1962 'She Loves You' and 'Please Please Me' echoed round the world: Beatlemania was born, and for the first time a totally non-London show-business phenomenon appeared in England. London has never quite recovered from the shock. There had, of course, been signs of things moving in that direction earlier: the emergence of specifically Northern actors like Albert Finney and specifically Northern playwrights like Shelagh Delaney just a few years earlier, for instance. But in 1962–64, Liverpool suddenly seemed like the capital of the world: for those of us living there then, it was a heady though disconcerting experience.

The first happenings in England were done by a group of artists and poets in Liverpool in 1962, as a result of my reading an article by Allan Kaprow earlier that year. I had been making assemblages, and,

93 GREAT GEORGES PROJECT *Gifts to the City: Six Memorials* 1971

as with Kaprow, happenings seemed a natural extension. The hap-
penings were presented as part of a Merseyside Arts Festival in 1962
and 1963, along with poetry-and-music and folk-evenings. The
'events', as we called them, quickly became a popular form of enter-
tainment: a mixture of poetry, rock'n' roll and assemblage. The early
ones like *City* (1962), by Henri/John Gorman/Roger McGough, used
a taped music track. Later events had live music by local 'Merseybeat'
groups, for instance the Roadrunners and the Clayton Squares, as in
Nightblues, 1963. The most popular of these were *Bomb* and *The Black
and White Show*, held at the Cavern in 1964 and 1965, and written in
collaboration with the poet Brian Patten, which were much more
directly political in implication. After 1963 the original group broke
up and the Scaffold, a poetry-satire group, was formed. Later I
founded Liverpool Scene, a poetry-rock group, with the guitarist-
composers Andy Roberts and Mike Hart, who, as leader of the Road-
runners, had taken part in a number of the earlier events.

 After some quiet years, activities of this kind have begun again,
based on the Great Georges Project run by Bill and Wendy Harpe, a
neighbourhood social and arts project in a poor, racially mixed area.

In their huge, blackened, tumbledown church building, they have put on a number of environmental theatre-pieces including *A Cultural Bingo Show* (1970), an extension into a happening of their normal weekly bingo-shows for local mothers, and a series of *Gifts to the City*, weekly happenings through summer 1970 by Wendy Harpe: a city bus on which commuters were given breakfast and a newspaper; wreaths laid by mourners in Victorian dress on demolished city landmarks; a re-creation of Kaprow's *Fluids*. At best, their discothèques, bingo-shows and play-groups merge naturally into Bill Harpe's interest in modern dance and Wendy Harpe's leanings towards the happening. Both are radically committed, socially and politically, and have suffered a certain amount of harassment from the local cultural and political establishment. A breakaway group from Great Georges, Zoom Cortex, was formed in 1972, presenting multimedia events based on a progressive rock group, Death Kit. Birmingham Arts Lab and Bath Arts Workshop are similarly engaged in art-oriented social projects.

Undoubtedly the most exciting mixed-media work in England today is being produced by young artists in Yorkshire. In 1963 the dramatist John Arden held a 'Festival of Anarchy' in the tiny village of Kirkbymoorside: contingents came from Liverpool, London and all over the north of England. Living near by was John Fox, a young artist who had left Newcastle University, disillusioned with the teaching there. Encouraged by Arden he worked with him and Boris Howarth, a remarkable composer who now concentrates on making theatre-pieces for children. Fox met Albert Hunt, a brilliant teacher who has turned the Complementary Studies Department at Bradford College of Art into the country's most progressive theatre workshop. Hunt has consistently refused to become involved with the commercial theatre, despite a growing reputation and despite his involvement in productions like Peter Brook's *US*. He prefers to work with students, accepting the fact of a regular turnover and consequent retraining of the company. His most striking teaching project was his 1967 re-creation of the October Revolution. The map of Bradford became that of Petrograd, and the events of the Revolution were re-enacted by hundreds of students from all over Yorkshire. Hunt's productions have since moved towards a didactic yet entertaining semi-vaudeville style, from *St Valentine's Eve*, 1968 (with Robin Page), a re-enactment of the bombing of Dresden, through *At Last the 1942 Show* and *The*

93

God Show to *James Harold Wilson Sinks the Bismarck* of 1971 and *The Passion of Adolf Hitler* of 1972. After teaching at Bradford, John Fox moved to teach at Leeds College of Art, where Robin Page, a Canadian member of the Fluxus group, was also teaching. Page, perhaps under the influence of the local ambiance, moved from a personal version of the dark rituals of the Vienna Group towards a popular vaudeville-style happening.

Fox, meanwhile, though still working with Arden and Hunt, had started the Welfare State, originally working as an art-oriented pop group, which gradually became more and more a form of anarchic street-theatre in the popular vein of Punch-and-Judy and fairground entertainments, probably influenced by his enthusiasm for the American Bread and Puppet Theater. He has simultaneously been working with the jazz composer Mike Westbrook, notably in *Circus-Time* (1970), *Earthrise* (1971) and *Winter Rising* (1972), huge epic productions of great length and considerable excitement, involving contrasts of frightening, atavistic rituals, music-hall techniques, and the use of modern technological devices like closed-circuit television. Fox says of Welfare State's summer 1972 tour of the south-west of England:

95

We placed standing stones on remote tors, built turf circles on dark moors, erected a maypole at night on a granite outcrop (for the autumnal equinox), lit giant beacons on inaccessible hills, walked twelve miles across Dartmoor at night, created a symphony in the Cheesering quarry with the Mike Westbrook Band, falling rocks and fire bombs. We have performed to all the cars on the A38 between Glastonbury and Burrow Mump in one afternoon. We have created a naming ceremony for a child in the Hurlers Stone Circle on Bodmin Moor, tried Judge Jeffreys in an ornamental fountain in Taunton, and more or less discovered the sunset in Her Majesty's Submarine *Andrew*. We also investigated the role of film and radio in extending audiences and images.

We have tried to follow the ideas of our January Manifesto: 'We make art using the traditions of popular theatre such as mummers, circus, fairground, puppets, music-hall, so that as well as being entertaining and funny and apparently familiar in style to the popular audience our work also has a more profound implication. We will react to new stimulus and situations spontaneously and dramatically and continue to fake unbelievable art as a necessary way of offsetting cultural and organic death.'

Al Beach, who started the Northern Open Workshop in Halifax in 1970, has been a tireless worker and publicist for new art. He, John Darling (an ex-member of the People Show who makes his own

119

performance-pieces), Mick Banks and Diz Willis have formed a loosely constituted group known variously as the Yorkshire Gnomes and *99* John Bull's Puncture Repair Kit. With the Cyclamen Cyclists, who share overlapping membership with them, they present a totally original form of ritual street and landscape theatre: brightly clad figures move in predetermined sequences across a landscape, planting coloured flags, or performing simple physical actions. For the *96* summer 1972 festival at the Serpentine Gallery in London, John Bull's Puncture Repair Kit presented a week-long event that seemed to epitomize their particular blend of artistic radicalism and comedy. In a room marked out with white lines in which sand-trays full of model tanks and soldiers, bits of old aeroplanes, shaving-tackle and maps were ritually disposed, four uniformed men lived out a fantasy-life as a 1942 R A F bomber squadron in the North African desert. Their whole day was organized to a timetable: cleaning, washing, eating, manœu-vring with desert-camouflaged wheelbarrows, doing bomb-disposal drill with an hilariously ramshackle fire-engine, all done with the absolute seriousness which is the hall-mark of real comic style.

Yorkshire houses a teeming network of collaborations. The role of transmitting information about these actions has now been taken over by *Collection*,[20] an information-sheet whose editors, Michael Scott and Ian White, are concerned with running the successful and truly popular Bradford Festivals.

Roland Miller joined the People Show some time after its inception and rapidly became the major writer/theorist for it, replacing Nuttall. In 1967 he and the theatre designer Tony Carruthers produced a catalogue of mail-order events, *Ideal Woman × Infinity*. In 1970, after leaving the People Show, Miller moved to a less theatrical context. With the sculptress Shirley Cameron he founded Landscape Gardening and Living Rooms. Now based on Swansea, they make simple ritual event-pieces in an indoor and outdoor context: one of the most *94* successful was done at the side of a railway line, events to be glimpsed from train-windows by the passengers.

Miller's larger groups, the Cyclamen Cyclists and the New Fol-de-Rols, are recruited from artists like John and Clare Darling, Jeff Nuttall (now living in Leeds) and Al Beach, who are working in the Yorkshire area. In the present proliferation of arts festivals, one or other of these groups is almost certain to appear anywhere in Britain. Some of Miller and Cameron's presentations have common factors

94 ROLAND MILLER AND SHIRLEY CAMERON *Railway Images* 1970

with Beach's John Bull group: a base area laid out with objects used
as the material for the action, and the presentation of found objects
under new conditions as exhibits. Where Miller and Cameron differ
is in the strong comment on sexual roles in society implicit in their
relationship. *Landscape Gardening versus Living Rooms* was a fortnight-
long event at their home near Swansea in spring 1972. In their work
for the summer programme of events at the Serpentine Gallery,
London, in 1972, this basic role-playing was amplified: Miller, wearing
a green costume, worked outdoors, setting out rows of small white
pegs on the lawn, related to sight-lines on distant objects or chance
events, a dead bird or a fallen leaf. In a white garment Cameron fussed
about indoors, moving small objects, putting beads on, preening her-
self, looking at him through the window. Periodically 'The Gardener'

95 overleaf THE WELFARE STATE London 1972

96 overleaf JOHN BULL'S PUNCTURE REPAIR KIT London 1972

stared at 'The Lady' through the french windows, or she would call out to him: there were strong undercurrents of sexual tension.

One other Northern town had been the focus of some interesting activities in the mid-1960s. At Newcastle University, where Victor Pasmore and Richard Hamilton were teaching, a group of young revolutionary artists under the group-name Icteric gathered round the theoretician Ronald Hunt, who was then university librarian. In the two issues of the magazine *Icteric*, and a travelling exhibition, 'Descent into the Street' of 1967, he and the group proposed a totally new reading of the Constructivist/Dada/Surrealist tradition, reaching a position similar to that of the New York Black Mask group (see Chapter Four). They not only spread information about little-known radical art activities but also reconstructed a number of earlier pieces or projects, like Tatlin's ornithopter and a Surrealist project for visionary architecture. Other members included the twin brothers David and Stuart Wise, Chris McConway and John Myers. Apart from their influential theoretical work and a number of happenings, they produced a variety of printed matter, posters, leaflets, manifestos, using popular imagery like 'The Bash Street Kids' from the *Beano* comic, rather in the way the Situationists (see p. 181) were doing in France. They had in fact become involved with the Situationists, and, pre-

97 ROB CON *The White Men* 1970

dictably, were eventually expelled. The group moved away, Hunt to Canada, the Wise brothers to London. Again, as with the ex-New York Surrealists of Black Mask, they turned towards entirely political activities: the publications *King Mob*, *Black Hand Gang* and the pro-Skinhead (street gang) paper *Aggro* have appeared, under their influence, from the Notting Hill area of London in recent years.[21]

The youngest artist represented in this book is Robert Conybeare (Rob Con) from South Wales, who works with a group called G A S P (Games of Art for Spectator Participation), the other members being Julian Dunn and Harry Henderson. One of Conybeare's most original works is a pair of trousers made of plastic tubes up which *98* coloured liquids are forced when the wearer puts his foot down. He has also done a number of public outdoor performances involving children, as well as more orthodox happenings like *The White Men*, *97* which was performed in a Wolverhampton secondary school. G A S P, which originated at the Wolverhampton College of Art and is based in Birmingham, has recently emerged as one of the most professional and fertile of the new touring groups of performance artists. Their repertoire ranges from silent, white, mysterious rituals based on the simple process of casting plaster to uproarious public demonstrations of Rube-Goldberg-like beer-drinking devices.

98 ROB CON *Liquid Boots (Visual Display Devices)* 1969

99 THE CYCLAMEN CYCLISTS Swansea Docks 1971

If England has made a contribution to this genre, it is in the area of social involvement: nothing could summarize this better than the Arts Council's highly successful public play-events, 'Blow-Up', of summer 1971: hundreds of happy children romping in an inflatable environment made by a team of young artists. The Arts Council's summer 1972 programme of events included Stuart Brisley, a maker of ominous, white, often violent rituals, and Peter Kuttner, whose *Edible Rainbow* is a project for making brightly coloured food, originally given away as part of happenings and now done as a commercial proposition: food originally conceived as art-works sold in boutiques and department-stores.

Other young artists working in the performance field are Ian Breakwell, whose pieces have included notable one-man works in the public library and swimming-baths of his home town of Taunton, and Anthony McCall, whose most successful recent event was *Foghorns and Fire Sirens*, an outdoor landscape/music event.

Eastern Europe

In all Communist countries, the espousal of any radical new art form is likely to be construed as a political action. Used to what Marcuse calls the 'repressive tolerance' of the West, we find it hard to see the amount of daring implied in presenting anything as radical as happenings.[22]

During the brief period of artistic freedom which ended in 1968, Czechoslovakia was the most active of Eastern European countries in this area. Just how serious this activity can be is seen from the *Black Happening* of the poet Josef Honys (1919–69), who arranged a fake funeral for himself as a 'Mystification Event', invited his friends, and then in fact committed suicide unknown to the friends.[23]

Milan Knížák, undoubtedly the best-known Czech maker of happenings, has been recently (1973) imprisoned for his allegedly 'anti-revolutionary' attitude by the present régime.[24] His work has included 'A Short Carting Exhibition', in which he and friends collected urban rubbish and made it into assemblages on the streets (1963); *An Individual Demonstration* (1964); *A Demonstration for All the Senses* (1964), which involved other members of the group Art of the Actual; and *Soldiers' Game* (Prague, 1965), a mock-battle in wooded parkland.

128

Sona Seclova, another member of the group, has written some un-performed demonstrations:

I am on a tram.
The tram is crowded with people.
I am smartly dressed, nicely coiffed and made up, so that I create the impression of being a lady.
After ten minutes, I suddenly ask the people standing near to me to please make room, I place a little white rag, about 5 centimetres square, on the ground and stand on it, after removing my shoes. From my luxurious beaded handbag I take shoe polish, a brush and a rag. I polish my shoes nicely and then put the equipment back into my handbag without saying a word, and proceed calmly to my destination. Or, if anyone asks me what I am doing, I politely offer the shoe-polishing materials.

Milan Grigor has presented visual poems as a stage-performance. In 1970, Robert Cyprich and Alex Mlynárčik presented *Gardens of a Contemplation* – people sweeping a street in Bratislava throughout the night – to honour the tenth anniversary of the New Realism (see Chapter Four). Mlynárčik had previously done a work involving 250 rubber fish floating in a lake, and a number of similar pieces. *Eva's Wedding* (1972) was a transformation of an ordinary wedding into a spectacular crowd-event based on Slovak peasant tradition. Another notable Czech maker of happenings is Evžen Bricsius, who was once prosecuted for using bread as part of one of his happenings.

100 IAN BREAKWELL
Episode in a Small Town Library 1970

101 MILAN KNÍŽÁK
An Individual Demonstration 1964

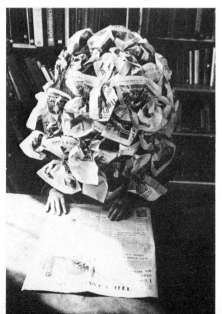

102 MOVEMENT COLLECTIVE *Improvisations* 1970

103 LEV NUSBERG *Plan for Kinetic Environment*
for the Seaside Area of Odessa 1970 ▶

The spread of 'earth art' has not missed Czechoslovakia: Peter Barkos made pieces involving snow in 1970, and Ladislas Novák has used trails of food laid for hens or ants to create environmental works. In Hungary, Gabor Attalai performed a public head-shaving piece, and Imre Bak, like Barkos, has used snow as a medium. In Yugoslavia, Braco-Slobodan Dimitjević presented a 'mind co-ordination' work in March 1971, involving simultaneous thought-transference by six hundred people in Belgrade, New York and Amsterdam. Slavko Bogdanović has, like some US artists, used the mail as part of conceptual works, and Grupa Ǝ are using radio-communication as a basis for their work. Less communication-oriented, Romanian artists like Paul Neagu (now resident in England) use traditional ideas in new ways: Neagu makes edible figures out of bread or cake, like giant gingerbread-men.

In Russia, a group centred on the artist Lev Nusberg, a collective called 'Movement', have been making a number of experimental environmental works. The feeling of these works, often a form of psychological theatre, is slightly Oriental, almost like a more abstracted version of the décor for the Ballets Russes, or the early work of Goncharova or Malevich. Nusberg staged a *Kinetic Action, Red and White* in 1965. The group, consisting of Galia Bitt, a girl dancer, Alexander Grigoriev, Tania Bistrova and Vova Grabenko, have designed an artificial environment for a children's toy village (1969), have made *Kinetic Colour/Music Settings*, and in 1970 made a happening called *Improvisations*, variations on traditional Indian and Beatle music. Nusberg has produced a major plan for a kinetic urban environment for the sea-side areas of Odessa (1970). This was approved by the Mayor of the city, and should be realized. The collective has already made other projects for urban environments, as well as theatre-pieces. In 1971, they collaborated on an environment for a film at the Mosfilm studios. It is heartening that some of the spirit of experiment that marked the Russian Revolution in 1917–23 seems to be reappearing, and that the spirit of Malevich and Tatlin is inspiring ambitious social projects. Nusberg and his fellow artists show no pro-Western tendencies, unlike a number of the new Russian poets. It would be encouraging to think they might escape the sort of counter-productive over-praise in the West that has been ruinous to writers like Pasternak and Solzhenitsyn, whose genuine desire to work for socialism has been consistently misinterpreted.

132

The Artist as Performer

The final aspect of the new tradition I want to examine is that of the artist becoming his own work of art, totally losing the usual boundaries between 'art' and 'life' and 'artist' and 'work'.

From the beginning of the Romantic movement it became clear that the artist's life, or legend, constituted some part of public reaction to his work; *vide* Byron or Gauguin. Van Gogh's severed ear may well be his best-known work as far as the mass of the public is concerned. In the new American art of the late 1940s and early 1950s, the artist's act of painting was the *subject* of the painting. *Art News*, the most influential magazine of the period, ran a regular stage-by-stage photo feature, 'So-and-so Paints a Picture'. The most radical innovator of them all, Jackson Pollock, said:

On the floor I am more at ease. I feel nearer, more a part of the painting, since this way I can work round it, work from four sides and literally be *in* the painting.[1]

In this context, it is not so much the end-products as the photographs – *106* or, even better, the films – of Pollock at work that are important. Wittingly or not, Pollock was an *actor*. Indeed, part of one's response to his pictures is a physical, kinetic 'following' of the artist's movements in painting it: hence the need to stand near to see them properly.

In France, a similar if less radical movement threw up one very conscious artist-performer: Georges Mathieu. Having carefully prepared a monochrome background, and wearing a special hood costume, Mathieu would then attack the canvas, mainly with paint squeezed from the tube directly, in a calligraphic way, often setting himself a deliberate time-limit to complete the work. The colours were heraldic, the titles often referring to historical events. In 1950 he presented *Night of Poetry* at the Théâtre Sarah Bernhardt in Paris, in which he executed an enormous painting, on stage, in twenty minutes. The following year he produced an event very like the old Surrealist exhibition-environments, *Ceremonies to Commemorate the Second Condemnation of Siger de Brabant*, which he called 'the most reactionary

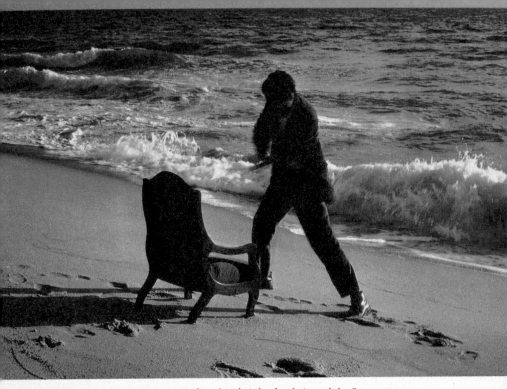

104 RALPH ORTIZ *Destruction of an Armchair by the Artist and the Sea* 1966

105 YVES KLEIN *The Vampire* 1960 ▶

134

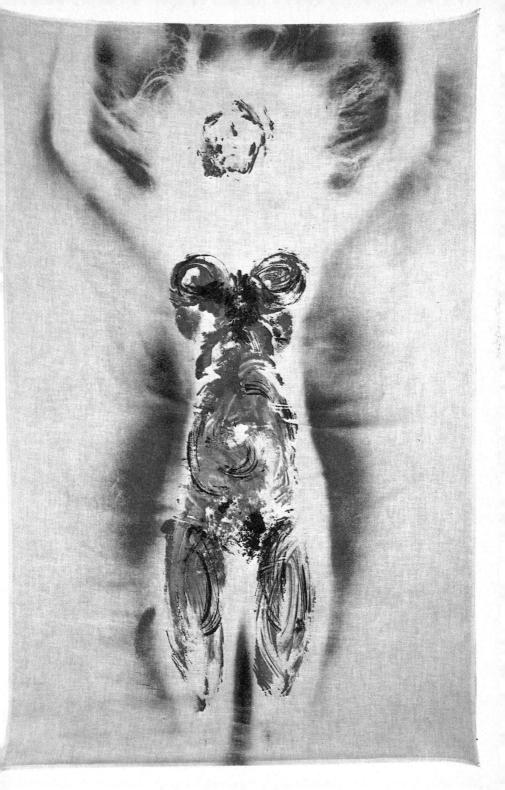

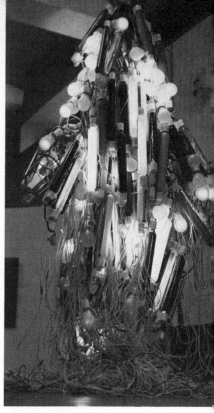

106 Jackson Pollock at work in his studio at Hampton, N.Y.

107 ATSUKO TANAKA
Light Costume 1956

in seven hundred years'. It was opened by an equipage of Rolls-Royces and went through a cycle of change every three days.[2]

In Japan, in the 1950s, the world-wide feeling for a 'non-formal' (*informel*) art was manifested in the Institute for Abstract Calligraphy and, of more interest here, in the work of the Gutai group. Gutai included Akira Kanayama, Sadamasa Motonaga, Shuso Mukai, Saburo Mirakami, Kazuo Shiraga, Atsuko Tanaka and Shozo Shinamoto. Kanayama made a four-hundred-foot-long work, *White Vinyl with Footprints*, which was shown in a park in Ashiya City in 1956. Toshiko Kinoshita showed a chemical-reaction painting in 1958, paralleling the work of Gustav Metzger in the West. The Gutai works
107 were primarily performances. Tanaka's light-bulb costumes were conceived for public appearances, Murikama's *Torn Paper Screen* was made publicly in 1956, and Shiraga was using his own body as a

136

medium and creating outdoor performance-pieces in 1955. Major 108 manifestations took place in 1957, 1958 and 1962. In 1960 Gutai produced a very beautiful and typically Japanese event: a Sky Festival. Large balloons bearing banners by the artists, and some invited foreigners like Lucio Fontana and Alfred Leslie, were released from the roof of a department-store in Osaka, recalling a similar piece by Yves Klein done in 1957.

This kind of artist-showmanship is a Japanese tradition. On the one hand, Han-Shan identifying himself with the mountain he lives on, and leaving poems to be found on trees and by waterfalls. On the other, Hokusai's self-publishing event of 1817: the creation of a huge painting on 2,250 square feet of paper, executed at great speed with vats of ink and brushes, which, when finally raised into position, was revealed as a sixty-foot-high portrait of the Japanese saint Daruma.

Yves Klein and New Realism

Perhaps the most startling image in this book: a suburban street of any 111 European town, quiet, leafy, a lone cyclist going out of the picture. A man is poised, frozen, in the act of leaping from a building. It is Nice, 1962; the man is Yves Klein. Klein, like Cage or Malevich, is a

108 KAZUO SHIRAGA *Making a Work with His Own Body* 1955

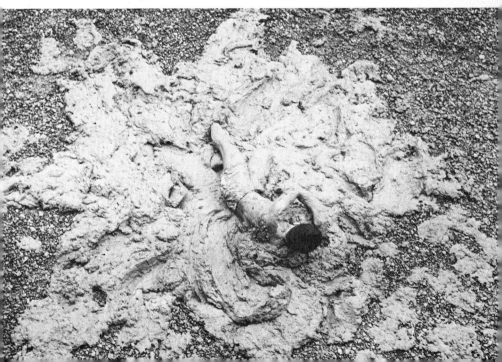

109 DANIEL SPOERRI *Cannibal Dinner* 1970

138

110 PETER KUTTNER *Edible Rainbow* 1971

completely radical innovator: like Cage, he has often not been taken seriously, even by other artists. In the picture he is shown making one of his *sauts dans le vide*, a physical exploration of space, 'the Void', at the risk of injury or even death.

Klein was a man of paradoxes. Typically French: the major themes of his work – *le vide, l'immatériel, anthropométries* – are the sort of abstract nouns that sound pretentious or meaningless in English. And yet he was perhaps the only Occidental artist to really come to terms with Oriental art. Mystical, yet working with physical realities, he was a purist and a poet with an equal flair for showmanship and publicity. Born in Nice in 1928, of artist parents, he studied, among other things, Oriental languages. He worked as a librarian, as a horse-trainer in Ireland, and in a jazz-band. Most important, he studied Judo. Later, he travelled round the world twice, received a Black Belt (fourth Dan) in Tokyo, set up a Spanish Judo Federation in 1964, and wrote a textbook on Judo in France.[3] In Nice in 1946 he had been friends with the young painter Arman and the poet Claude Pascal, and had made his first 'monochrome' paintings, experimenting with printing his own hands and feet or the shapes of various plants on his paintings, and even on his clothes. In the mature monochrome paintings the colour is everything. Plain blue canvases, deep, vibrant, endless: each particle of pigment seems to glow with intensity. This unique shade of blue he called IKB (International Klein Blue). Some of his monochromes were pink, some gold, some yellow.

It is Klein's mode of work that interests us here, rather than the very beautiful end-products. He made paintings using a flame-thrower and exhibited walls of blue Bengal-matches or blue gas-jets. In 1957 he made an 'aerostatic sculpture', a thousand blue balloons released into the sky. *The Wind of Travel* of 1960 was a newly painted canvas exposed to the action of the wind on the roof of his car on a fast drive between Paris and Nice; *Cosmogeny of Rain* of the same year was made by the action of raindrops on pigment, later to be fixed permanently. Almost the only other material he used in painting was sponges. Made rigid with plastic resin and dipped in IKB, 2,800 of them are massed to form his giant mural for the theatre at Gelsenkirchen in Germany (1959).

His best-known, or most notorious, pieces are the *Anthropometries*, paintings made by 'human brushes'. The artist used the naked bodies of girls as the object, not the subject, of his painting. They dipped

112

105, 116

140

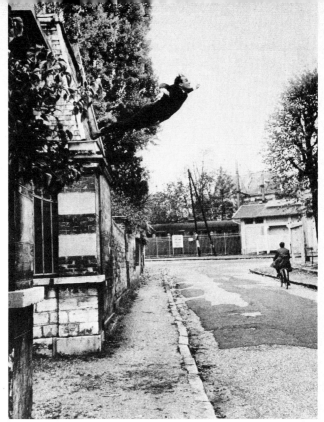

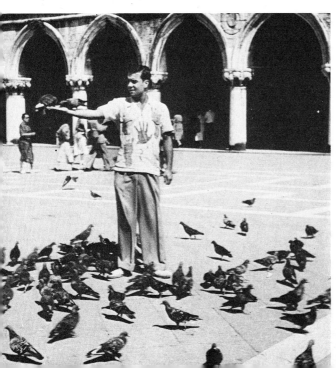

112 Klein wearing a shirt
designed by himself, Venice
1947

141

113 WOLF VOSTELL
You: Diagram 1964

114 WOLF VOSTELL
You 1964

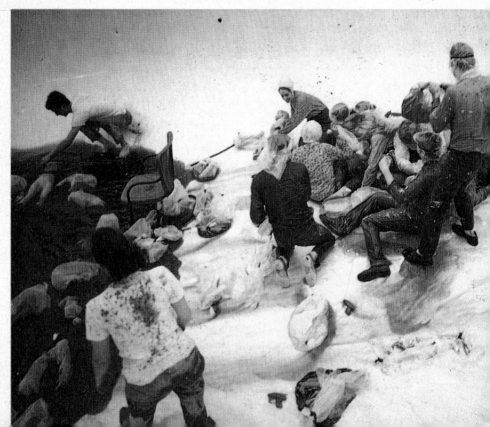

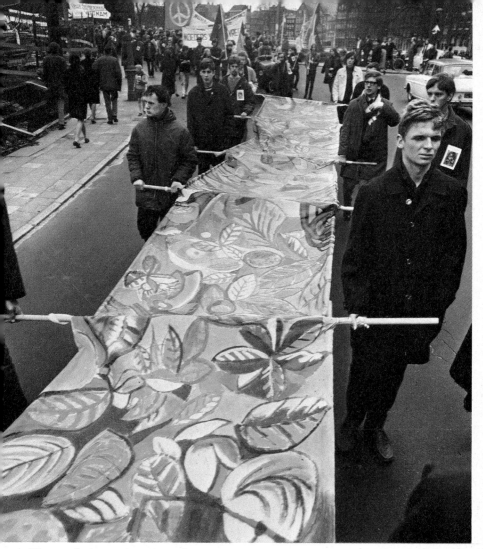

115 Vietnam demonstration, Amsterdam 1970

themselves in paint and printed themselves on to the canvas at the artist's direction. He even contrived to be included in the film *Mondo Cane* doing a full-dress anthropometry performance accompanied by one of his own *Monotone Symphonies*. Despite his inclusion in this macabre and sensational film, there is little hint of violence in his work; these paintings are often startlingly erotic, but not violent at all. Indeed, he apparently once got a model to print herself in blood on a canvas and then couldn't sleep and had to destroy the work.

His other major works are gestures or concepts rather than 'works'. In 1958 he presented *The Void* at the Galerie Iris Clert. A newly whitened gallery was emptied, then filled with the Void. Should someone wish to purchase some of the Void there was a symbolic transfer; the imagined work was exchanged for a certain amount of gold, which was then ritually disposed of by, for instance, dropping it into the Seine. A more effective critique of the whole 'painting-as-investment' syndrome than many polemics. To publicize this event, invitations were sent out through the mails with plain blue stamps on. This provoked further scandal, since the French post office objected strongly to this illegal use of the mail. In 1960 he presented the World to Itself as the ultimate theatrical spectacle. *Yves Klein presents . . .* (Sunday, 27 November 1960) was a mock-up of a popular French Sunday paper, in which Klein presented himself, the Void, his ideas.

Klein died of a heart-attack in 1962. His concept of an 'immaterial architecture' will perhaps, ultimately, be his most enduring work: cities roofed and walled with columns of air, water or fire.

His major immediate influence was the formation of the New Realism group in October 1960. With the critic Pierre Restany as major theorist, the group consisted of Arman, Martial Raysse (both also from Nice), Daniel Spoerri, Raymond Hains, Jacques de la Villeglé and François Dufresne. Later the sculptor César was added. A sort of neo-Dada, the New Realism was not so much pictorial as literal. César exhibited *Compressions*: a particular make of car crushed into a cube. Arman made a long series of *Accumulations* – dozens of one kind of object (spectacles, paint-tubes, bottle-tops) encased in a box or block of transparent plastic – and *Angers*, fragments of smashed or sawn-up objects carefully fastened down on to canvases. Spoerri lovingly preserved the remains of meals on the original table-top.

Spoerri has already been mentioned in other contexts.[4] Born in Romania, he is a truly international and truly 'intermedia' figure.

116 YVES KLEIN
Anthropometry ANT 49 1960

117 YVES KLEIN
Painting Ceremony

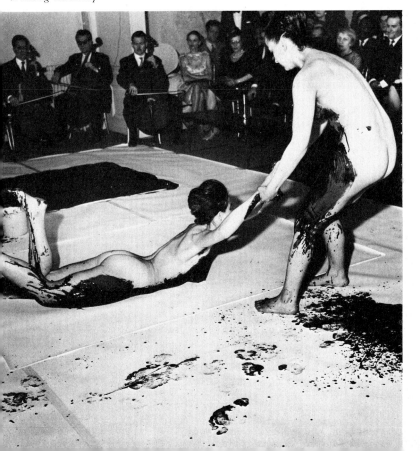

Originally a dancer, he moved to Paris where he worked on concrete poetry in 1954, founded Editions M A T, an enterprise for making multiples, and was best known in the early 1960s for his *Trap Paintings*, in which the remains of a meal, or the debris of his workbench, were fixed to the table-top and exhibited, hung vertically, as a painting. While working in Paris, he became interested in the idea of cooking as an art form and presented several evenings in which a gallery was transformed into a restaurant. In 1961 he exhibited *Bread*, loaves baked with sharp or otherwise undesirable objects in them, and he has more recently made works with bread baked inside such objects as a type-writer and a pair of shoes. Some of his pieces have been made with the collaboration of rats, being left in the gallery cellars until the edible parts have been largely eaten away. In 1970, after moving to Düssel-dorf, he set up the *Restaurant Spoerri*, the walls covered with his correspondence of the last ten years, and hung with some of his earlier works, and the Eat Art Gallery, which has commissioned edible art-works by such people as Richard Lindner, Diter Rot and Joseph Beuys. Spoerri still writes, makes paintings, does collaborations with various friends, and typifies the best of the New Realist outlook: a new realism in the use of 'real' materials, and a constant dissolution of the boundaries between art and everyday life.

118

146

Joseph Beuys and Zero

Of all the artists in this book, Joseph Beuys is the most difficult to characterize, because his work forms a continuous investigation and synthesis of a whole range of material and spiritual phenomena.[5] His activity partakes of the character of both high priest and research scientist. Furthermore, Beuys is quintessentially German, even more so than Klein was French, and there is something in both his work and his words that is often untranslatable and inexpressible. For instance, his use of the word *Plastik* to denote all creative activity has no useful equivalent in English: 'plastic' has too many overtones of Woolworth's, 'sculpture' too many of the museum.

Like Klein, Beuys seems a total original, uninfluenced by others. He has hardly travelled or lived abroad. He studied at Düsseldorf Academy with the sculptor Ewald Mataré, then took a teaching post at the same Academy in 1961, which he retained until a political crisis forced his resignation in 1972.

Since Wilhelm Worringer published *Form in Gothic*, German artists have been increasingly aware of a sense of rediscovery of their true heritage, of a renewal of an older, pre-Renaissance tradition, Northern rather than Southern: what Herbert Read called 'the spirit of great forests'. Through all Beuys's work there runs a strain of what he and his interpreters are forced to call the 'transcendental'. This is what distinguishes him from superficially similar artists working today: his work is not a demonstration of the nature of materials or processes but their use to express certain fundamental philosophical premises. Many of his 'actions' and objects involve the use of humble materials, of the sort that have become increasingly popular with sculptors in the last few years: felt, fat or earth. But Beuys uses them as part of a system of balances of energies and potentials, not simply as an extension of the sculptor's normal materials.

Beuys was born in Kleve, Germany, in 1921. After the war he studied natural sciences, became interested in biology, but gradually rejected its 'atomistic' methods of interpretation in favour of 'plastic' demonstration. He owes something to the development of cybernetics, the study of natural and artifical systems (i.e. events in sequence); his objects and actions are 'models' for certain physical principles. Cybernetics, however, is limited to the physical; Beuys's pieces involve metaphysical entities, too. It must be noted that the area of the

119 JOSEPH BEUYS *Fat-corner* 1963

Rhineland he comes from has traditionally been a home for extreme forms of mysticism. The intimate bond of man, nature and animal in the sympathetic magic of pre-Christian religions, and the transubstantiation of bread and wine into flesh and blood, the central fact of Christian religion, are as near to the centre of his works as the discoveries of Planck and Einstein. The fat-corner – *Fettecke* – that recurs so often in his work, is a crucial concept. The fat equals energy, an inert mass capable of infinite manipulation. The corner, a meeting of angles and straight lines, is capable of different levels of symbolic interpretation. One of the best-known fat-corners was the one he made in 1953 in the angle between the back and the seat of a chair. The resulting work was then hung at different levels above the floor. These pieces, however, are signs rather than symbols: total, non-verbal reductions of facts of experience. A bone conceals a tiny radio where the marrow should be (*Radio*, 1961): one form of energy replaced with another, perhaps. A C-shaped sign, suggesting a blood-sausage, or an oxbow lake, or electric terminals, is drawn on a blackboard placed, apparently carelessly, on the floor across a snaking electric cable (*Scottish Symphony*, 1970). Or the artist himself lies wrapped in a roll of felt, at each end of the roll a dead hare. A cable runs out from the roll to a loudspeaker where strange, guttural sounds emerge intermittently from the artist within (*Chief-Fluxus-Song*, 1964). These are simply images to add to other images, forming a new, non-Aristotelian description of natural processes.

148

119

122

One important aspect of Beuys's extraordinary personality is his transcendence of his own physical limitations. A Stuka pilot during the war, he fought on the Russian Front, and when his plane crashed he was trapped, badly injured, in the wreckage for several days, in freezing weather. Despite the permanent damage from these injuries, he persists (rather like Klein) in involving himself in extreme acts of physical endurance. In the action *Twenty-Four Hours* of 1965 he stood *120* or knelt on a white box for twenty-four hours, performing a complex series of actions involving objects placed at full stretch from him.[6] He had prepared himself for this work by fasting for several days. At the climax of his *Scottish ·Symphony* he stood motionless for over an hour. *122* As with Klein, it seems necessary to Beuys to push himself to extreme physical limits, to test his own endurance.

Beuys's life and work (indivisible, like those of Klein) involve endless apparent contradictions. Deliberately shunning exhibitions and museum shows, he was an enthusiastic member of the radical German/American group Fluxus. Apparently remote from any kind of gallery contract that guarantees the delivery of so many handmade works per year, he has yet found two sympathetic patrons who will buy virtually

120 JOSEPH BEUYS
Twenty-Four Hours 1965

everything he produces. Apparently remote from the cult of personality that surrounds a figure like Warhol, he nevertheless creates a deliberate *persona* in much the same way. The trilby hat, ammunition-jacket, waistcoat, jeans and hunter's boots are components of a costume he carefully duplicates and replaces, as well known now in Germany as the Beatles' uniform of mop-cut and collarless jacket once was.

Since Beuys abandoned science as a mode of inquiry in the early 1950s, he has successfully used and discarded various artistic processes. Drawing was originally his major activity. His drawings are strange, diagrammatic, like scribbled corners of a Leonardo sketch-book. There is an affinity with Celtic ornament, *sgraffito* cave-drawings: girls and skeletons, reindeer and mountain streams mingle with abstract diagrams like lines of force. From drawings, he moved on to making objects, at once crude and delicate: two bones linked together to form a movable reclining woman; piles of cut felt crowned with a steel plate; a caked paintbrush attached to a tiny thread. Increasingly these objects were incorporated in, or made during, his various actions. Thus in *Vacuum/Mass, Mass/Vacuum* (1968) he arranged a roomful of bicycle pumps wrapped in fat. In the action, the air was expelled loudly from each pump, then the pumps were placed, together with an extra thirty-five pounds of fat, in a T-shaped steel box on which Beuys welded a lid. This T-shape, a tau cross, is one of the most frequent images in his actions, a symbolic meeting of lines of force as well as a religious symbol.[7] His later drawings are more and more like an experimental scientist's notebook.

Without appearing to court controversy, Beuys has regularly been at the centre of it. His teaching methods, his desire to work across the barriers of media, his acceptance of students from other disciplines, have caused friction with academic authorities. He was once punched on the nose by an outraged spectator at one of his actions. He carried on, blood streaming down his face. He said recently that teaching is his supreme work, that he will make less and less actions because he feels no desire to repeat himself. And yet, in a piece of 1964, he produced, in public, a large, crudely lettered board proclaiming THE SILENCE OF MARCEL DUCHAMP IS OVERRATED. Some images from his other major actions: in *How to Explain Pictures to a Dead Hare* (1963), Beuys sat, his face greased then covered with gold-leaf, gently talking to a dead hare cradled in his arms. He said in an interview that he

121

121 JOSEPH BEUYS *How to Explain Pictures to a Dead Hare* 1965

thought the hare would understand pictures better than people. Hares appear in other actions, *Eurasia* and *Twenty-Four Hours*, where a dead hare lay beside one made with a jelly-mould. Beuys often refers to himself as 'Chief of the Reindeer' or 'Chief of the Animals', but also sometimes as 'Chief of the Hunters'. A white horse, spotlit in a darkened room, was the central image of *Iphigenia* (1969), and a white horse appeared in the 'Moor' section of the film he made for *Scottish Symphony*. *Manresa,* in 1968, was notable for having an explicit religious title. Vertical props of all kinds, including the familiar T-shaped half-cross, leaning against the wall and completed with a chalk line, were major elements in *Eurasianstaff,* of 1967.

Scottish Symphony (or *Celtic*), performed in Edinburgh in 1970, was, in many ways, his most complex action.[8] This work, like many of his recent pieces, was a collaboration with the composer Henning Christiansen. It included tapes by Christiansen, some film of earlier actions, and a special film made on Rannoch Moor, part of which showed Beuys's hand squeezing first a lump of fat, then a lump of plasma, against the bleak background of the moor. He used a gnarled

122

151

122 JOSEPH BEUYS *Scottish Symphony (Celtic)* 1970

stick as a prop/pointer throughout the piece (perhaps an echo of Harry Lauder?). He had asked Richard Demarco to arrange for a piano to be taken to the gallery and tuned. On the morning of the action, a piano-tuner arrived and tuned the piano, which was never played during the piece. Only some days later did Demarco realize that the tuning had been the real beginning of the piece. At the climax of the action, having very slowly and methodically covered the walls of the room with tiny gobbets of plasma, and as meticulously collected them again, Beuys emptied the boards with them on over his head in one convulsive movement.

One of his most controversial actions was his founding of the German Student Party in 1967. Typically, this was both radical and non-aligned, a stance that has attracted some criticism both in the highly charged political atmosphere of West Germany and elsewhere.[9] Invited to do an action at the Tate Gallery in London in 1972, Beuys spent a day explaining his political philosophy. In contrast to the cryptic silences of his Edinburgh event, the London one was all talk. Oddly vague in detail, and using an idiosyncratic language of his own, he appeared to advocate a sort of idealized, Utopian socialism.

Beuys certainly possesses an extraordinary charisma, simultaneously shunning the art press and courted by it. Equally, his whole life is an art-work, of which the actions and objects are only the islands that show above the surface. This is well shown in a recent unpublished interview with the young British artist Rob Con.[10] Beuys talks about working with bees in his studio:

152

When I make warm this bee wax they come Zzzz Zzzz a lot . . . when I leave the doors open I have had millions in but in other years . . . I have had only ten.

About his domestic life, liking to eat eggs with a silver spoon:

In egg there is sulphur, and silver making the reaction, silver becomes black. The reaction between yellow of the egg and silver gives black, and a special taste a bit, and I like it, this reaction.

or his prowess as a cook:

I think about ten years ago I got many invitations for cooking from different places. . . . I don't do this any more, only at my home.

(We might remember here that hare and venison are as important to the German gourmet as to the hunter.)

Beuys's major piece in the 1970 Edinburgh Festival's Düsseldorf exhibition 'Strategy: Get Arts' was *The Pack*, 1969, a grey VW minibus with Beuys's familiar tau crosses painted on the side. From the open rear doors, a host of little wooden sledges tumbled down a ramp and along a corridor, not moving but with an extraordinary feeling of animation. Each sledge carried a roll of felt, a lump of fat and a small headlight. *123*

123 JOSEPH BEUYS
The Pack 1969

Beuys has constantly asserted that the power of the artist is to *create* truth, not simply reveal it as the priest or scientist does. His work may be summed up in the title he gave one of his rare exhibitions: 'Creator of Truth = Man'.

Klein and Beuys may well prove to be the two most influential European artists of the post-war period. Both have sought transcendental aims; both been influenced by certain religious practices. Both have used their whole life-style as a complete work of art; both have tested their devotion to this principle through a series of alarming physical ordeals. Both embody extreme aspects of their respective national characters; both have the sort of charismatic quality that creates a 'school' of other artists.

It would be impossible to discuss Beuys in a vacuum. Düsseldorf at the beginning of the 1970s became the centre (apart from New York) of the avant-garde world – as unlikely a place for this as Birmingham or Detroit. The presence and teaching of Beuys is a major factor, as is the enthusiasm of gallery-owners and the emergence of a new breed of patron willing to support the latest experimental art rather than make investment purchases of Impressionists or Old Masters. Post-war Germany has always shown a willingness to co-operate with new and progressive artists. Yves Klein also found his most sympathetic audience in Germany, and the Gruppe Zero in Düsseldorf were particularly affected by him, as in their *Void of Meditative Expansion*, a street painted entirely white (1961). Zero lasted from 1957 to 1967, and its members have now been drawn into the wider circle of artists working in Düsseldorf, artists like Robert Filiou, George Brecht and Diter Rot from the Fluxus group (see p. 160), members of New Realism like Daniel Spoerri, the composers Maurice Kagel and Henning Christiansen, and the young English artist and film-maker Tony Morgan, as well as pupils of Beuys like Palermo and Reiner Ruthenbeck. At 'Strategy: Get Arts' (the title a palindrome by the poet-artist André Thomkins) in 1970, the world at large was shown for the first time the extraordinary array of talent now working in Düsseldorf.[11] Günther Weseler showed a roomful of disturbing objects; a laid trestle-table and chairs, in the earthenware bowls on the table little pancakes of fur that rippled occasionally; a child's cot containing a huge heap of fur that would occasionally leap up convulsively, then slowly subside groaning; fur things twitching in cages. The abstractionist Adolf Luther showed one of his light-and-mirror

126

154

4 KLAUS RINKE
Water Sculpture
70

5 STEFAN WEWERKE
Chair-Piece
70

6 ADOLF LUTHER
Smoke and Light Sculpture
70

127 FERDINAND KRIWET *Apollo America* 1970

109 pieces. Spoerri made a special opening banquet, one course consisting
of phalluses made from bananas, hard-boiled eggs and salmon
125 mousse called *Banana Fishpricks*. Stefan Wewerke made a *Chair-Piece*
124 up the main staircase. Klaus Rinke, interested like Beuys in the energy
sources in natural materials, particularly water, devised a powerful
water-cannon which shot across the main entrance, causing visitors to
sidle nervously past it. Günther Uecker contributed a beautiful and
poetic work, a big studio door which banged constantly, affording
brief glimpses of a darkened studio inside, tantalizing as a miniskirt.
Ferdinand Kriwet is a poet who works on an environmental scale. He
has made a number of black-and-white environments consisting of a
repeated work or phrase printed on plastic sheets, like *WALK/TALK*
(Edinburgh 1970), and has also made a room-sized film-and-slide
127 projection environment, *Apollo America*.[12] Another member of Zero,
Otto Piene, must be mentioned for the *Light Ballets* he made first in
1959 and has presented in different versions since.

Fluxus and the Event

There seems to be a separate tradition from the happening, stemming
directly from John Cage's music-pieces, that can be traced back to
common origins in the late 1950s. There is a definite distinction be-
tween these post-Cage actions (usually called 'events' or 'pieces') and

happenings proper. On the one hand chance-generated, random-performed pieces, on the other tightly programmed (at least in the early years) environmental works, generally of much longer, and defined, duration. This is not to say that chance does not play some part in the creation of happenings, as with the opening of Grooms's *The Burning Building*, or that planning does not enter into a typical post-Cage event.

The 'monostructural event' became the standard activity of the Cage-influenced multi-media artists of the 1960s. Typically, these would involve mainly one performer (normally the composer), be of short duration, be performed under normal concert conditions, involve few or no environmental factors, and would take place as part of a concert of other similar 'events'.

In the field of music-events Cage's most radical follower is probably La Monte Young:

COMPOSITION 5

Turn a butterfly (or any number of butterflies) loose in the performance area.

When the composition is over, be sure to allow the butterfly to fly away outside.

The composition may be any length, but if an unlimited amount of time is available, the doors and windows may be opened – the composition may be considered finished when the butterfly flies away.

La Monte Young, 1960[13]

Young's more recent works, like *Dream House*, played in collaboration with Marian Zazeela, are long, ritual music-events consisting of electronic sound with live music played over a sustained note, and light-projections added: a hypnotic, timeless flow owing much to Oriental influence.

George Brecht had already reached many of the same conclusions as Cage about the use of chance from a study of Dada and the work of Pollock.[14] Some of his early performance-pieces involved 'kits' of objects given to the audience to make their own works with. The 'art-works' seen in his exhibitions generally consist of a similar collection of objects for potential use in an event. In 1963, he and Robert Watts held a 'Yam Festival', in which small notations on cards were sent to a number of people through the mail over a given period. Typical Brecht pieces:

Write the word EXHIBIT on each of 5 small cards.
Set each card in a place distant from the others.

EXERCISE
Determine the centre of an object or event.
Determine the centre more accurately.
Repeat, until further inaccuracy is impossible.

It will merely be necessary to note how often the phrase 'Something Else Press' recurs in the notes to this book to see the importance of only one area of Dick Higgins's activities, which is publishing and publicizing what he himself calls 'intermedia'.[15] He operates mainly within the area of dance and music; his *Danger Music* works are brief instruction-pieces like those of Young or Brecht. Those in the *Graphis* series *128* are visually generated, performed as theatre-pieces. *Graphis 82* is a typical example: the original plan was made by drawing round the

Lining
Linen
Locksmith
Macaroni
Losing money
Locks
Locusts
Lungs
Lodging house
Lodging
Lute
Lover
Loadstone
Looking-glass
Lynx
Louse
Lizard

128 DICK HIGGINS
*Graphis 82: Diagram
from Jefferson's Birthday
and Postface* 1962

129 DICK HIGGINS *Graphis 82* 1962 130 ALISON KNOWLES *The Big Book* 1967

outlines of some scissors in different positions. The words were obtained, all from one book, by taking successive words beginning with the same letter. They were added to the *Graphis*. Some time later a blow-up was made on a twenty by twenty-four foot black *129* polythene sheet which was laid on the floor of a performance-area, actors following the lines, and reacting as they thought suitable at particular words.[16] Higgins's wife, Alison Knowles, is similarly involved with 'intermedia' activities. Her major work so far has been *The Big Book* – eight feet high, with four foot wide pages: the contents *130* include a grass tunnel, a fan, a hotplate, a mattress, lights, cookies and silkscreen prints. She aims to make *The Big Big Book* – 'There'll be a real waterfall on Page 2, an elevator running up the edge of another page.'

FLUX ART – non art – amusement forgoes distinction between art and non-art forgoes artists' indispensability, exclusiveness, individuality, ambition, forgoes all pretension towards a significance, variety, inspiration, skill, complexity, profundity, greatness, institutional and commodity value. It strives for nonstructural, non-theatrical, nonbaroque, impersonal qualities of a simple, natural event, an object, a game, a puzzle or a gag. It is a fusion of Spike Jones, gags, games, Vaudeville, Cage and Duchamp.

159

This extract from a Fluxus manifesto by George Macunias characterizes exactly the activities of this radical German/American group. Apart from members already mentioned, like Spoerri, Young, Higgins, Beuys, it includes the poets Emmett Williams and Robert Filiou, who has recently founded Territory No. 2 of the Genial Republic in a farmhouse outside Nice, for research into genius and 'stupidology'. Ben Vautier (Ben), from Nice, is a completely unclassifiable artist who sees himself as the subject-matter of his own pieces, often exhibiting himself for a week at a time with a placard announcing that, for instance, the artist will eat an egg at a particular time daily. Musician members include Joe Jones, Tomás Schmidt, Benjamin Patterson – who wrote a piano-piece in which a piano was whitewashed on stage – and the versatile Korean artist Nam June Paik, who lives in Cologne and works in both Germany and America.

The author of a number of often violent music-events, Paik has made a series of robot figures, such as *Robot K456 with 20-channel Radio Control and 10-Channel Data Recorder* (1965), a figure with a skeletal framework, breasts, and moving arms and legs. He has also made some very beautiful word/performance pieces:

> The First Swallow you meet next Spring
> – that is my first performance.
>
> In autumn – the raindrops in the puddle.
>
> On a very cold winter morning
> follow the trace of the fox-brush
> in the snow (Thoreau)
>
> from *Do It Yourself*, 1961–62

Macunias himself makes music-generated performance-pieces, like *Piano Piece No. 13*, in which each key of the piano is nailed down, starting with the lowest notes and finishing with the highest. He has further defined Fluxus as 'mixed-media neo-baroque theatre' and 'monomorphic neo-haiku flux-events'. Fluxus concerts nevertheless consist of a number of disparate events rather than an all-embracing environmental whole, and relate more closely to Dada (a similarly loose title) and its espousal of chance, than the much more tightly structured happenings of the New York school.[17] Fluxus made an impression on a number of young English artists at the time of the 1962 'Festival of Misfits'. Robin Page – one of whose music-events for this entailed kicking a guitar out of the concert-room and around a

city block and back, wearing a silver helmet and followed by the audience – was from Canada but settled for a time in England, where he achieved some notoriety for pieces like *Shouting a Plant to Death*, before finally settling in Düsseldorf. Anthony Scott presents performances under the generic title of *SWIZZ*, and is engaged on making *The Longest, Most Meaningless Movie in the World*. John Cage's chief follower in England is Cornelius Cardew, who has recently founded the Scratch Orchestra, a loose-knit group of composers, musicians and performers who perform free-form, chance-generated works, often in specially contrived environments.[18]

The New Dance and Body Art

Robert Rauschenberg's major activity as a painter is not within the scope of this book. He has, however, made a number of important contributions to the 'new dance', and been involved with several multi-media demonstrations. Rauschenberg was a participant in John Cage's 1952 Black Mountain event, and since then has maintained a connection with most progressive elements in American music and dance, particularly in his involvement from 1955 to 1964 with Merce Cunningham's troupe. In 1963 he presented *Pelican*, a dance-piece with Alex Hay, involving performers wearing parachutes and roller-skates, and at the 'New York Theater Rally' of 1965 he did a one-man piece, *Spring Training*. In this he appeared in a white dinner-

131 jacket with strings like guitar-strings down the front. A bucket was hung round his neck on a strap. Boiling water was poured from a kettle into the bucket which contained dry ice. The artist strummed the strings on the jacket to the music of a Hawaiian guitar record. He also made important contributions, both as performer and director, to the 'Evenings in Art and Technology'.

Perhaps the most important names in the new developments in dance are Jill Johnston, Yvonne Rainer and Ann Halprin. Halprin's workshop in San Francisco in 1960 had Rainer, Robert Morris, La Monte Young, Terry Riley and others as members. Robert Dunn's composition class in New York in 1961 seems to have been as influential as was Cage's in 1958.

Out of this has emerged a preoccupation with using the human body as the subject of the dance, or with the simple physical manipulation of objects. Yvonne Rainer's *Continuous Project Altered Daily* of 1970 generated The Grand Union, a sort of dance supergroup. Trisha Brown, a member of this, has presented a number of 'Equipment Dances' – like *Man Walking Down the Side of a Building* (1969) and *Walking on a Wall* (1970) – in which gravity-defying equipment is used. In *Rummage Sale and the Hanging Forest* (1971) the audience took part in a rummage sale while two dancers climbed in and out of various pieces of clothing suspended from a network of ropes above their heads. Elaine Summers, a dancer who has also been involved in happenings by Al Hansen and others, is best known for her film *Fantastic Gardens*. This, although basically a movie, involved unusual elements – multiple projectors, live actors in front of the screens, the use of reflected light from small mirrors held by members of the audience.

Very near in spirit to the new American landscape-artists are the landscape dance-pieces of Joan Jonas. One of these was a work done to be viewed from a cliff-top in Nova Scotia in 1971; and in *Delay Delay* (1972) she used a large demolished site near the docks in New York, an open, desolate area criss-crossed by disused roads, as the scene for a large-scale dance-landscape event.[19] Jonas has also used video, notably in *Organic Honey's Visual Telepathy* (1972).

Robert Morris, like Oldenburg, is too versatile an artist to pin down in one category. Some years ago, the critic Gene Swenson, in an exhibition called 'The Other Tradition', gathered together a number of works of modern art, both abstract and figurative, all of which

162

posed certain kinds of questions. Robert Morris has consistently used a variety of media to set problems, rather than present answers. His most famous early pieces – *Box with the Sound of its Own Making* of 1961, a wooden box containing a tape-loop of the artist sawing and polishing the components of the box; *37 Minutes 3879 Strokes*, a pencil-drawing of 1961; and an early dance-piece, *21'30"*, in which Morris mimed to a taped excerpt from Panofsky's *Studies in Iconography* for that length of time – all testify to his constant questioning of the relationship between art and reality. Morris has worked with Yvonne Rainer on a number of dance-pieces, as well as his own works like *Check* and *Site*. In this, wearing a rubber mask of his own face *132* made by Jasper Johns, Morris performed a sequence of physical manipulations of simple-shaped objects, at one point revealing Carolee Schneeman reclining against a white board in the pose of Manet's *Olympia* (an image also used by Joseph Beuys in *Twenty Four Hours*). Morris also took part (with Robert Rauschenberg, among others) in *Parts of Some Sextets*, a piece 'for ten people and twelve mattresses' by Yvonne Rainer, in 1965. All these pieces involve not only permutations of movement, sound, action, but also an exploring of the potential of the human body in relation to simple physical objects.[20]

Morris's subsequent 'Minimal' sculpture does not need describing

here: his works in steel, fibreglass, felt or combustible materials are notable for their relationship not only to their environment but also to the scale of the spectator.[21] Like a number of the new American artists, Morris writes extremely well, and has been a perceptive and radical critic of the new sculpture. In one recent piece, he marked a line across a field by riding a succession of horses across it. In his environment for a Tate Gallery exhibition in London, Morris returned to some of his dance preoccupations, except this time it was the objects that manipulated the people, not the people the objects: the ramps, giant cylinders, climbing-frames, provided a kinetic playground for the participants. He was instrumental in starting the Peripatetic Artist Guild, a means of by-passing the gallery situation by hiring the artist out at an hourly rate, like a workman, a project related to Ed Kienholz's concept tableaux.

134

133

As with landscape art, it was Morris, in his early dance-pieces, who pioneered this concentration on the artist's own body as a medium; this is a form of alienation in which the identity which is called in question is not that of an object (as with Christo's wrappings) but that of a human individual. Dennis Oppenheim makes pieces using his own body, and in *Energy Displacement: Approaching Theatricality* he organized a swimming-race for artists with theatre-tickets as a reward, numbered according to their placings. It is Vito Acconci who has made the most extensive use of the human body as an object or 'art-work'.[22] In *Rubbing Piece* of 1969 he sat in Max's Kansas City (a New York artists' hangout), rubbing his left forearm with a finger of his right hand until a sore was produced. He has made films of himself thrusting his hand as far down his throat as possible, and in *Step Piece* took thirty steps a minute on to a stool at 8 a.m. every day. His *Room Piece* of 1970 involved a daily transplant of his possessions to an art gallery, using whatever was there in his normal daily routine. In 1969 he did *Following Piece*, following a person selected at random as far as possible, as part of 'Street Works IV', a month-long series of events in New York.[23]

Two London-based artists, Gilbert and George, have carried their poker-faced *personae* as 'living sculptures' over into their entire professional and social life. Perhaps their best-known event was *Singing Sculptures*, in which the two artists, with their hands and faces gilded, mimed to a record of an old music-hall song ('Underneath the Arches') while standing on a plinth in a gallery. In their endeavour to make

164

135 CLAYTON BAILEY *Rubber Grub* 1966

themselves into works of art they reach a typically English compro-
mise: their work lies somewhere between the total commitment of
Beuys and the dandyism of Noël Coward.

The West Coast artists have, on the whole, been less involved in
body art than those in the East. Jim McReady had four girls in shiny
nylons walking back and forth along a three foot by nine foot carpet
to create *Sound Sculpture* at the Museum of Conceptual Art in San
Francisco in 1970: the sort of aural turn-on once tellingly used by
135 Harold Pinter in his TV play *The Lover*. The 'funk' artist Clayton
Bailey has made rubber masks and figures to be worn by himself or
others; and Bruce Nauman, in addition to larger environments such
as *Wind Room*, narrow corridors with strange lighting effects, and a
simultaneously projected four-wall film of rotating discs called
Spinning Spheres, has produced a number of films of himself distorting
his face, or other parts of his body, in as many ways as possible.
Nauman, in common with a number of young artists, makes increas-
ing use of not only film but videotape for these activities; video in the

166

next few years may well become as standard equipment for the artist as an easel and palette once were.

Destruction and Violence in Art

In 1956 the ICA in London put on 'A Study for an Exhibition of Violence in Contemporary Art', a preliminary survey of tendencies that culminated in the 'Destruction in Art Symposium' (DIAS), sponsored by the same institution in 1966. The most energetic and influential figure in this area is undoubtedly Gustav Metzger.[24] In *136* many ways akin to Beuys and Klein, Metzger has been largely ignored or misinterpreted by the English art world; he has nevertheless remained an important figure since the early 1960s.

A sheet of nylon, stretched against plate glass about 4½ feet high and 8 feet in length, was painted with nitric and/or hydrochloric acid. Duration of acid application about 20 minutes.[25]

He has made a number of public demonstrations of destructive processes, as well as being an energetic pamphleteer and theorist.

136 GUSTAV METZGER *Demonstration of Acid Nylon Technique* 1960

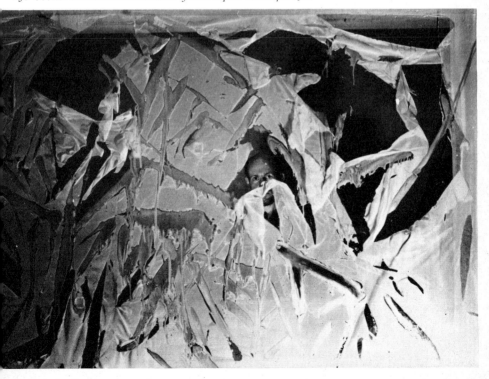

DIAS was a *succès de scandale*, with the appearance of groups like ZAJ from Spain and the Institute of Direct Art from Vienna. The latter group were the cause of the prosecution of two of the organizers, Metzger and John Sharkey, for presenting an 'obscene performance'. The English artist John Latham, who had regularly used the burning of books as part of his assemblages, demonstrated some of his 'skoob' towers, columns of one particular book containing fireworks being detonated. Latham, who put on a number of public performance-pieces, later achieved notoriety by being dismissed from a teaching position for 'distilling' a book by Clement Greenberg belonging to the college library. The book was returned as a neatly labelled jar of fluid. Recently he documented a car crash by exhibiting both the wreckage of the vehicle and a sequence of X-ray plates of his injuries. Ralph Ortiz, from America, was one of the most interesting artists to emerge at DIAS. His work is made from objects first destroyed by him, then subjected to various weathering processes, like immersion in the sea, the remains finally being made rigid with plastic resin.

Austria seems to have become the home of the most extreme forms of violence in art. There is a whole school of artists who are creating sadistic fantasies, notably Hermann Nitsch:

On 4 June 1962, I shall disembowel, tear and pull to pieces a dead lamb. This is a manifest action (an 'aesthetic' substitute for a sacrificial act), the sense and necessity of which will become clear after a study of the theory of the OM Theatre project.

Through my artistic production (a form of the mysticism of being), I take upon myself the apparent negative, unsavoury, perverse, obscene, the passion and the hysteria of the act of sacrifice so that YOU are spared the sullying, shaming descent into the extreme. I am the expression of all creation. I have merged into it and identified myself with it. All torment and lust, combined in a single state of unburdened intoxication, will pervade me and therefore YOU. The play-acting will be a means of gaining access to the most 'profound' and 'holy' symbols through blasphemy and dese-cration. The blasphemous anthropologically determined view of existence in which grail and phallus appear as two mutually necessary extremes.[26]

Nitsch has made actions with the most extreme sado-erotic images as part of his 'abreaction theatre' or OM Theatre. Blood, warm lymph, yolks of eggs, poured over the genitals of young boys; violent public disembowelling of carcasses; petals of roses cut to pieces with scalpels

and covered with warm blood. Nitsch has been arrested and tried for his work in both Austria and England.

Nitsch had conceived his OM Theatre idea in 1957, but his first public actions were in 1961. This was the culmination of a number of elements in post-war Viennese art: the 'action/destruction' paintings of Arnulf Rainer, first seen in 1948; the 'literary cabarets' of the Vienna Group of poets in 1957–59, neo-Dada evenings of sound-poems and action-pieces by H.G. Artmann, Gerhardt Ruhm and others; the films of Peter Kubelka and Ferry Radax.[27] The film-maker Kurt Kren has been an integral part of the Vienna Group's activities, collaborating with all the artists, in particular with Günter Brus. In 1967 he filmed a *Scheiss-Aktion* by Brus, involving a ritual public defecation by the artist. This anal-erotic theme recurs constantly in Brus's work. Some of his actions of the mid-1960s, in which his own body was distorted or apparently mutilated, anticipate the more recent interest of American artists like Vito Acconci in 'body art'. Brus's more violent and extreme fantasies are played out in *Irrwisch*, book of texts and drawings:[28] a man slicing a meat-loaf that is his own penis in aspic, elaborate sado-masochistic torture machines, usually with women as the degraded victims, and violently anti-clerical images, like Christ on the Cross excreting on the faces of the two Marys. Otto Mühl also uses his own body as the subject of his actions, submitting himself to all kinds of humiliations: in *Libi* (1969) an egg was broken into the vagina of a menstruating girl who was then positioned to allow the egg to drip into his mouth. The total rejection of taste involved in Vienna Group presentations is perhaps epitomized by the title of Mühl's event at the 'Kunstmarkt' show in Cologne in 1969: *The Death of Sharon Tate*.

The DIAS events, and more particularly the actions of the Vienna artists, pose a number of extreme questions: is, for example, a filmed orgy of coprophagy more defensible because made in the name of Art? The Surrealists revered the Marquis de Sade because his sexual fantasies were part of an assault on the whole Western system of ethics of his day. Is it too easy to imitate his fantasies now? What is certainly disquieting is that Germany and Austria are the homes of this violently sadistic art, only a generation after the Nazis had embodied Sade's worst fantasies more thoroughly than he could have imagined. Is the work of Mühl, Brus and Nitsch an elaborate act of self-abasement for the sins of their fathers, or merely an echo of the hideous Nazi ethos?

169

137 WOLF VOSTELL *Nein-9-Dé-collagen* 1963

Whether Nitsch and the others really shoulder our sins for us, act out for us our worst fantasies, or whether their work is merely self-indulgence, it is certain that their collective erotic fantasy is mainly homosexual. When women appear in their work they are used as props, always debased and humiliated. The only notable female artist of the Vienna Group, Valie Export, presents actions in which she greatly resembles the anonymous degraded heroine of *The Story of O*, wearing garments that deliberately reveal her genitalia or performing public acts of fellatio.

The use of violence is not always as brutally literal as it is in the work of the Viennese Group; a number of other artists, to whom violence is merely a part of their artistic stock-in-trade, have made a notable contribution to recent art.

Wolf Vostell, from Cologne, makes his various works under his own label, 'Décollage', a word which he found in a newspaper head-line, not only implying the opposite of collage but also a secondary sense (the take-off of an aeroplane). He has, like Nam June Paik, worked with TV sets adjusted to show distorted images, has made paintings out of torn posters, and has partly erased photographs. At the end of the 1950s he was working in Rome and Paris presenting one-man street works.[29] An early concept-work was a project to make

sculptures by fixing crashed cars permanently to the street in the place where they crashed, the resulting accumulated sculptures eventually bringing the traffic to a standstill. Later, in America, he arrived at a 'Festival of Happenings' in the cab of a mobile crane which carried a juke-box which kept playing throughout. At a suitable point the juke-box was dropped from a considerable height and smashed on the pavement. The plans for his various happenings include some of the most delicate and beautiful drawings being done today. Vostell's work has, nevertheless, a tendency towards the cathartic use of violence as a form of political allegory. In part of a German happening he arranged for a collision between a car and a railway train. In one of his works he even managed to involve the Luftwaffe. Vostell has recently moved more and more into the sphere of direct political-artistic action.

113, 114

137

In 1965, Niki de Saint-Phalle made a white environment that was not completed until the guests at the exhibition opening fired paint-bullets at it; another work is an altarpiece assemblage containing aerosol paint-cans which explode when shot at. Her husband, Jean

138

138 NIKI DE SAINT-PHALLE
Autel-tir 1962

Tinguely, is undoubtedly the most spectacular artist involved in these
139 destructive processes.[30] His huge self-destroying machine *Homage to
New York* of 1960 is well documented. An enormous ramshackle
construction involving weather-balloons, smoke-bombs and pianos
as well as tons of more conventional machinery, the piece slowly
pulled itself apart in the garden of the Museum of Modern Art in
New York in front of a bemused crowd of onlookers.

An even more spectacular piece was *Study for an End of the World
140–42 No. 2*, made in the Nevada desert in 1962. Tinguely's erratic machines
always require the intervention of the apparently fearless artist himself
at some point. Always playful, and gifted with a strong sense of
humour, he once covered a London audience for a lecture with yards

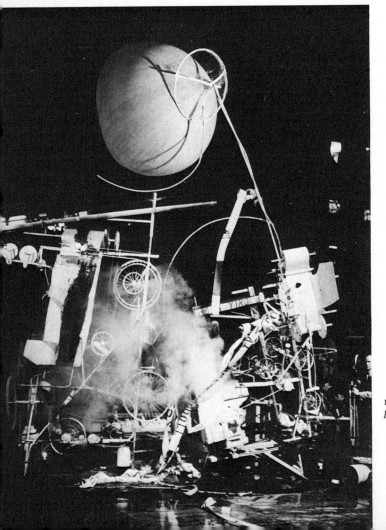

139 JEAN TINGUELY
Homage to New York 1960

140–42 JEAN TINGUELY *Study for an End of the World No. 2* 1962

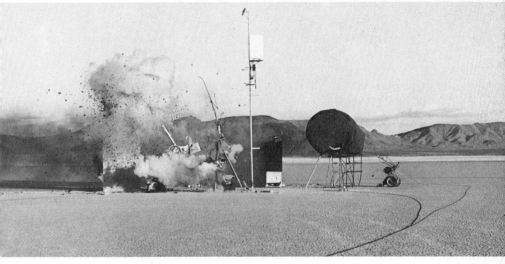

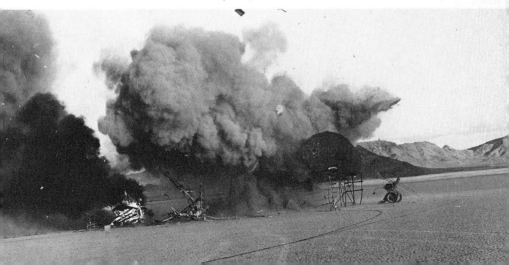

of machine-painted 'abstract expressionism'. After the early 1960s he gave up the destructive side of his work to concentrate on other areas of activity.

Perhaps humour, and the capacity to abstract from one's own instinctual processes, are what distinguishes Metzger, Vostell and Tinguely from the Vienna artists; with them, as with the paintings of Lucio Fontana, violence is used as part of an artistic process, rather than an end in itself.

Art and Politics

None of us feel like doing happenings again. The storming of the Pentagon is much more vital!

Ronald Hunt[31]

Art is what we do: culture is what is done to us.

Carl Andre[32]

Since the days of the Roman emperors, art has been used as an opiate for a politically subservient audience. Sometimes this has succeeded only too well; sometimes it has proved a two-edged weapon; and sometimes artists themselves have decided to move into the political arena. Environmental and performance works are, by nature, eminently well suited to this latter category.

In Chapter One I described some of the works made during the spell in which political and artistic revolution worked side by side in Russia. New discoveries about how art could be brought into the street were made, with outdoor stage-sets, Vertov's outdoor cinema-screens, and huge spectacles like the re-enactment of the storming of the Winter Palace, by Evreinger, Kugel and Petrov, in 1920. This last required a cruiser and cast of 6,000, and was watched by a crowd of about 100,000. Similarly, J. L. David organized mass street-spectacles during the French Revolution.

143 Allan Kaprow has pointed out the effectiveness of the Nuremberg Rallies as theatre, and certainly the rally organized by Albert Speer in 1934 must have been amazing visually: 130 searchlights were trained into the night sky, formed in a square, inside which ten lanes of standard-bearers were spotlit. The light-beams were visible to about 20,000 feet, and clouds occasionally drifted into them. Speer later said: 'I imagine that this "cathedral of light" was the first luminescent architecture of this type'; and the British Ambassador, Neville

143 ALBERT SPEER *Cathedral of Ice* 1934

Henderson, was reported to have described the event as 'both solemn and beautiful . . . like being in a Cathedral of Ice'.[33]

The ultimate in mass-spectacles are, of course, the enormous rallies held in China, in which thousands of pieces of coloured card held in the air form a patriotic message or a portrait of Chairman Mao.

In the West, perhaps the greatest public mixed-media events today are concerts of rock music. An event like the first Isle of Wight Festival is an interaction of hardware (amplification equipment by Watkins) and software (the stage-presence of, say, Robert Plant and Jimmy Page) in an open-air form of public ritual theatre. The horrible public murder by a motor-bike gang at the disastrous Altamont Festival far surpassed the worst spectacles conceived by the Vienna Group. Pop music, in one sense pure capitalism, has within it a kernel of revolutionary potential: this paradox is allied to another, that it is often most subversive when least intentionally political. The life-style and stage act of Mick Jagger is far more truly subversive than the often mawkish and naïve lyrics of the 'political' John Lennon songs.

The mixed-media content of rock festivals grew out of the private fantasies of Ken Kesey and his Merry Pranksters: 'It was more like he had a vision of the forest as a fantastic stage setting . . . in which every day would be a happening, an art form.'[34] Kesey's legendary bus-trip

175

across America in 1964, and the totally mixed-media *Acid Tests* of 1965 and *Trips Festivals* of 1966, finally became diluted and formalized in the 'group/light-show/concert' formula operated successfully for five years by Bill Graham in his Fillmores East and West, a venture copied with varying degrees of success elsewhere.[35] Certainly, the work of the best light-shows, like The Joshua's show for the rock opera *Tommy* (by The Who) at the Fillmore East in 1969, or Glenn McKay's work with Jefferson Airplane, and Mark Boyle's work in England, are an important contribution to the visual arts.

Los Angeles, home of so much of the bizarre, has recently given birth to two groups who include deliberate outrage as part of their act. Alice Cooper attempt to combine rock, theatre and satire. Les Cockettes, an extraordinary group of female-impersonators, have presented shows like *Elephant Shit – The Circus Life*, *Tinsel Tarts in a Hot Country* and *Tricia's Wedding* in both rock theatres and art galleries. Both have been influenced by Frank Zappa and his Mothers of Invention. Zappa, an important contemporary composer, uses humour, satire and shock as integral parts of his stage act.

Abbie Hoffman's concept of a 'theatre of confrontation' is important too: the 'Chicago Seven' trial was seen by the defendants as a spectacle for the mass media, a means of bringing their ideas to people via radio and T V: the political act as theatre-spectacle.

The New York Surrealist Group and the American Anarchist Group[36] provided the basis for Black Mask, a radical artistic/political group who produced some ten issues of a powerful broadsheet and a number of politico-artistic demonstrations, like attempting to close down the Museum of Modern Art, and changing the name of Wall Street:

WALL STREET IS WAR STREET!
The Traders in stocks and bonds shriek for New Frontiers – but the coffins return to the Bronx and Harlem. Bull Markets of murder deal in a stock exchange of death. Profits rise to the ticker tape of your dead sons. Poison gas RAINS on Vietnam. You cannot plead 'WE DID NOT KNOW'. Television brings the flaming villages into the safety of your homes. You commit genocide in the name of freedom.

BUT YOU TOO ARE THE VICTIMS!
If unemployment rises, you are given work, murderous work. If education is inferior, you are taught to kill. If the blacks get restless, they are sent to die. This is Wall Street's formula for the great society!

Led by Ben Morea and the poet Dan Georgiakis, Black Mask finally transformed themselves into a totally dedicated underground revolutionary group, Up Against the Wall Motherfuckers, a number of whose members have been imprisoned for their activities. This rejection of art for politics is also shown in the name of a new black poetry/music group who call themselves The Last Poets: the last poets before the revolution makes poets unnecessary.

In a more 'traditional' gallery way, there had been important work done by a group based on the Gertrude Stein and March Galleries. Sam Goodman and Boris Lurie made rough, deliberately crude *144* assemblage environments with a powerful politico-social content through the late 1950s and early 1960s, notably in Goodman's 'No Sculpture' at the Gertrude Stein Gallery in 1964, and the 'Vulgar Show', 'Involvement Show' and 'Doom Show' at the March Gallery between 1957 and 1962.[37]

On the West Coast, apart from the free street-theatre of the San Francisco Mime Troupe, the Diggers instituted a free shop, The Trip Without a Ticket, where people brought and took what they wanted, and which was thought of as a continuing theatre-piece. The Los Angeles Provos, notably Joseph Byrd, Michael Agnello and Peter Leaf, did a number of inventive social theatre-pieces, including a project for collecting unwanted possessions from poor areas of the city, and distributing them from a decorated lorry to the rich of the suburbs. A greasy, old-fashioned gas-stove from Watts lying on an

144 SAM GOODMAN
Psyche and Vanity 1960–61

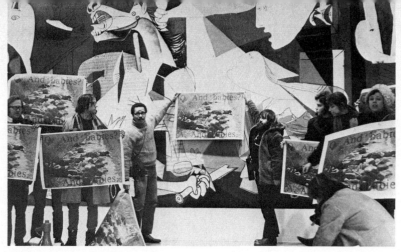

145 ART WORKERS' COALITION *Demonstration in front of Picasso's 'Guernica' with My Lai posters* 1969

immaculate lawn in Beverly Hills is a telling symbol of the inequality existing in the 'Sunshine State'.[38]

Most recently, a number of the most progressive artists in New York have got together to protest against cultural privilege (non-representation of black and women artists in museums, for instance) and political abuses (the Vietnam War, the Attica prison killings). The Art Workers' Coalition was established at a meeting on 10 April 1969 at the School of Visual Arts. They staged a sit-in and 'New York Art Strike' at the Metropolitan Museum of Art in May 1970, having already protested against the opening of museums on Vietnam 145 Moratorium Day, 1969, and mounted a protest against the Song My massacre in front of Picasso's *Guernica* at the Museum of Modern Art (Appendix 4). Many of the artists mentioned earlier, like Morris, Grosvenor, Haacke, Oppenheim and Andre, have demonstrated with the AWC, which continues to mount art-oriented protests.[39]

The militant wing of this movement, the Guerilla Art Action Group, consisting of Jean Toche, a Belgian artist 'in exile', and Jon Hendricks (both former members of the Destruction in Art movement), together with Poppy Johnson and others, have presented a number of highly imaginative artistic/political events. As well as being involved in the Song My demonstration, they have made demonstrations like the one in October 1969, at the opening of the 'New York Painting and Sculpture 1940–1970' exhibition. In this a trunk was delivered by

178

taxi to the steps of the Museum. A 'curator' in tails and an 'artist' appeared. The 'artist' was forced into the trunk and forcibly fed, and spattered, with milk, champagne, caviare, strawberry sherbet and other goodies. The public (wealthy patrons hurrying up the steps to the opening) were invited to crush eggs over him. The police and Museum security guards eventually intervened, whereupon the 'curator' insisted on delivering the 'package' containing the 'artist', now covered in a revolting sticky mess, to Henry Geldzahler, organizer of the exhibition.

Since then they have mounted a number of actions of a similar kind, in the streets and in museums, and in 1971 sent out a series of 'action letters' to various eminent politicians.[40] Toche and Hendricks were also instrumental in mounting 'The People's Flag Show', 1971, in which a number of artists used the American flag (illegally) as the basis of an art-work. The exhibition was closed, and Hendricks and Toche, together with Faith Ringold, a black woman artist, were charged with 'Flag Desecration'. The prosecution of the 'Judson Three', and the violence with which some recent G A A G demonstrations have been treated by museum guards (notably in January 1971

146

146 JAN VAN RAAY *Photo Collage* 1970

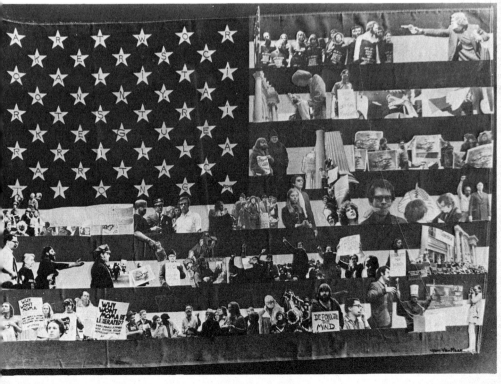

at the Museum of Modern Art), show how much the political and artistic establishment still fears the committed artist.

Many of the artists whose work I have mentioned earlier have moved into a directly political or social confrontation. The new interest in ecology was tellingly demonstrated by Gustav Metzger when, as a protest at the opening of an exhibition of kinetic art at the Hayward Gallery in London in 1970, he demonstrated his *MOBBILE*: a car with a PVC-covered box on top containing meat, fruit and flowers which had a tube from the car exhaust leading into it, so that the contents slowly became blackened and decomposed. (The American group Artists against Ecological Suicide have similarly exhibited sticky canvases which had been exposed to the air in seven cities and had slowly turned black.) Metzger, a leading figure in the International Coalition for the Liquidation of Art, attempted, with the help of his own An End to Art group, to close down the Tate Gallery in London on 20 October 1970. Metzger's example, however, has not been followed by others: what little protest-art there has been in England has been very mild compared with American or European events of the last few years.

Possibly the most conscious and successful use of the technique of the happening for political purposes was in the work of the Dutch Provo group. Growing out of the outdoor happenings of Robert Jasper Grootveld, their works developed in 1965 into a system of art-oriented protest against police repression.[41] The following year saw the full range of their activities: their long hair, white suits and out-rageous street-actions dominated Amsterdam. Their actions were not only a form of 'creative vandalism' but also made highly practical proposals, as for instance in their campaign against the motor-car. The *White Bicycles* scheme, a pilot for a proposed municipal distribution of twenty thousand public bicycles and provision of free public trans-port, and the *White Corpses* scheme, which would provide for the drivers of cars who had killed pedestrians to make white outline figures of the bodies of their victims on the road surface where they fell, were examples of this. They made constructive proposals for family planning (*White Wives*) and town-planning (*White Housing*). They also adopted the principles of the revolutionary Dutch architect Constant Nieuwenhuys. After winning a number of seats in muni-cipal elections in 1966, they disbanded in 1967. Other Dutch groups, such as the militant Women's Liberation group, Mad Minas, have

147

180

147 MAD MINAS *Demonstration in Amsterdam* 1970

used Provo street-theatre and happening techniques,[42] as have the Kabouter, the 'Gnomes' or 'Pixies', whose deliberately whimsical and playful approach covers a political determination equal to that of the Provo group, many of whose leading figures, like Roel Van Duyn, have joined the Kabouter Orange Free State.[43] The Provos and Kabouter have shown that art-based protest can move from a purely *115* negative position to a conscious participation in public planning and civic affairs.

In France in 1968 came the chance for artists to play a leading role in a radical popular uprising which seemed for a few weeks to have a real chance of succeeding. No artist had been in such a position since the artists of Berlin Dada and *Der Sturm* had worked for the uprising of 1919.

In November 1966, a revolutionary group led by the Situationists *148* had occupied the University of Strasbourg. They remained there for three weeks, the walls of the city being plastered with collaged comic-

148 SITUATIONIST GROUP *The Return of the Durutti Column* 1967

strips like *The Return of the Durutti Column.*[44] The repercussions of this event were enormous: from Berkeley to the Sorbonne students realized not only their own power but the possibility of a real *rapprochement* with the workers. The Situationists had begun as an artistic socio-political group, including the Danish painter Asger Jorn and other artists of the Cobra group, and produced studies like Guy Debord's work on the psycho-geography of cities, and a notable critique of the 'Spectacular Society'. By 1968, through a series of dramatic splits and expulsions, they had slowly moved to an extreme Anarcho-Communist stance:

The only *real* subversion is in a new consciousness and a new alliance – the location of the struggle in the banalities of everyday life, in the supermarket and the beatclubs *as well as* on the shopfloor. . . . Art and the Labour movement are dead! Long live the Situationist International!

149 What is important in this context about the events of May 1968 in Paris is that part of the inspiration came from the Situationists, that many of the demonstrations were deliberately conceived as street-

182

149 CITROËN WORKERS *Demonstration, Paris* 1968 ▶

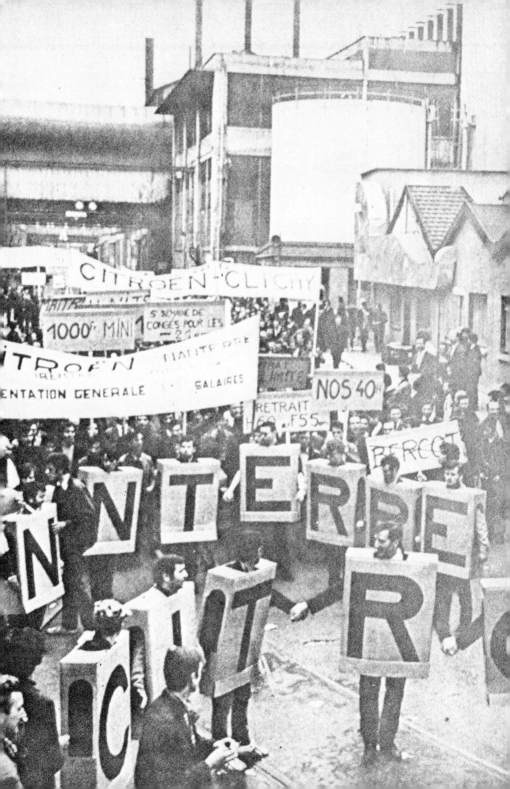

theatre, and that the role of the Beaux-Arts students was crucial. Peter Buckman, in *The Limits of Protest*, records a conversation with a student who claimed that distinctions between artists and non-artists didn't exist, any more than distinctions between painters and sculptors: all these belonged to the bourgeois system they had overthrown.[45] The revolt of 1968 certainly threw up two distinctive art forms: the posters of the Atelier Populaire, and graffiti slogans. The aerosol spray-can, a godsend to English football-fans and street gangs, became an instrument of great power in the hands of the May revolutionaries. The Paris Surrealists contributed the slogan BE REALISTIC: DEMAND THE IMPOSSIBLE!

Jean-Jacques Lebel is the most active member of the group of younger artists who have worked in the New Realist tradition. In an early happening, *Funeral Ceremony of the Anti-Process* (Venice, 1960), the audience were invited to attend the ceremony in formal dress. In a suitably decorated room in a large house was a 'body' draped on a plinth. This was then ritually stabbed by an executioner-figure. A 'service' was read, consisting of extracts from Huysmans and Sade. Pall-bearers then carried the coffin out into a gondola. The 'body' – which was in fact a sculpture by Tinguely – was finally ceremonially tipped into a canal. Lebel subsequently organized a number of 'Festivals of the Free Spirit' in Paris, during one of which he presented a happening, *To Invoke the Spirit of Catastrophe* (1962), in which he and a number of other artists created an environment for a violent social, sexual and political drama. Nudity and political provocation are essential parts of Lebel's early works: one event included naked girls with the heads of Kennedy and Khrushchev bathing in blood. At that stage, it seemed to me that he was using the form merely as a platform for his own social and political views to the detriment of the medium itself – he once said that Courbet's finest work was the destruction of the Vendôme Column – but he came into his own in May 1968.[46] He was prominent throughout the *événements* in Paris, and he and Julian Beck of the Living Theatre were instrumental in turning the liberated Odéon theatre into a forum for social and artistic debate. He was also involved in the protests at the repression of the Living Theatre at the Avignon Festival in July of the same year.[47]

Lebel's political commitment has come to dominate his work; during and since the May 1968 revolt he has worked in a highly radical form of street and factory-gate theatre. In a recent letter to me

184

he says, speaking of a British revolutionary political group, the Angry Brigade: 'theirs is a completely creative force; they are building the new world upon the ashes of the old'. When asked for a photograph to illustrate his recent activities, he suggested I print the diagram below. 150

From Berlin Cathedral and the streets of Moscow in 1919 to the streets of Amsterdam and Paris in 1968 and the closing of the Metropolitan Museum of Art in 1970, artists have demonstrated something of the ways in which the minds, as well as the bodies, of people can be liberated. André Breton said:

Today's authentic art goes hand in hand with revolutionary social activity: like the latter it leads to the confusion and destruction of capitalist society.

To many artists, like the G A A G, Lebel, Morea, Vostell, Baruchello, the Newcastle Group, art has come to take a second place to direct political action. To others, like Kaprow and the young street-artists of Yorkshire, art has meaning only to the extent that it involves itself in the life of the community around it. Yet others would seek relevance for their work as a new, non-logical form of scientific or social inquiry.

Whatever the next developments in the visual arts may be, it seems certain that the museum, and the private collection of handmade masterpieces, will be increasingly irrelevant to a generation of artists who have returned to a far older tradition of social integration and interaction.

150
JEAN-JACQUES LEBEL
Do It Yourself 1969

185

A Partial Chronology to 1963

This is not intended to be a complete or exhaustive list, but a representative one showing the development of allied activities in different parts of the world over the same period of time.

1952 John Cage, Charles Olsen and others, Event at Black Mountain College, U S A.

1957 First 'Gutai Theatre Art', Tokyo/Osaka.

1958 Allan Kaprow, exhibition Hansa Gallery, N Y C.
Wolf Vostell, street-pieces in Rome.
Dick Higgins/Al Hansen, 'Audio-Visual Group', N Y C.
Yves Klein, *Manifestation of the Void*, Paris.
Allan Kaprow, untitled happening, Douglas College, N Y C.
Second 'Gutai Theatre Art', Osaka.

1959 Wolf Vostell, *TV De-Collage*, Cologne.
Allan Kaprow, *18 Happenings in 6 Parts*, Reuben Gallery, N Y C.
Red Grooms, *The Burning Building,* Reuben Gallery, N Y C.

Otto Piene, *Light Ballet*, Düsseldorf.

1960 Robert Whitman, *Small Cannon*, Reuben Gallery, N Y C.
Allan Kaprow, *The Big Laugh*, Reuben Gallery, N Y C.
Red Grooms, *The Magic Train Ride*, Reuben Gallery, N Y C.
Jim Dine, *The Smiling Workman*, Judson Church, N Y C.
Claes Oldenburg, *Snapshots from the City*, Judson Church, N Y C.
Robert Whitman, *A Small Smell*, Judson Church, N Y C.
Allan Kaprow, *Coca-Cola, Shirley Cannonball?*, Judson Church, N Y C.
Jean Tinguely, *Hommage à New York*, Museum of Modern Art, N Y C.
J.-J. Lebel/Alain Jouffroy, *Anti-Process 1, 2*, Venice and Paris.
Yves Klein Presents, Paris.
Jim Dine, *The Car Crash*, Reuben Gallery, N Y C.
Robert Whitman, *The American Moon*, Reuben Gallery, N Y C.
Jim Dine, *The Shining Bed*, Reuben Gallery, N Y C.
Arman, *Manifestation of Garbage*, Galerie Iris Clert, Paris.

Allan Kaprow, *Garage Environment*, N Y C.
Wolf Vostell, *Street-pieces*, Barcelona.
Yves Klein, *Anthropometry of the Blue Epoch*, Paris.
Allan Kaprow, *Apple Shrine*, Judson Church, N Y C.
Nam June Paik, *Etude für Piano*, Cologne.
Robert Whitman, *E.G.*, N Y C.
Spur Group Manifesto, Munich.
George Brecht, *Motor Vehicle Sundown Event*, N Y C.
'International Sky Festival', Osaka.
Daniel Spoerri, first *Trap Painting* (*Tableau-piège*), Paris.

1961 Claes Oldenburg, *Ironworks/Fotodeath*, Reuben Gallery, N Y C.
Robert Whitman, *Mouth*, Reuben Gallery, N Y C.
Allan Kaprow, *A Spring Happening*, Reuben Gallery, N Y C.
Dick Higgins, *Danger Music*, Judson Church, N Y C.
Benjamin Patterson/Wolf Vostell, *Lemons*, Cologne.
Wolf Vostell, *Cityrama 1*.
Allan Kaprow, *Words*, Smolin Gallery, N Y C.
Allan Kaprow, *A Happening for Ann Arbor*, Ann Arbor, Mich.
Zero Group demonstration, Düsseldorf.

Claes Oldenburg opens The Store.
Allan Kaprow, *Yard*, Martha Jackson Gallery, NYC.
Karlheinz Stockhausen, *Originale*, Cologne.

1962 Claes Oldenburg, *Injun*, Dallas, Texas, and N Y C.
Allan Kaprow, *A Service for the Dead*, Maidman Theatre, N Y C.
Allan Kaprow, *Chicken*, NYC.
Allan Kaprow, *Courtyard*, Greenwich Hotel, N Y C.
J.-J. Lebel, *To Exorcize the Spirit of Catastrophe*, Paris.
'Gutai Theatre Art', Osaka.
Wolf Vostell, *Actions for Gallery Visitors*, Paris.
Yvonne Rainier/Steve Paxton Dance Workshop, Judson Church, N Y C.
Wolf Vostell, *Inner Circle* (*Petite Ceinture*), Paris.
Wolf Vostell, *Rokin*, Amsterdam.
Claes Oldenburg, *Store Days*, The Store, N Y C.
Claes Oldenburg, *Nekropolis*, The Store, N Y C.
Benjamin Patterson/Robert Filliou, *Sneak-Preview Fluxus*, Paris.
Ay-O, *Hydra*, N Y C.
Adrian Henri, *City*, Liverpool.
Rauschenberg, Raysse, Saint-Phalle, Ultvedt, Spoerri, Tinguely, *Dylaby*, Stedelijk Museum, Amsterdam.
'Festival of Misfits', Gallery One, London.

Dick Higgins, *The Broadway Opera*, Cologne.
Adrian Henri, Roger McGough, John Gorman, *The Machine*, Liverpool.
'Fluxus 2', Cologne.
'Fluxus 3', Paris.
Henri / McGough / Gorman, *Death of a Bird in the City*, Liverpool.
Claes Oldenburg, *Voyages*, The Store, NYC.
Claes Oldenburg, *World Fair*, The Store, NYC.

1963 Stanley Brouwn, *This Way Brouwn*, Amsterdam.
Hermann Nitsch/Otto Mühl, first *Actions*, Vienna.
'Festival of Happenings', George Segal's farm, NY State.
George Brecht, *Yam Festival*, NYC.
Hansen / Brenner / Vostell / Higgins, *3rd Rail Happenings*, NYC.
Al Hansen, *Parisol 4 Marisol*, NYC.
Wolf Vostell, *9 De-Collages*, Wuppertal.

Henri / McGough / Gorman, *Playthings, Hat-Tricks, Milk Bottles*, Liverpool.
John Arden, 'Festival of Anarchy', Kirkbymoorside, Yorkshire.
Wolf Vostell, *Morning Glory*, NYC.
'Fluxus 4', Amsterdam.
Nam June Paik, *An Exposition of Music*, Wuppertal.
Henri / McGough / Gorman / The Roadrunners, *City and Blues*, Liverpɔol.
Allan Kaprow, *Trees*, New Brunswick.
Milan Knížák, *Short Carting Exhibition*, Prague.
Allan Kaprow, *Push and Pull* (for Hans Hofmann), NYC.
Claes Oldenburg, *Gayety*, Chicago.
Claes Oldenburg, *Stars*, Washington.
Claes Oldenburg, *Autobodys*, Los Angeles.
Robert Whitman, *Flower*, NYC.
Robert Whitman, *Water*, Los Angeles.

Happenings by Allan Kaprow: a Partial Chronology

1958 Untitled happening, Douglas College, N Y.
Untitled happening, George Segal's farm, New Brunswick, NJ.
Various untitled works: composition class of John Cage, New School for Social Research, N Y C.

1959 *18 Happenings in 6 parts*, Reuben Gallery, N Y C.

1960 *The Big Laugh*, Reuben Gallery, NYC.
Coca-Cola, Shirley Cannonball?, Reuben Gallery, N Y C.
Theatre Happening, Pratt Institute, N Y C.
Apple Shrine, Judson Church, N Y C.
Intermission Piece, Reuben Gallery, N Y C.

1961 *A Spring Happening*, Reuben Gallery, N Y C.
A Happening for Ann Arbor (Night), Ann Arbor, Mich.

1962 *A Service for the Dead, I*, Maidman Theatre, N Y C.
A Service for the Dead, II, outdoor version, Easthampton, N Y.
Chicken, YMHA, Philadelphia.

Courtyard, Greenwich Hotel, N Y C.
Sweeping, Woodstock, NY.
Mushroom, Minneapolis, Minn.

1963 *Tree*, New Brunswick, NJ.
Bon Marché, Théâtre des Nations, Paris.
Out, Edinburgh Festival Drama Conference (with Ken Dewey and others).

1964 *Eat,* Bronx, N Y C.
Birds, University of Southern Illinois, Carbondale.
Household, Cornell University.
Orange, Miami Arts Council, Fla.
Paper, U C Berkeley, Calif.

1965 *Calling*, N Y/N J.
Soap, Florida State University, Sarasota, Fla.
Self-Service, Boston/New York/Los Angeles/simultaneously.
Raining, never realized due to drought.

1966 *Gas*, A.K. and Charles Frazier, W C B S-T V, East Hampton, N Y.
A Three-Country Happening (with Wolf Vostell, Berlin,

189

and Marta Minujin, Buenos Aires).

Towers, Fourth Annual Avant-Garde Festival, NYC.

1967 *Moving*, Institute of Contemporary Art, Chicago.
Fluids, Pasadena Museum, California.
Flick, NY.
Interruption, State University of New York, Stonybrook, NY.
Watching, WCBS-TV, NYC.

1968 *Overtime* (*for Walter de Maria*), NYC.
Population, Colby Junior College, New London, NH.
Round Trip, State University of New York, Albany, NY.
Arrivals, Nassau Community College, NY.
Travelog, Fairleigh Dickenson University, NJ.
Record, I, University of Texas.
Transfer (*for Christo*), Wesleyan University, Conn.
Refills, Hofstra University, NY.
Runner, Washington University, DC.
Hello, WGBH-TV, Boston, Mass.

1969 *6 Ordinary Happenings*, Berkeley, Calif. (*Charity, Pose, Fine!, Shape, Giveaway, Purpose*).
Transplant, University of South Nevada, Las Vegas, Nev.
Dial, San Francisco, Calif.

Takeoff, US International University, La Jolla, Calif. (Version II at Sacramento State College, Calif.)
Homemovies, NJ and NY (Schmidt wedding).
Course, University of Iowa.
Work, Jewish Museum, NYC (cancelled due to problems).
Moon Sounds, El Mirage Dry Lake, Calif. (Blau wedding).
Heavenly Pastime, E A T, Osaka Fair (cancelled by Pepsi-Cola).

1970 *Graft*, Kent State University, Ohio.
Level, Aspen, Colo.
Don't, Los Angeles County Parks Dept, Calif.
Publicity, California Arts, Burbank, Calif.
Sawdust, Cologne, Germany (Kölnischer Kunstverein).
A Sweet Wall, Block Galerie, Berlin.

1971 *Tracts*, California Arts, Burbank, Calif.
Tag, Aspen Design Conference, Aspen, Colo.
Print-Out, Cultural Affairs Comm, Milan, Italy.
City Works, Galerie Baeker, Bochum, Germany.
Calendar, California Arts, Valencia, Calif.
Scales, California Arts, Valencia, Calif.

1972 *Message Units*, California Arts, Valencia, Calif.

190

Some Scripts for Happenings

Claes Oldenburg: Store Days (Extracts from working script.)

LIGHTING
—Five main stations of light 15 watt white
 15 watt white
 5 watt blue
 15 watt white
 25 watt white
—Three 5 watt colour lights on throughout, one in each room. Near floor in first room
—Extra—15 watt hammock light and in far station (toilet)
—Eccentrics—none

LIGHTING INSTRUCTIONS AND OTHER INSTRUCTIONS

3 periods of 10 minutes each—2 pauses.
Each 10 min. period divided into $2\frac{1}{2}$ min. periods—one length of 5 stations at 30 seconds each.
Stations are changed every 30 seconds in sequence 1–2–3–4–5, 1–2–3–4–5, etc.
Pause between 10 min. periods of 30 seconds.
Lights cue action (at station) which freezes when light leaves for adjoining station.
Total time 31 min.
Action thus for each station 6 min. total out of 30.
Script (by individual performers, operator) identifies pieces, room, station treated, activity, partners, on same page.
Performers' action is described by 30 second periods, in three parts:
(a) opening action
(b) middle, combined action, or development
(c) closing action
Closing action of one 30 sec. period is same as opening action of next [. . .]

191

ROOM II

A room slightly larger than Room 1. Also painted black with the relief of a few cut-outs mostly of reproductions of food from magazines. A piece in the form of a painting like a dressing table with a shelf on which a cracked mirror, a woman's head from a postcard, a large smudged postcard of the Empire State Building, fragments of makeup.

R. a sink and a cutting board. A hose leads from the faucet over the window to a point at the end of the cutting board where the water spouts out into a pan. On the cutting board a cleaver, some slashed vegetables (red cabbage, yams, sweet potatoes, f.ex.). On the ledge above, between Room 1 & 2, some blue cloth flowers in a bottle, shaving cream, Lavoris, a prescription bottle, etc.

Above the sink, an alcove, over which, a white shade, half lowered, to catch projections of Spirit II in attic. Full of painted paper bags of all kinds stuffed with paper and various debris arranged to fall down easily.

To left several bundles of firewood, an axe, a saw.

A trumpet hanging on wall and an unfinished ship model.

Furniture: A table and two chairs. The table has a top of stuffed muslin on which plates, cups, silver and food debris is sewn or otherwise attached (glued, stuck in plastic). Under this stuffed top another and under that still another, all like pillows (or pancakes). [. . .]

ROOM II MAN AND WOMAN

Station 2
Description, costume & general position
Woman: Blond, 'plump'.
Man: 'Stocky'.
Costumes: woman wears T-shirt on which something is printed in several colors and an ordinary white skirt with a pink heart on it. Short socks.
Man: long underwear top & pants.
Generally at ease in kitchen.
Woman at sink, cutting board and table to right.
Man seated & moving around to left.

ROOM II SPIRIT II

Description, costume and general position
SHORT, LONG-HAIR GIRL
Costume:
General position in 'attic' over room

Woman	Man
1 Drying dishes Stacks them above drinks water smiles mascara runs Same	1 Carving ship model Examines it carves Sands it
2 Takes pie out of plastic container Picks at it sobs Pushes it into man's face impulsively laughs	2 Sanding Sudden anger, grabs up table and crumples it throws it down Sits down gets pie in face
3 Laughs Unwraps ice cream bar Eats it	3 Wipes pie off face with second table top Picks up first sets everything right Takes up magazine
4 Eats bar, leaves it half eaten it falls on floor Pulls at tooth mouth fills w. blood, wipes it Laughs, look for ice cream bar but its fallen down	4 With shears cuts pinup from magazine Same Pastes it up on wall with tape

Allan Kaprow: Calling

A Happening for performers only. Performed Saturday, August 21, and Sunday, August 22, 1965.

In the city, people stand at street corners and wait.
For each of them:
A car pulls up, someone calls out a name, the person gets in, they drive off.
During the trip, the person is wrapped in aluminium foil. The car is parked at a meter somewhere, is left there, locked; the silver person sitting motionless in the back seat.
Someone unlocks the car, drives off. The foil is removed from the person; he or she is wrapped in cloth or tied into a laundry bag. The car stops, the person is dumped at a public garage and the car goes away.

At the garage, a waiting auto starts up, the person is picked up from the concrete pavement, is hauled into the car, is taken to the information booth at Grand Central Station. The person is propped up against it and left.

In the woods, the persons call out names and hear hidden answers.

Here and there, they come upon people dangling upside down from ropes. They rip the people's clothes off and go away.

The naked figures call to each other in the woods for a long time until they are tired. Silence.

Notes to Calling:

1. Places (other than train station) and times are to be decided just prior to performance.
2. Performance should preferably take place over two days, the first in the city, and the second in the country.
3. At least twenty-one persons are necessary to perform this Happening properly. For this number six cars are required. Thus there would be three persons waiting at street corners, a car containing three people including the driver, to pick each one up; and a matching number of second-stage cars, also manned by three people, to carry the wrapped persons to the railroad station. But this basic number of participants can be multiplied proportionately for as large a group as is desired.
4. Names used throughout are to be the names of those involved.
5. Wrapping of foil and cloth should be as thoroughly applied as possible, the face covered except for breathing gap.
6. Second-stage cars should be parked at pre-chosen self-service garages, widely separated from each other. Drivers then proceed to part of city where first-stage cars are parked at meters. There the two drivers exchange car keys, the first-stage trio hurrying to garage positions, where they enter the autos and await the arrival of the human packages. The latter, of course, are brought by the second-stage trio. Timing for this, and all other stages of the event, must be worked out exactly.
7. The cars depositing packages at garages next proceed to the homes of their drivers, where phone calls will be received.
8. After the human packages unwrap themselves at the information booth, calls should be made from a public booth to the drivers of the last-mentioned cars. Phone is allowed to ring fifty times before it is picked up. Answerer says only "Yes?" Caller asks if it is x (stating the right name), and quietly hangs up.
9. The people hanging from ropes in the woods are those who drove and accompanied the cars the day before. An exchange of positions takes place here (underscored by the inverted positions on the ropes), with the former

194

package people taking the active role. There should be no less than five bodies suspended, although all car people may choose to hang this way. If less than the total (of, say, eighteen), the others should sit motionless beneath each rope and join in the answering and the calling of names. When called from afar by the package people, the answer is simply 'here!' 'here!' until each body is found and violated.

10. The package people, arriving at the woods, call out the names of the car people hidden over a wide area among the trees. Moving as a group, they follow the sounds of the voices and reach each dangling figure. Its clothes are rapidly cut off, and after all have been so treated, the group leaves. Each suspended person (and those sitting beneath him) should cease answering his name when found. Gradually the answering will diminish to silence, and at that point they start to call out each other's names, like children lost.

APPENDIX 4

The Art Workers' Coalition

The Art Workers' Coalition and the Song My Massacre

DOES MOMA APPROVE OF THE SONG MY MASSACRE?

This poster protesting the Song My Massacre was initially conceived as a joint production of the Museum of Modern Art and the Art Workers' Coalition. It was proposed and unanimously approved at a large meeting of the two groups at the Museum of Nov. 25, 1969. On Dec. 18, after three weeks' work, it was peremptorily rejected by William S. Paley on the behalf of the Museum's Board of Trustees, despite broad support from the Museum's staff. 50,000 copies have now been published by the Art Workers' Coalition alone; they are being distributed free of charge all over the world, without benefit of the Museum's name or distribution facilities.

195

A Summary of the Events between Nov. 25 and Dec. 18:

Nov. 25: At the meeting, attended by the Museum's Ad Hoc Planning Committee, other members of the staff, the Art Workers' Coalition, and seven non-aligned artists invited by the Museum, the poster proposal was brought up and voted in. The Coalition offered to pay for it if the Museum would handle distribution via other Museums here and abroad. It was decided that the poster should be a documentary photograph and that no artist's name should appear on it. Timeliness and the need for rapid execution of the project was stressed. A Committee was formed of Arthur Drexler and Elizabeth Shaw of the Museum staff, Frazer Dougherty, Jon Hendricks, and Irving Petlin of the A W C.

Dec. 3: After several delays on the Museum's part, the Committee finally had its first meeting. Certain staff members were reluctant to support the documentary nature of the image chosen, but the Poster Committee was authorized to use the Museum's name in seeking reproduction rights, printer, etc. The specific photograph (first published in *Life* Magazine), the quotation, 99% of the layout, and the edition number were decided upon by the Committee that morning.

The Museum Executive Committee had a lunch meeting that day at which the poster was brought up (presumably for the first time), and a second $2\frac{1}{2}$ hour meeting of the Poster Committee was necessary to re-convince Arthur Drexler of the importance of the Museum's involvement. The majority of the Museum's actual work on the poster was done by the non-executive staff with open enthusiasm.

Dec. 9: Having heard no results from the Museum Committee members on the work they were supposed to be doing, and with the growing reluctance of the Executive Staff apparently paralyzing the Committee, the Coalition asked Arthur Drexler for a yes or no answer on the Museum's intentions to go ahead with the project. The reply was yes, and the A W C Committee members proceeded independently to secure donation of printing costs and 30,000 sheets of paper; on Dec. 16 one-time reproduction rights were acquired by the A W C from the photographer – Ron Haeberle. The remaining 20,000 sheets of paper were bought by the Coalition. The credit line on the poster still referred to the project as jointly sponsored by the A W C and M O M A.

Dec. 18: The color plate completed, and the printer waiting for the Museum's approval of the final credit line, the staff, still with one exception in favor of the Museum's participation, decided to 'touch base'. The mock-up was taken to William S. Paley, President of the Board of Trustees. At 6 p.m. Irving Petlin was informed by telephone that the Museum could not

196

(or was not allowed to) be associated with the poster. Mr Paley said that if the staff felt strongly about the issue, it could be presented to the Board of Trustees on Jan. 8 but that it would definitely be rejected.

Dec. 26: The poster, now sponsored by the Art Workers' Coalition, alone, was published in an edition of 50,000 copies and distribution began through an informal network of artists, students and peace movement workers throughout the world.

Practically, the outcome is as planned: an artist-sponsored poster protesting the Song My Massacre will receive vast distribution. But the Museum's unprecedented decision to make known, as an Institution, its commitment to humanity has been denied it. Such lack of resolution casts doubts on the strength of the Museum's commitment to art itself, and can only be seen as bitter confirmation of this Institution's decadence and/or impotence.

Guerilla Art Action in Front of Guernica on January 3, 1970

OBJECTIVES
To hold, in front of Picasso's Guernica, a memorial service for dead babies murdered at Songmy and all Songmys, the service to be conducted by a priest or a member of the clergy. This included the placing of flowers and wreathes in front of the painting and the participation of a live baby, symbolic of all babies.

DESCRIPTION
Just before 1 p.m. Saturday January 3, 1970, performers, witnesses and members of GAAG, DIAS, and AWC, infiltrated the Museum of Modern Art of New York, gathering on the third floor in front of Picasso's Guernica.

Some artists had smuggled wreaths and flowers in. At 1 p.m. members of the Guerrilla Art Action Group quietly went up to the painting, Guernica, and placed four wreathes against the wall underneath the painting. At this moment, Joyce Kozloff, carrying her 8-month old baby, Nikolas, sat on the floor in front of the wreaths. Father Stephen Garmey came forward and began reading a memorial service for dead babies (see text which follows).

During the reading, a guard who was standing next to the painting came up to Mrs Kozloff and the baby Nikolas, and told her she and the baby could not remain on the floor. The mother continued being busy with the baby, after continuous prodding by the guard, who finally put his hand on

197

Mrs Kozloff's arm, she picked up the baby and stood quietly in front of the painting during the remainder of the service.

When Father Garmey had finished his readings a number of people, including children, came forward and placed flowers and wreaths under the painting. Throughout the service for dead babies, people remained quiet and reverent.

SERVICE READ AND PREPARED BY FATHER STEPHEN GARMEY
Jesus called them unto him and said, suffer the little children to come unto me, and forbid them not; for of such is the Kingdom of God.

(Prayer Book, p. 338.)

There was a little boy walking toward us in a daze. He'd been shot in the arm and leg. He wasn't crying or making any noise. A G.I. knelt down next to him and fired three shots into the child. The first shot knocked him back, the second shot lifted him into the air, the third shot put him down and the body fluids came out. The G.I. just simply got up and walked away.

(*Life*, Dec. 5, 1969.)

The Lord himself is thy keeper; the Lord is thy defence upon thy right hand; so that the sun shall not burn thee by day, neither the moon by night. The Lord shall preserve thee from all evil; yea, it is even he that shall keep thy soul.
The Lord shall preserve thy going out, and thy coming in, from this time forth for evermore. (Ps. 121:5.)

At the same time came the disciples unto Jesus, saying, who is the greatest in the Kingdom of Heaven? And Jesus called a little child unto him and set him in the midst of them, and said, verily I say unto you, except ye become as little children, ye shall not enter into the Kingdom of Heaven.

(Matt. 18.)

There was a small boy about three or four years old clutching his wounded arm with his other hand while blood trickled between his fingers. He just stood there with big eyes staring around like he didn't understand. Then the radio operator put a burst of M-16 fire into him.

(*Life*, Dec. 5, 1969.)

The Lord himself is thy keeper . . . (see above).

Then Herod, when he saw he was mocked of the wise men, was exceeding wroth, and sent forth and slew all the children that were in Bethlehem, and in all the coasts thereof, from two years old and under, according to the time which he had diligently enquired of the wise men. Then was fulfilled that which was spoken by Jeremy the Prophet, saying, in Rama was there a

198

voice heard, lamentation and weeping, and great mourning, Rachel weeping for her children, and would not be comforted, because they are not.
(Matt. 2.)

Just outside the village there was this big pile of bodies. This really tiny kid/ he only had a shirt on/nothing else/he came over to the pile and held the hand of one of the dead. One of the G.I.'s dropped into a kneeling position and killed him with a single shot. (*Life*, Dec. 5, 1969.)

The Lord himself is thy keeper . . . (see above).

We have breathed the grits of it in, all our lives,
Our lungs are pocked with it,
The mucous membrane of our dreams
Coated with it, the imagination
Filmed over with the gray filth of it:

The knowledge that humankind,
Delicate man, whose flesh
Responds to a caress, whose eyes
Are flowers that perceive the stars,

Whose music excels the music of birds,
Whose laughter matches the laughter of dogs,
Whose understanding manifests designs
Fairer than the spider's most intricate web,

Still turns without surprise, with mere regret
To the scheduled breaking open of breasts whose milk
Runs out over the entrails of still alive babies,
Transformation of witnessing eyes to pulp-fragments,
Implosion of skinned penises into carcass-gulleys.

(Denise Levertov.)

LORD HAVE MERCY UPON US.
LORD HAVE MERCY UPON US.
LORD HAVE MERCY UPON US.

Guerrilla Art Action Group
Jon Hendricks
Poppy Johnson
Jean Toche

199

Notes on the Text

Chapter One (pp. 7–26)
Towards a Total Art

1 Andrew and Marilyn Strathern, *Self-Decoration in Mount Hagen*, Duckworth, London, 1971. A superb and fascinatingly illustrated book.

2 See the book which emerged from a historic exhibition of 'vernacular architecture': Bernard Rudolfsky, *Architecture Without Architects*, Doubleday, New York (especially plates 7, 8, 12, 40, 50, 101, 103). Similar attempts have been made recently to see non-fine-art modern American architecture in perspective, notably in the chapter on Las Vegas in Tom Wolfe's *The Kandy-Kolored Tangerine-Flake Streamline Baby*, Farrar, Straus & Giroux, New York, and Cape, London, 1965, and more recently in Reyner Banham's *Los Angeles: the Architecture of Four Ecologies*, Allen Lane, London, and Harper & Row, New York, 1971.

3 For fully illustrated articles on these works see *The Saturday Book*, 27, Hutchinson, London, 1967.

4 See Ralph Pomeroy, 'José Jordá's Paraíso', *Art and Artists*, London, September 1966.

5 The 'Surrealist' aspect of Portmeirion was eagerly seized on by the producers of a television drama serial, *The Prisoner*.

6 See the article by Stephen Green-Armytage in *Daily Telegraph Colour Magazine*, London, 27 February 1970; and numerous illustrations in Allan Kaprow, *Assemblages, Environments, Happenings*, Abrams, New York, 1966, as well as a long description on pp. 170–71.

7 See Michael Kirby, *Futurist Performance*, Dutton, New York, 1971.

8 See *Marinetti: Selected Writings*, Farrar, Straus & Giroux, New York, and Secker & Warburg, London, 1972.

9 Described in Dick Higgins, *Postface*, Something Else Press, New York, n.d.

10 Translated in Ann Arbor paperback, n.d.

11 For a full account of the art of this period, see Camilla Gray, *The Russian Experiment in Art, 1863–1922*, Thames and Hudson, London, and Abrams, New York, 1971.

12 See Michael Braun, *Meyerhold on Theatre*, Methuen, London, 1969.

13 From the exhibition catalogue 'Art in Revolution', Arts Council, London, 1971, an invaluable survey with translations of important documents.

14 Kasimir Malevich, *Essays on Art*,

Rapp & Whiting, London, 1969, and Wittenborn, George, New York, 1971.

15 See Hans Richter, *Dada: Art and Anti-Art*, Thames and Hudson, London, and Abrams, New York, (1966) 1968, p. 12.

16 A full account and illustrations of these works can be found in Werner Schmalenbach, *Kurt Schwitters*, Abrams, New York, and Thames and Hudson, London, 1970, pp. 129–39.

17 First published in *Sturmbühne*, 8, and translated in Robert Motherwell's definitive *The Dada Painters and Poets,* Wittenborn, Schultz, New York, 1951, pp. 62–63.

18 See H.L.C. Jaffé, *De Stijl*, Thames and Hudson, London, and McGraw-Hill, New York, 1970.

19 See L. Moholy-Nagy, F. Molnar and D. Schlemmer, *The Theatre of the Bauhaus*, Wesleyan University Press, Middletown, Conn., 1961.

20 For a lucid exposition of this problem, see Ludwig Hoffmann, 'The Working Class in the Theatre', *The Times Literary Supplement*, London, 15 October 1971.

21 See the exhibition catalogue 'Erwin Piscator, Political Theatre 1920–66', Arts Council, London, 1971.

22 For a concise summary of Brecht's work and theories, see John Willett, *The Theatre of Bertolt Brecht*, Methuen, London, 1959, and New Directions, New York, 1968.

23 Calder & Boyars, London, publish complete translations of Artaud's theoretical works: *Complete Works*, London, 1971.

24 Ronald Hunt, in the exhibition catalogue 'Descent into the Street', 1967. This show, and Hunt's more extended version of it in Stockholm, are interesting not only for posing so many questions about the relationship of art and politics (see Chapter Four of this book) but also as an indication of the attitudes of the group of young artists working in Newcastle in the mid-1960s.

25 See Maurice Nadeau, *The History of Surrealism*, Macmillan, New York, 1967, and Cape, London, 1968, for this tragi-comic story. The best available book in English conveying the spirit of Surrealism is *Surrealism: Permanent Revelation*, by Roger Cardinal and Robert Stuart Short, Studio Vista, London, and Dutton, New York, 1970.

26 Salvador Dali, *The Secret Life of Salvador Dali*, Vision Press, London, (1948) 1973.

27 Paul C. Ray, *The Surrealist Movement in England*, Cornell University Press, Ithaca, 1971.

28 Dali (note 26), pp. 309–11.

29 Illustrated scripts of *L'Age d'or* and *Un Chien andalou* have been published by Lorrimer, London, 1968.

30 An illustrated script of *Le Sang d'un poète* has been published by Penguin, Harmondsworth and Baltimore, 1969.

31 Scenario printed in vol. 3 of Artaud's *Complete Works* (note 23), together with scripts for a number of other short films.

32 See Sarane Alexandrian, *Surrealist Art*, Thames and Hudson, London, and Praeger, New York, 1970, pp. 177–78. For details of similarly environmental post-war Surrealist shows, see ibid., pp. 190–93, 225–27, 230–32.

33 See Anne d'Harnoncourt and Walter Hopps in *Bulletin of the Philadelphia Museum*, 25 June 1969, and John Perrault, 'The Bride Needs New Clothes', *Village Voice*, New York, 11 September 1969.

34 Keith Arnatt in *Studio International*, London, May 1971

35 In Pierre Cabanne, *Conversations with Marcel Duchamp*, Viking, New York, and Thames and Hudson, London, 1971.

Chapter Two (pp. 27–85)
Art as Environment

1 Claes Oldenburg, *Store Days*, Something Else Press, New York 1967.

2 The Independents' Group consisted of Lawrence Alloway, art critic and theorist, Reyner Banham, architectural historian, Eduardo Paolozzi, sculptor, Theo Crosby, architect, Peter and Alison Smithson, architects, the critic Toni del Renzio and others. They operated as a programme/discussion group within the ICA, of which Alloway became, for a time, director. For a useful collection of reprinted statements by group members see John Russell and Suzi Gablik, *Pop Art Redefined*, Thames and Hudson, London, and Praeger, New York, 1969, pp. 41–52, 73–76.

3 The ICA, in its original small premises at 17 Dover Street, was virtually the only centre for display and discussion of avant-garde art at this period. Victor Musgrave's Gallery One was, for its brief life, the nearest London equivalent to the Green Gallery in New York or the Galerie Iris Clert in Paris.

4 The hero of Alfred Bester's science-fiction novel *Tiger! Tiger!*

5 See Lawrence Alloway, 'Size Wise', *Art News and Review*, London, 1960.

6 For a full documentation see *Store Days* (note 1). The best general work on Oldenburg is Ellen H. Johnson, *Oldenburg*, Penguin, Harmondsworth and Baltimore, 1971.

7 At the Judson Gallery, New York, 1960. Oldenburg did a later version, using similar materials, at the Reuben Gallery during the following year.

8 See Claes Oldenburg, *Oldenburg: Proposals for Monuments and Buildings*, Big Table Press, Chicago, 1969.

9 Ibid., p. 168.

10 See Russell and Gablik (note 2), pp. 85–87, for some characteristic Johnson letters.

11 'The man is naked. He hurts. He has just been beaten on the stomach with a bar of soap wrapped in a

towel (to hide tell-tale bruises). . . . His mind can't think for him at the present moment. He is committed there for the rest of his life.' From the exhibition catalogue '11 Tableaux by Kienholz', Kunsthaus, Zürich, and ICA, London, 1971, the only available work on the artist. For his early work, see Harriet Janis and Rudi Blesh, *Collage*, Chilton, New York, 1967, pp. 232–33.

12 See Gregory Battcock, 'Humanism and Reality: Thek and Warhol in the New Art', in Battcock, ed., *The New Art*, Dutton, New York, 1966.

13 See *Agenzia*, 11/12, Paris, 1969.

14 See Germano Celant, ed., *Art Povera*, Studio Vista, London, and Praeger, New York, 1969.

15 See Daniel Buren in *Studio International*, London, March and August/September 1970, April 1971.

16 See Guy Brett, *Kinetic Art*, Studio Vista, London, and Reinhold, New York, 1968, pp. 57–71, for a chapter on Clark and Oiticica; also the catalogue 'Helio Oiticica', Whitechapel Art Gallery, London, 1969.

17 See Neal Weaver, 'The Polka-dot Girl Strikes Again', *After Dark*, New York, May 1968.

18 Yoko Ono, *Grapefruit*, Sphere, London, 1970.

19 See Annette Michelson, 'Towards Show', and an article on Wieland's films, *Artforum*, New York, June 1971.

20 See the exhibition catalogue 'Software', Jewish Museum, New York, 1970. See also Jonathan Bent-hall, *Science and Technology in Art Today*, Thames and Hudson, London, and Praeger, New York, 1972, p. 75; a statement by Nicholas Negroponte, 'SEEK's Software', is printed as an appendix.

21 *A Report on the Art and Technology Program of the Los Angeles County Museum of Art, 1967–71*, Los Angeles, 1971.

22 See the exhibition catalogue 'Lucht/Kunst', Stedelijk Museum, Amsterdam, 1971.

23 Anton Ehrenzweig, *The Hidden Order of Art*, University of California Press, Berkeley, 1967, pp. 175, 186, ills. 21–23.

24 Alfred Jarry, *Collected Works*, ed. Roger Shattuck and Simon Watson Taylor, Methuen, London, 1965, p. 225.

25 See Lawrence Alloway, *Christo*, Thames and Hudson, London, and Abrams, New York, 1969. Umbro Apollonio, ed., *Christo*, Milan, deals with his early work in some detail; on later pieces see the exhibition catalogue 'Christo: Projects Not Yet Realized', Annely Juda Gallery, London, 1971.

26 See Benthall (note 20), pp. 129–31, and Jack Burnham, 'Haacke's Cancelled Show at the Guggenheim', *Artforum*, New York, June 1971.

27 Jan van der Kam and Dick Hellenius, 'At the Boundary of Land and Sea', *Delta*, Holland, Winter 1971–72.

28 See *Studio International*, London, May 1971.

29 See *Interfunktionen*, 1, pp. 30–47.

30 See *Interfunktionen*, 5, and 'Discussion with Heizer, Smithson, Oppenheim', in *Avalanche*, 1, New York, 1970.

31 See Robert Smithson, 'Incidents of Mirror-Travel in the Yucatan', *Artforum*, New York, September 1969.

32 See Terry Fulgate-Wilcox, 'Force Art: a New Direction', *Arts Magazine*, New York, March 1971.

Chapter Three (pp. 86–132)
Happenings

1 The best single source for this aspect of Oldenburg's work is his *Store Days*, Something Else Press, New York, 1967.

2 See Ken Dewey's account in *Encore*, 46, London, 1964.

3 From John Hodgson and Ernest Richards, *Improvisation*, Methuen, London, and Baines & Noble, New York, 1966, pp. 62–65: 'Happenings'.

4 Michael Kirby, *Happenings*, Sidgwick & Jackson, London, and Dutton, New York, 1965, p. 21.

5 See 'Happenings Issue', *The Drama Review*, Winter 1963, pp. 224–28.

6 See Harriet Janis and Rudi Blesh, *Collage*, Chilton, New York, 1967.

7 See interview with Michael Kirby and Richard Schechner in 'Happenings Issue' (note 5).

8 'Silence, by which John Cage means unintended, indeterminate noise.' *Silence* is in fact the title of his first and most influential book, Wesleyan University Press, Middletown, Conn., 1961.

9 See 'Happenings Issue' (note 5), p. 85, for the full text.

10 Hans Richter, *Dada: Art and Anti-Art*, Thames and Hudson, London, and Abrams, New York, (1966) 1968, p. 51.

11 Quoted by Kirby (note 4), pp. 44–46.

12 Kirby (note 4) is the best source for texts and descriptions of early happenings.

13 Ibid., p. 188.

14 Ibid., pp. 134–36.

15 Oldenburg (note 1).

16 Al Hansen, *A Primer of Happenings and Time/Space Art*, Something Else Press, New York, 1965.

17 See Victor Musgrave, 'The Unknown Art Movement', *Art and Artists*, London, October 1972.

18 See Hansgörg Meyer, ed., *Journey to the Surface of the Earth: Mark Boyle's Atlas and Manual*, Cologne, London and Reykjavik, 1970.

19 Jeff Nuttall, *Bomb Culture*, Paladin, London, 1968, and Delacorte, New York, 1969.

20 *Collection*, from Orchard House, St Helens Lane, Leeds.

21 See *BAMN*, Penguin, Harmondsworth and Baltimore, 1971, pp. 149–51, 168–75, 229–31.

22 See Klaus Groh, *Aktuelle Kunst in Osteuropa*, DuMont Aktuell, Cologne, 1972, for an account of

East European activities in the visual arts.

23 See 'In Memoriam Josef Honys', *Pages*, 2, London, Winter 1970.

24 See the section on Knížák in Allan Kaprow, *Assemblages, Environments, Happenings*, Abrams, New York, 1966, and 'Aktuel in Czechoslovakia', *Art and Artists*, London, October 1970.

Chapter Four (pp. 133–85)
The Artist as Performer

1 Jackson Pollock, in *Possibilities*, New York, Winter 1947-48.

2 The cycles were *Cycle sacerdotal*, with an altar; *Cycle royal*, a condemnation of humanism, the Renaissance and the Reformation, with the altar replaced by a throne; *Cycle bourgeois*, with heads of Diderot, Voltaire and others as hanged men, and the throne replaced by a safe; and a final cycle of Frigidaires and juke-boxes. There was also a portrait of Descartes to be walked on.

3 The best available work on Klein is the exhibition catalogue 'Yves Klein', Union Centrale des Arts Décoratifs, Paris, 1969.

4 For a complete survey of his work to date see the two-volume exhibition catalogue 'Daniel Spoerri', Stedelijk Museum, Amsterdam, 1971.

5 The best available survey of Beuys's work is the exhibition catalogue 'Joseph Beuys', Moderna Museet, Stockholm, 1971.

6 See *24 Stunden*, a book of happenings by Beuys, Vostell, Paik and others, Galerie Parnass, Wuppertal, 1965.

7 Notably in *Iphigenie*; see *Interfunktionen*, 4, for drawings and photographs of this action.

8 See, for instance, Michael Kustow, 'A Case History: Joseph Beuys', *The Guardian*, London, January 1970.

9 See *Interfunktionen*, 5, for drawings and photographs of this action.

10 Robert Conybeare, 'Interview with Joseph Beuys', presented as part of Dip. A.D. thesis, Faculty of Art, Wolverhampton Polytechnic, 1971.

11 See Adrian Henri, 'Strategy: Get Arts', *Scottish International*, 12, Edinburgh, November 1970.

12 See also Gerald Woods, Philip Thompson and John Williams, eds., *Art Without Boundaries 1959–70*, Thames and Hudson, London, and Praeger, New York, 1972, pp. 140–41.

13 Quoted in 'Happenings Issue', *The Drama Review*, Winter 1963. This invaluable issue contains articles, interviews and other texts by Young, Cage, Higgins, Oldenburg, the Fluxus group, and many others.

14 See George Brecht, *Chance Imagery*, Something Else Press, New York, 1965; this is a published version of a text written in 1957.

15 See three articles by Dick Higgins in *The Something Else Newsletter*, New York: 'Intermedia', Feb-

ruary 1966; 'Games of Art', March 1966; 'Intending', April 1966.

16 See 'Happenings Issue' (note 13) for a full account of this work, and also a Higgins theatre piece, *The Tart*.

17 See 'Fluxus Issue', *Art and Artists*, London, October 1972.

18 See Cornelius Cardew, ed., *Scratch Music*, Latimer, London, 1972.

19 See *The Drama Review*, September 1972, pp. 142–50.

20 See *The Drama Review*, June 1972, pp. 66–74.

21 See the exhibition catalogue 'Robert Morris', Tate Gallery, London, 1971.

22 A study of work in this field is 'Bodyworks', *Avalanche*, 1, New York, 1970.

23 See John Perrault, 'Taking to the Street', *Village Voice*, New York, 16 October 1969.

24 Metzger, an ex-pupil of David Bomberg, gave a number of lecture-demonstrations during this period. His *Auto-destructive Art*, published by Destruction/Creation, London, 1965, prints a long lecture, manifestos and photographs. *Art and Artists*, London, August 1968, devoted a whole issue to the various DIAS activities; this is a very useful source of information.

25 Metzger, *Auto-destructive Art* (note 24).

26 Hermann Nitsch, *Orgien Mysterien Theater*, März-Verlag, Frankfurt, 1969.

27 See *Wien: Bildkompendium Wiener Aktionismus*, Kohlkunst-Verlag, Frankfurt, 1970, for a comprehensive account, with copious illustrations, of the work of the Vienna school.

28 Günter Brus, *Irrwisch*, Kohlkunst-Verlag, Frankfurt, 1971.

29 Wolf Vostell, *Happening und Leben*, Werk, Berlin, 1970.

30 For a good general account of Tinguely's work see Calvin Tomkins, *The Bride and the Bachelors*, Weidenfeld & Nicolson, London, 1965, and Viking Press, New York, 1968.

31 Letter to the author, 1967.

32 Carl Andre in *Interfunktionen*, 5, 1970.

33 Albert Speer, *Inside the Third Reich*, Macmillan, London, 1969, and Macmillan, New York, 1970, pp. 63–64.

34 Tom Wolfe, *The Electric Kool-Aid Acid Test*, Farrar, Straus & Giroux, New York, and Weidenfeld & Nicolson, London, 1968, p. 58. This book contains an account of the 'Trips Festivals' and other mixed-media activities. See also Ralph Gleason, *The Jefferson Airplane and the San Francisco Sound*, Ballantine, New York, 1969.

35 Before opening the Fillmore West, Bill Graham had been working with the San Francisco Mime Troupe, who were giving free mixed-media mime performances in the city.

36 See *Rolling Stone*, New York, 14 October 1971.

37 See their manifesto in Jeff Nuttall, *Bomb Culture*, Paladin, London, 1968, and Delacorte, New York, 1970.

38 See Kurt von Meier, 'Los Angeles, the Failure and Future of Art', *Art International*, Lugano, May 1967.

39 See *Document 1* and *Open Hearing*, published by the Art Workers' Coalition, 299 Broadway, New York, 1969.

40 *GAAG Action/Letters*, communiqués published from 1 White Street, New York, 1971.

41 See *Delta*, Holland, Autumn 1967, for a full account in English of Provo activities.

42 See *Delta*, Holland, Autumn 1970.

43 There is a profile of Roel van Duyn, 'The Pixie Prophet', in *The Observer*, London, 16 May 1971.

44 See *Ten Days that Shook the University*, published by the Situationist International, 1968.

45 Peter Buckman, *The Limits of Protest*, Panther, London, and Bobbs-Merrill, Indianapolis, Ind., 1970.

46 Lebel's development can be traced in his books, from *Le Happening*, Denoël, Paris, 1966, through *Lettre ouverte au regardeur*, Librairie Anglaise, Paris, 1966, to *Entretiens avec le Living Theatre*, Belfond, Paris, 1969. His work in street theatre is documented in his article 'Street Theatre, Paris, 1968, 1969', *Radical Arts*, London, 1970.

47 Jean-Jacques Lebel, *Procès du Festival d'Avignon, supermarché de la culture*, Belfond, Paris, 1968.

Further Reading

One of my reasons for writing this book was to bring together existing material from ephemeral or hard-to-trace sources, so as to present a mosaic of expanding activities in the hope of stimulating more. This book should, therefore, be an incentive to further reading by those interested enough to want to work in this area themselves, or merely to find out more about it. Instead of a formal bibliography, I have used the footnotes as a guide to further reading, in each case citing the most easily available, the cheapest, or the English-language source wherever possible. The notes make no attempt to be exhaustive, merely to present the best available relevant information.

Michael Kirby's classic *Happenings*, Dutton, New York, and Sidgwick & Jackson, London, 1965, is an absolute necessity, as is Allan Kaprow's *Assemblages, Environments, Happenings*, Abrams, New York, 1966; and happenings are to be found in Max Kozloff's *Renderings*, Simon & Schuster, New York, 1968, and Studio Vista, London, 1970. Udo Kultermann's *The New Sculpture*, Thames and Hudson, London, and Praeger, New York, 1968, and *The New Painting*, Pall Mall Press, London, and Praeger, New York, 1969, are helpful, as are Jean-Jacques Lebel's *Le Happening*, Denoël, Paris, 1966 (now out of print), Al Hansen's *Primer of Happenings and Time/Space Art*, Something Else Press, New York, 1965 (now also out of print). Kultermann's recent *Art-Events and Happenings*, Matthews Miller Dunbar, London, 1972, is a useful picture-book, but the rather confused text makes little or no distinction between theatre, happenings proper, dance and other related work. Some texts of happenings and a translations of a long theoretical piece by Lebel can be found in *New Writers Four*, Calder & Boyars, London, and Transatlantic, Levittown, N.Y., 1967.

208

List of Illustrations

Measurements given are in cm. and in. height first

WIM GIJZEN (b. 1941)
67 *Project for Schouwburgplein, Rotterdam*, 1966. Photomontage.

PIERO GILARDI (b. 1942)
36 *Featherweight Cobbles*, 1972. Painted polyurethane.

SAM GOODMAN (b. 1919)
144 *Psyche and Vanity*, 1960–61. Mixed media.

GREAT GEORGES PROJECT
93 *Gifts to the City: Six Memorials*, Liverpool, 1971. Action, performed on the site of Harry's Chip Shop.

RED GROOMS (b. 1937)
20 *City of Chicago*, 1968. Plywood and beaverboard painted with acrylic. Art Institute of Chicago.

HANS HAACKE (b. 1936)
63 *Chickens Hatching*, Forsgate Farms, N.J., 1969 (detail).

DUANE HANSON (b. 1925)
44 *Race Riot*, 1969–71 (now destroyed). Mixed media. O.K. Harris Works of Art, New York.

ALEX HAY (b. 1930)
56 *Grass Field*, New York, 1966. Action.

DICK HIGGINS (b. 1938)
128 *Graphis 82: Diagram from Jefferson's Birthday and Postface*, 1962.
129 *Graphis 82*, Living Theatre, New York, 1962: actors at 'love', 'looking glass' and 'lizard'. Both copyright © 1964 by Richard C. Higgins. All rights reserved. Reprinted by permission of Dick Higgins.

JOHN BULL'S PUNCTURE REPAIR KIT
96 Action, Serpentine Gallery, London, 1972.

RAY JOHNSON (b. 1927)
28 *Moticos*, 1955. Assemblage.

CAROL JOSEPH
55 *Living Room*, 1970. Environment. Shown at ICA, London.

ALLAN KAPROW (b. 1928)
70 *Garage*, 1962. Environment.
71 *Calling (City Section)*, New York, 1965. Action.
72 *Calling (County Section)*, 1965. Action.
73, 74 *Pose*. Action.
75 Poster for *Fluids*, 1967.
76 *Fluids*, Pasadena, Calif., 1967. Action.
77 Poster for *Runner*.

ED KIENHOLZ (b. 1927)
31 *Roxy's*. 1961. Environment. Furniture, bric-à-brac, live goldfish, incense, disinfectant, perfume, juke-box, clothing, etc. Formerly Dwan Gallery, New York.
33 *State Hospital*, 1964 (detail). Environment. Formerly Dwan Gallery, New York.
34, 35 *Back Seat Dodge*, 1964. Environment. Collection Mrs Edward Kienholz, Los Angeles.
39 *The Beanery*, 1965. Environment. Stedelijk Museum, Amsterdam.
40 *The Birthday*, 1964. Environment. Private collection.

YVES KLEIN (1928–62)
105 *The Vampire*, 1960. Canvas, 140 × 94 (55 × 37). Galerie Karl Flinker, Paris.
111 *Leap into the Void*, Nice, 1962. Action.
112 Klein wearing a shirt designed by himself, Venice, 1947.
116 *Anthropometry ANT 49*, 1960. 110 × 60 (43½ × 23½).
117 *Painting ceremony*, Paris. Action.

MILAN KNÍŽÁK (b. 1960)
101 *An Individual Demonstration*, Prague, 1964. Action.

ALISON KNOWLES (b. 1933)
130 *The Big Book*, 1967. Mixed media.

FERDINAND KRIWET (b. 1942)
127 *Apollo America*, 1970; from 'Strategy: Get Arts', Edinburgh, 1970. Environment with six slide-projectors.

YAYOI KUSAMA (b. 1940)
41 *Endless Love Room*, 1965–66. Environment.

PETER KUTTNER (b. 1941)
110 *Edible Rainbow*, London, 1971. Action.

JEAN-JACQUES LEBEL
150 *Do It Yourself*, 1969. Diagram.

LES LEVINE (b. 1935)
30 *Levine's Restaurant*, New York, 1969. Environment/action.

ADOLF LUTHER (b. 1912)
126 *Smoke and Light Sculpture*, from 'Strategy: Get Arts', Edinburgh, 1970. Mixed media.

ALEXANDER MACDONALD (1914–64)
5 *The Burma Road*, 1939–45. Mallaig, Inverness-shire, Scotland.

MAD MINAS (DOLLE MINAS)
Demonstration, Amsterdam, 1970.

GUSTAV METZGER
136 *Demonstration of Acid Nylon Technique*, London, 1960. Action.

ROLAND MILLER AND SHIRLEY CAMERON
94 *Railway Images*, 1970. Action.

MEREDITH MONK
86 *Education of a Girl-child*, New York, 1972. Action.

ROBERT MORRIS (b. 1931)
132 *Site*, New York, 1964. Action,

performed in 1965 at the New York Theater Rally.

134 *Plan for Tate Gallery exhibition*, London, 1971.

MOVEMENT COLLECTIVE

102 *Improvisations*, Moscow, 1970. Action.

LEV NUSBERG

103 *Plan for Kinetic Environment for the Seaside Area of Odessa*, 1970.

JEFF NUTTALL (b. 1933)

90 *The Stigma*, London, 1965. Action.

91 *The Marriage*, London, 1966. Action.

CLAES OLDENBURG (b. 1929)

23 *Preliminary Report on the Store*, 1965. Reproduced from *Store Days*, Something Else Press, New York, 1965, by courtesy of Claes Oldenburg.

24 *The Store*, 1965. Environment.

25 *Icebag*, 1970. Polyvinyl, foam rubber, blowers, hydraulic cylinders, etc., diam. 5·55 m (18 ft), h. 5·55 m max. Shown at Expo 70, Osaka, 1970.

27 *Postcard Study for Colossal Monument: Thames Ball*, 1967. Altered postcard, 8·9 × 14 (3½ × 5½). Collection Carroll Janis, New York.

29 *Store Days*, New York, 1965. Action.

DENNIS OPPENHEIM (b. 1938)

53 *Branded Mountain*, 1969. San Pablo, Calif.

MERET OPPENHEIM (b. 1913)

41 *See* ANONYMOUS.

48 *Spring Feast*, Paris, 1959. Action. Photograph taken at the opening of the International Exhibition of Surrealism at the Galerie Cordier, Paris, 1959–60.

RALPH ORTIZ

104 *Destruction of an Armchair by the Artist and the Sea*, 1966. Provincetown, Mass. Chrysler Museum at Norfolk, Gift of Walter P. Chrysler.

EDUARDO PAOLOZZI, NIGEL HENDERSON, ALISON AND PETER SMITHSON

15 *Drawing for Patio and Pavilion*, for 'This is Tomorrow', London, 1957.

THE PEOPLE SHOW

92 *Christian Aid World Hunger Demonstration*, Trafalgar Square, London, 1969.

DAVID PEARSON

42 *Bedroom at Arles*. Environment.

PERIPATETIC ARTISTS' GUILD

133 *Prospectus for Robert Morris*, 1970.

ADRIAN PHIPPS-HUNT

64 *The Drops into Concrete*, 1971.

ROBERT RAUSCHENBERG (b. 1925)

131 *Spring Training*, New York, 1965. Performed at the New York Theater Rally.

KLAUS RINKE (b. 1939)

124 *Water Sculpture*; from 'Strategy: Get Arts', Edinburgh, 1970.

JAMES ROSENQUIST (b. 1933)

19 *F-111*, 1965. Oil, canvas and aluminium, 3 × 26·5 m (10 × 86 ft). Collection Mr and Mrs Robert C. Scull, New York.

21 Detail showing right hand panel of ill. 19.

NIKI DE SAINT-PHALLE (b. 1930)

138 *Autel-tir*, 1962. Mixed media.

NIKI DE SAINT-PHALLE, JEAN TINGUELY, PER OLOF ULTVEDT

37–38 *Hon*, 1966 (now destroyed). Environment. Moderna Museet, Stockholm.

LUCAS SAMARAS (b. 1936)

59 *Room 2*, 1966. Environment. Wood, mirrors, 2·44 × 3·05 × 2·44 m (8 × 10 × 8 ft). Albright-Knox Art Gallery, Buffalo, New York.

CLARENCE SCHMIDT

6 *Environment*, 1930. Woodstock, N.Y.

17 *Environment*, c. 1970. Woodstock, N.Y.

CAROLEE SCHNEEMAN

85 *Meat Joy*, Mason Church, New York, 1964. Action.

KURT SCHWITTERS (1887–1948)

10 *Hanover Merzbau*, c. 1927 (now destroyed). Environment.

GEORGE SEGAL (b. 1924)

16 *Costume Party*, 1965–67. Acrylic on plaster, metal, wood, and mixed media, 183 × 366 × 274 (72 × 144 × 108). Sidney Janis Gallery, New York.

KAZUO SHIRAGA (b. 1924)

108 *Making a Work with His Own Body: Material is Mind*, Tokyo, 1955. Action.

PAUL SILLS

69 *Monster Model Fun House*, 1965. Diagram.

SITUATIONIST GROUP

148 *The Return of the Durutti Column*, 1967.

ROBERT SMITHSON (b. 1938)

52 *Spiral Jetty*, 1970. Great Salt Lake, Utah.

66 *Fifth Mirror Displacement*, Yucatán, 1969.

SPACE STRUCTURE WORKSHOP

46 Giant airbed from 'Blow-Up '71', Kensington Gardens, London, 1971.

49 *Colour Village* from 'Blow-Up '71', Kensington Gardens, London, 1971.

ALBERT SPEER (b. 1905)

143 *Cathedral of Ice*, Nuremburg Rally, 1934.

DANIEL SPOERRI (b. 1921)

109 *Cannibal Dinner*, Restaurant Spoerri, Düsseldorf, 1970. Action.

118 *Catalogue Tabu*, 1961. Mixed media. Kölnisches Stadtmuseum, Cologne.

ATSUKO TANAKA (b. 1932)

107 *Light Costume*, 1956.

VLADIMIR TATLIN (1885–1953?)

8 *Drawing for Letatlin, c.* 1930.

9 The artist in an overcoat designed by him, in front of a homemade stove; detail of a page from *Krasnaya Panorama*, 1924.

PAUL THEK (b. 1933)

43 *Death of a Hippie*, 1967. Environment. Pink painted hardboard, wax body. Stable Gallery, New York.

JEAN TINGUELY (b. 1925)

139 *Homage to New York*, 1960 (destroyed). Mixed media. The Museum of Modern Art, New York.

140–42 *Study for an End of the World No. 2*, 1962 (destroyed). Mixed media. Nevada Desert.

JAN VAN RAAY

146 *Photo Collage*, 1970. From 'The People's Flag Show', Judson Memorial Church, New York, 1970.

WOLF VOSTELL (b. 1932)

113 *You: Diagram*, 1964. Collection H. A. Baier, Mainz.

114 *You*, Great Neck, N. Y., 1964. Action.

137 *Nein-9-Dé-collagen*, Wuppertal, 1963. Action.

ANDY WARHOL (b. 1930)

22 *Clouds*, 1966. Leo Castelli Gallery, New York

26 *Cow Wallpaper*, 1971. Silkscreen. Leo Castelli Gallery, New York.

THE WELFARE STATE

95 Action, Tower of London, City of London Festival, 1972.

TOM WESSELMANN (b. 1931)

18 *Great American Nude No. 54*, 1964. Assemblage. Neue Galerie, Aachen, Collection Ludwig.

STEFAN WEWERKE (b. 1928)

125 *Chair-Piece*, from 'Strategy: Get Arts', Edinburgh, 1970. Mixed media.

ROBERT WHITMAN (B. 1935)

81–83 *The American Moon*, New York, 1960. Action.

84 *Shower (Cinema Piece)*, 1968. Mixed media.

Photo acknowledgments

Art and Artists 104; ANEFO, Amsterdam 147; Arts Council of Great Britain 7; Denise Bellon, Images et Textes, Bazainville 12, 13; Kors van Bennekom 115; John Bryson 140, 142; Leo Castelli Gallery, New York 19, 22, 26; Art Institute of Chicago 20; Museum of Contemporary Art, Chicago 84, 130; Daily Telegraph Colour Library 17; Richard Demarco 5; Everson Museum of Art, Syracuse, N.Y. 58; Galerie Editions Karl Flinker, Paris 105; George Franklin 70; © David Gahr 139; © copyright Gemini G. E. L. © copyright Claes Oldenburg 25; Giraudon 4; Gufram, Turin 36; Landesgalerie Hanover 10; Ichiro Hariyu 107, 108; O. K. Harris Works of Art, New York 44; Heinrich Hoffmann 143; Dennis Hopper 76; Sidney Janis Gallery, New York 16, 27, 51; Peter Jones 49; Keystone, courtesy Editions du Seuil 1; Ute Klophaus 119, 120, 121, 123; Jacques-Dominique Lajoux 60; J. S. Lewinski 62; Edward Lucie-Smith 46, 95, 96, 122; Robert McElroy 24, 29, 78–83; Peter Moore 6, 56, 71, 72, 85; Colene Murphy 141; Hans Namuth 106; Elisabeth Novick 131, 132; *The Observer* 92; George A. Oliver 124–27; Lütfi Özkök 38; Pace Gallery, New York 59; Jan van Raay 145; Rheinisches Bildarchiv 118; Martha Rocher 48; Rotterdam Arts Foundation 67; Rowan Gallery, London 65; Ruder and Finn Fine Arts 57; John D. Schiff 14; Shunk-Kender 111, 112, 116, 117; Shunk-Kender. Copyright Valley Curtain Corp. 1971 54; Archiv Sohm 101; Stable Gallery, New York 43; Susan Sterne 86; Nationalmuseum, Stockholm 8, 9; Tiofoto, Stockholm 37; M. B. Trace 90, 91; John Weber Gallery, New York 52, 66; Whitechapel Art Gallery, London 15.

Index

213

216